PLANT
KINGDOM

Design with Plant Aesthetics

SendPoints

PLANT KINGDOM - Design with plant Aesthetics

© SendPoints Publishing Co., Ltd.

SendPoints

EDITED & PUBLISHED BY SendPoints Publishing Co., Ltd.
PUBLISHER: Lin Gengli
PUBLISHING DIRECTOR: Lin Shijian
EDITORIAL DIRECTOR: Sundae Li
EXECUTIVE EDITOR: Casey Kwan, Elly Ho, samsam
ART DIRECTOR: He Wanling
EXECUTIVE ART EDITOR: WangXue, He Wanling
PROOFREADING: Sundae Li, Heart Fensch

ADDRESS: Room 15A Block 9 Tsui Chuk Garden, Wong Tai Sin, Kowloon, Hong Kong
TEL: +852-35832323 / **FAX:** +852-35832448
EMAIL: info@sendpoints.cn

DISTRIBUTED BY Guangzhou SendPoints Book Co., Ltd.
SALES MANAGER: Zhang Juan (China), Sissi (International)
GUANGZHOU: +86-20-89095121
BEIJING: +86-10-84139071
SHANGHAI: +86-21-63523469
EMAIL: overseas01@sendpoints.cn
WEBSITE: www.SendPoints.cn

ISBN 978-988-13834-4-0

Plant Kingdom focuses on the artistic shape of the plants, and their application and psychological value in modern design.

CONTENTS

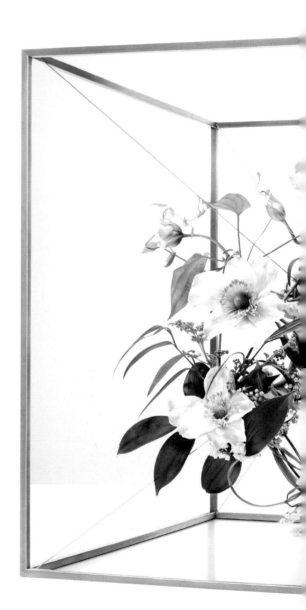

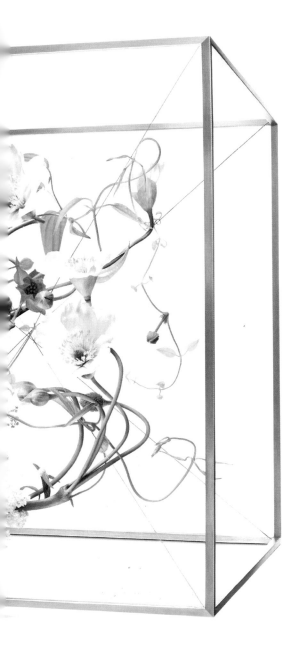

- *Feel Nature* -

Japan

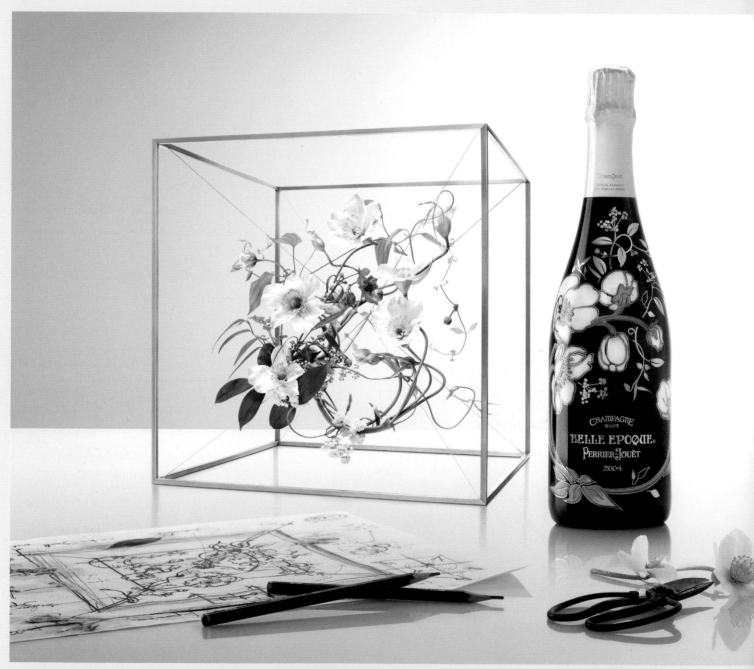

The bottle design is for a world limited edition of Bell Epoque, Perrier-Jouët's iconic line. This champagne comes from historical long-established wine house and is made with sincere human care from fruits of the earth. To reflect that, using a motif of the Japanese white anemone, the designers reinterpreted these worldviews for modern times and used them in the design.

Since the early 1900's, Perrier-Jouët has worked with artists. This tradition continues with French glass artist Emile Gallé who designed a timeless champagne bottle which he adorned with magnificent and delicate flower, the anemone. The new limited edition bottle, created by renowned floral Japanese artist Azuma Makoto, pays homage to Gallé's famous Art Nouveau design. Originally inspired by Japanese art and nature, the anemone has become the iconic image of Perrier-Jouët's artistic heritage through its prestige cuvée.

Challenging aesthetic boundaries, Azuma created unique artwork, made of a single delicate botanical arabesque dotted with white Japanese anemones. This artwork recalls the original 1902 design, which is further reinforced with a handcrafted motif of golden flowers on the bottle of Belle Epoque 2004.

The world changed greatly in 200 years from the age that Galle had drawn. Azuma Makoto wanted to express "contemporary" aesthetics by using "frame" which is symbol of artifact and "present time " with Japanese white anemones that Galle drew.

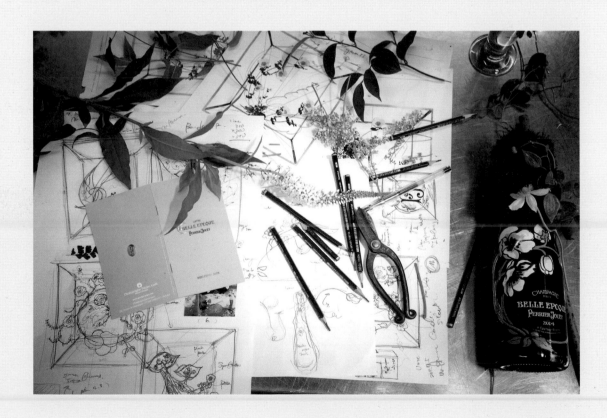

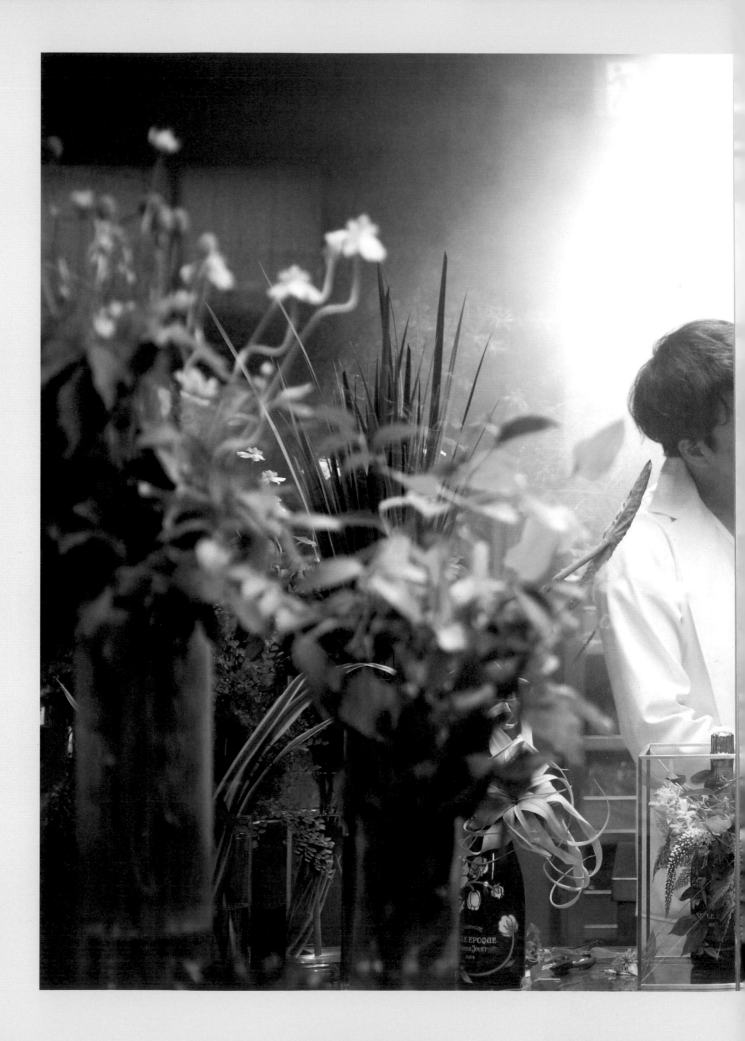

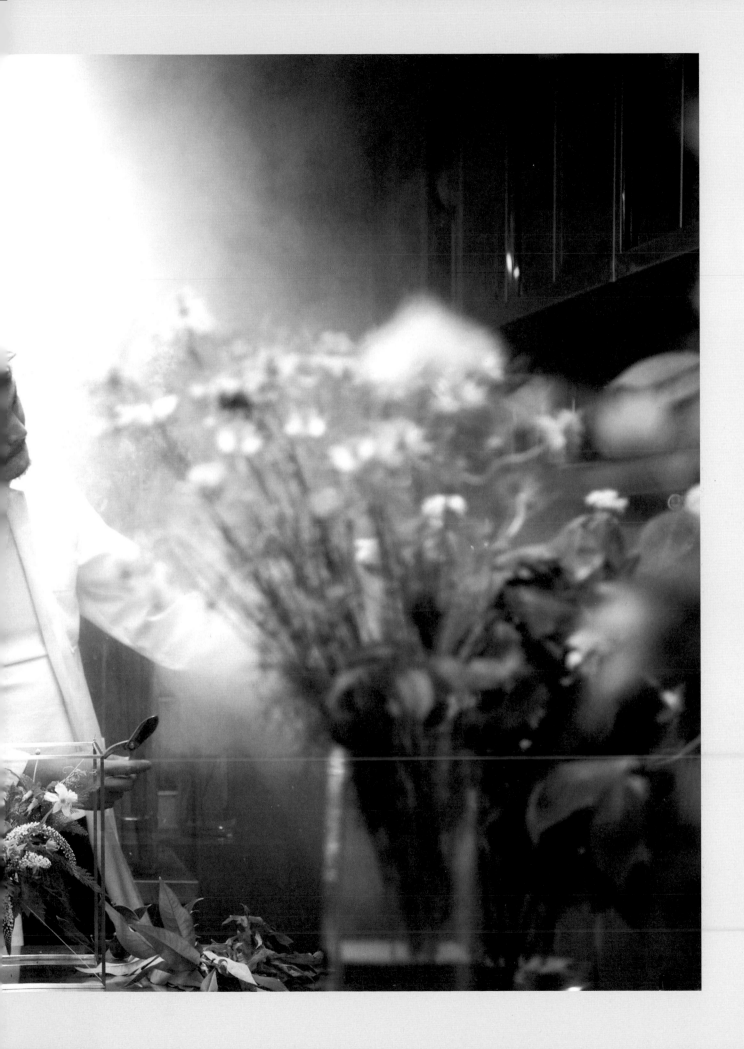

Thinking about Plant Aesthetics

The artist wanted to express the way that flower and leafs appear as if they are free and uplifted just as Belle Epoque's rich taste has a light and refreshing feel. The flowers included Japanese white anemone, Stemona japonica, Japanese meadowsweet, clematis, Japanese knotweed and monarda.

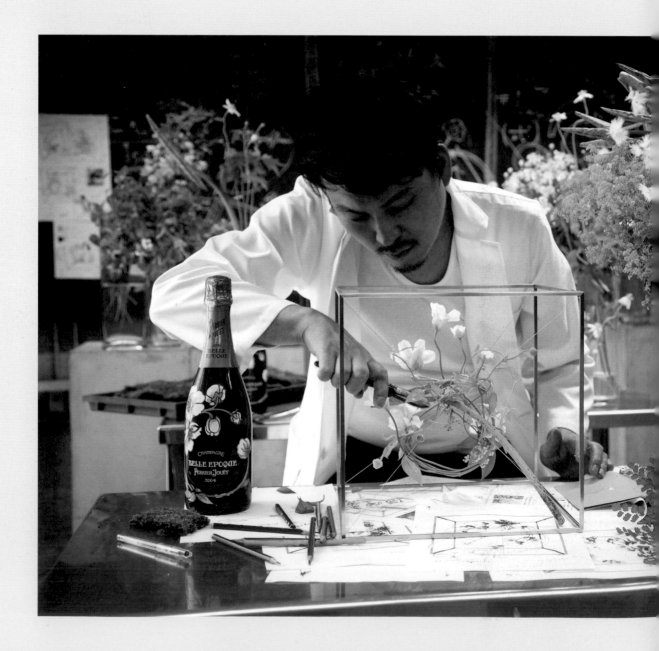

"I wanted to make something extraordinary, taking inspiration from the sensation of champagne inside the mouth, and the delicate movement of the ivy and leaves with a special attention and tribute given to Emile Gallé's anemones."

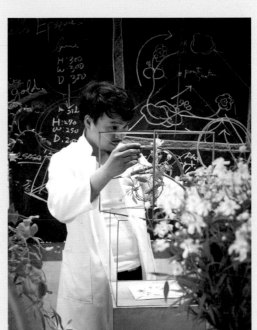

The flowers are arranged in frame and wire, the life of the flower in this setting emphasizes the concept of nature in contrast to man-made surroundings. Appreciating nature is important in life, but to be connected with nature when introduced in other settings is how we expect to relate to nature today and in the future.

"I wanted to make something extraordinary, taking inspiration from the sensation of champagne inside the mouth, and the delicate movement of the ivy and leaves with a special attention and tribute given to Emile Gallé's anemones," explains Azuma.

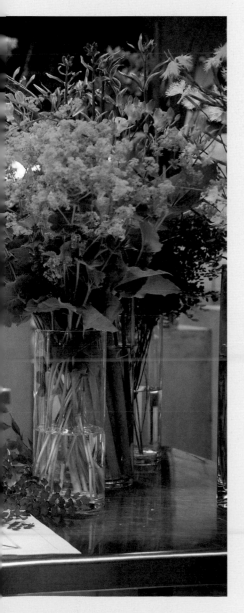

"Azuma Makoto and Perrier-Jouët share the same values of tradition, passion for nature and genuine originality," said Lionel Breton, Chairman & CEO Martell Mumm Perrier-Jouët. "We are delighted to have found in Azuma Makoto the Emile Gallé of modern times through his unique creation".

From the specific choice of flowers, to the endless series motif on the bottle itself, Belle Epoque Florale Edition perfectly expresses the luxury and craftsmanship of Perrier-Jouët, while delivering a contemporary vision of beauty.

/

Foreword

/

Plants have sustained life on this planet since the beginning of humanity and continue to influence and alter our world. It would be reasonable to assume that the life cycles across the entire planet would disappear without these voiceless living things.

In the progress of human culture, our way of life and aesthetic standards have always been affected by plants. Their flowers, fruits, leaves and twigs have brought food and fire, as they flourish and die in the cycle of seasons. They were used to build living places in the earliest times and to treat illnesses. Later, as farming techniques advanced, they changed human diets and even the way societies were organized. Plants in different environments can lead to various aesthetic experiences: refreshing green grasslands, romantic red roses, awe-inspiring tall trees, wonderfully delicate flowers or melancholy dead leaves. They are rich in colors and can be regarded as a kind of visual language. Human understanding of these well-known and intimate neighbors is affected by functional and aesthetic experiences.

From the perspective of functional experience, early on in history societies had started to classify different plants and function, with a focus on medicinal plants. In China, a professional book on plants — A Record of Plants in the South (Nan Fang Cao Mu Zhuang) —appeared in 304A.D. In the Ming Dynasty, the book Compendium of Materia Medica (Ben Cao Gang Mu) introduced a variety of medicinal plants. During the Qing Dynasty, Illustrated Book of the Study of Plants (Zhi Wu Ming Shi Tu Kao) noted the appearance and function of different plants through artistic illustrations. Europe has its oldest botanical garden in Padua, Italy which was established in 1545 and still exists in its original location.

From the perspective of aesthetic experience, the emphasis on crucial role of plants remains the same in different civilization periods and areas. The beauty of plants is an everlasting theme both in eastern conceptual ink painting and in western figurative oil painting. The recording of nature's extraordinary works and unpredictable changes is also tied to the psychological reactions of people to the world they exist in. The best-known Chinese painting Dwelling in the Fuchun Mountains by Huang Gongwang from Yuan Dynasty, and Morning Glory from Qi Baishi, etc. show vigor, with simple brush strokes. French impressionist Monet expressed his feeling about the world through changing light and shades in Lotus. In the depiction and imagination of rural land in Christina's World, the American realistic painter Andrew Wyeth demonstrated the loneliness and poignant beauty of human inner world. Through all these master pieces we can see the beautiful diversity of plants as well as the different expectation of affection implied.

Dwelling in the Fuchun Mountains *by Huang Gongwang*

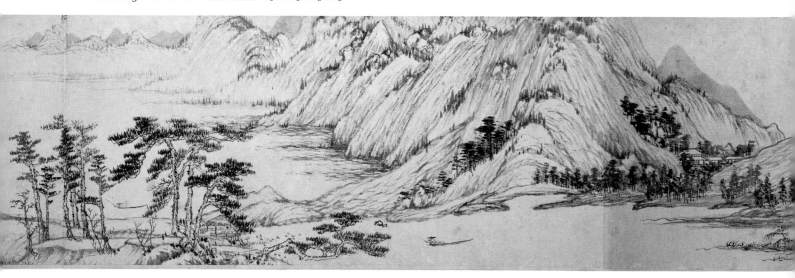

Our daily life is constantly affected by objects decorated with various botanical elements. Throughout history, in every part of the world, images of plants have been often utilized in our dressing materials, articles of everyday use and living spaces. In modern society, different types of artistic representations of plants are plentiful: color, realistic, abstract, material, synthetical, tridimensional, digital, etc.

The beauty of plants keeps changing the world, affecting people's lifestyles and guiding us to create a magnificent world.

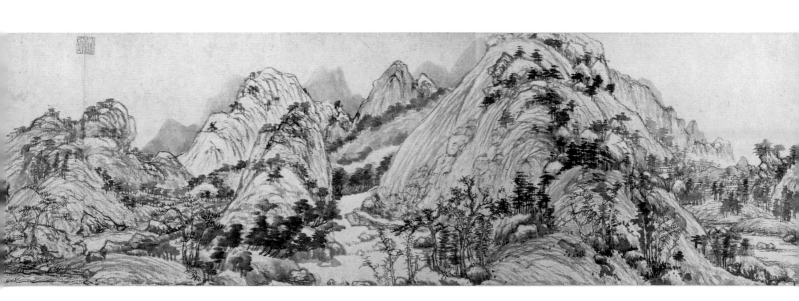

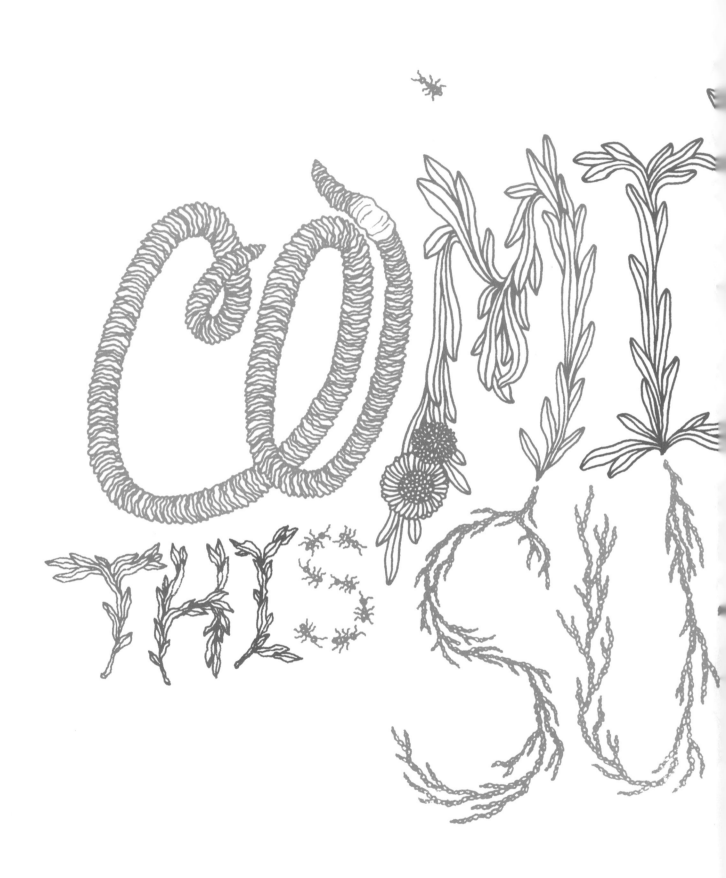

/

Projects

/

Haishe Cosméticos

 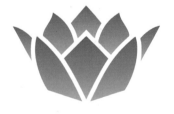

Brazil

Designer
Junior Zek

The brand Haishe Cosmetics was inspired by the lotus flower. In the Orient, the lotus flower signifies spiritual purity. The "padma" (lotus), also known as Egyptian lotus or sacred Indian lotus, serves as a symbol of femininity so it was chosen for the brand. The resulting graphic symbol was beautiful and relatable for their clientele.

The Decemberists - flowers

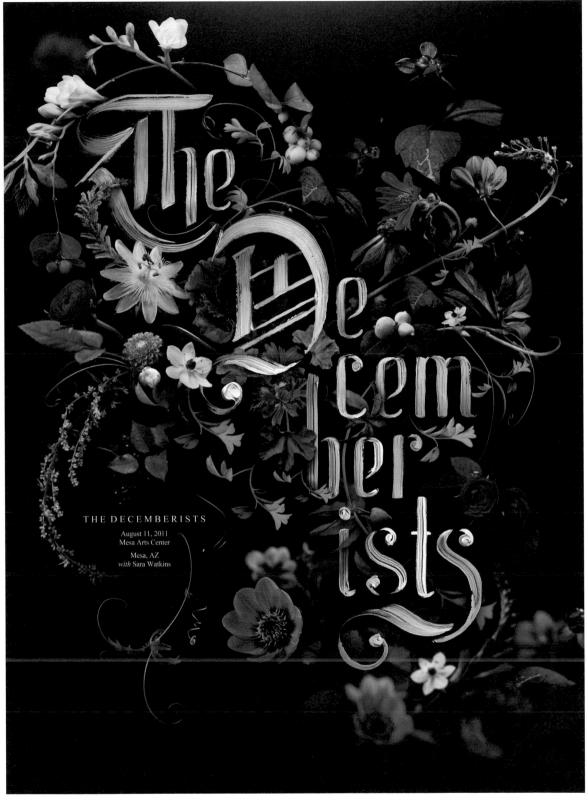

THE DECEMBERISTS

August 11, 2011
Mesa Arts Center

Mesa, AZ
with Sara Watkins

UK

Design & Photography
Sean Freeman

Production & Art Direction
Eve Steben

Design Firm
THERE IS Studio

Client
Another Planet Entertainment

Special edition concert poster for the band The Decemberists made out of flowers and paint.

Exploded Flowers

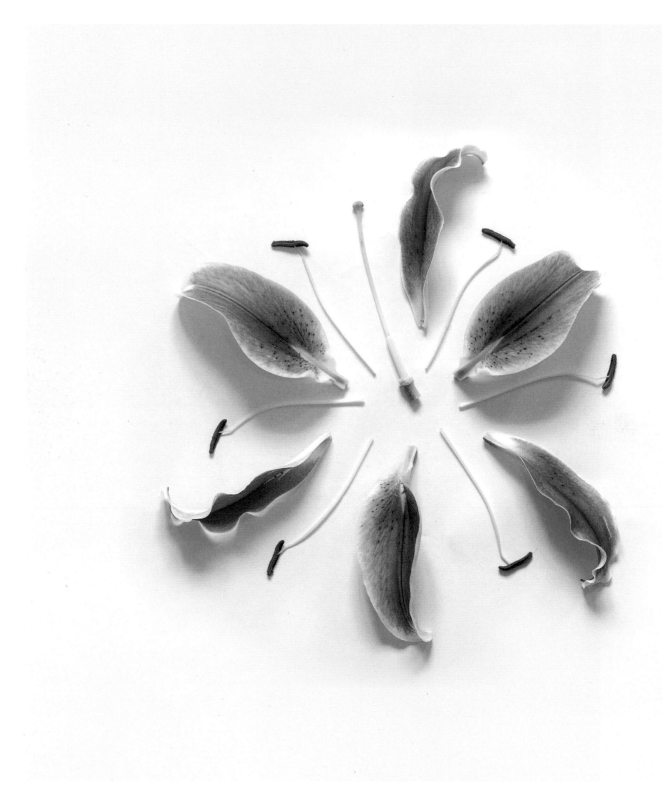

Singapore

Designer
FONG QI WEI

Fong Qi Wei's flowers are amongst the most intricate and beautiful structures nature has ever inspired. "Exploded Flowers" is a series that presents familiar flowers with a unique perspective, showing the aesthetic value of each petal, pistil and stamen. The ultimate aim of art is to change the audience's perspective, and with this series, the designer hopes that he can do so for every single viewer.

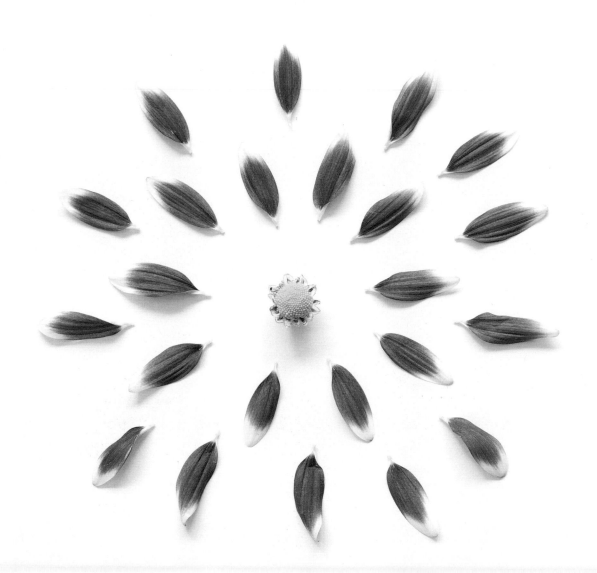

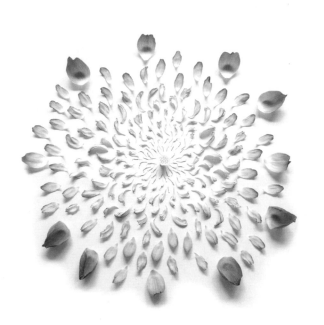

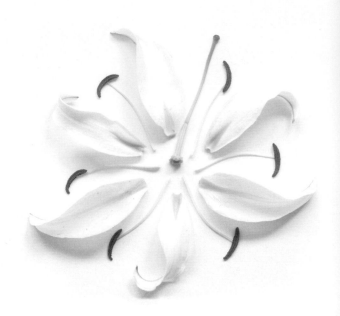

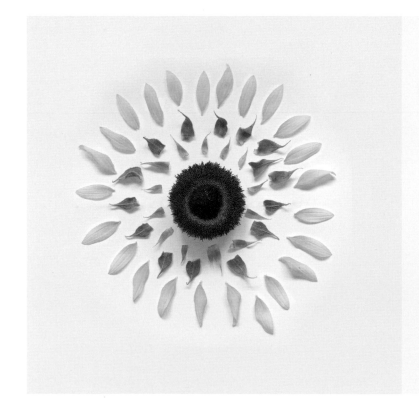

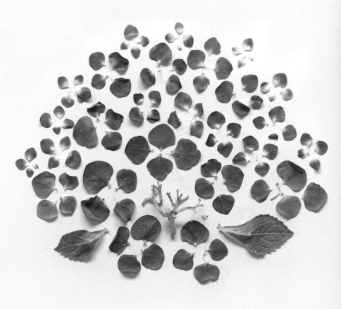

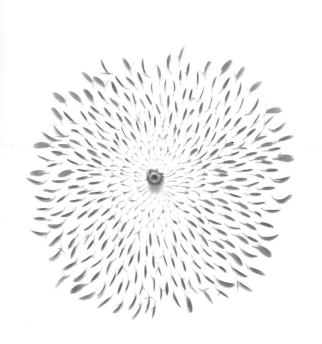

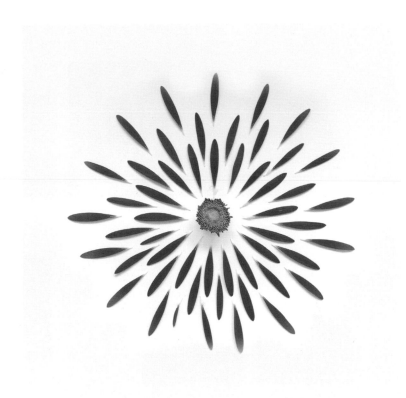

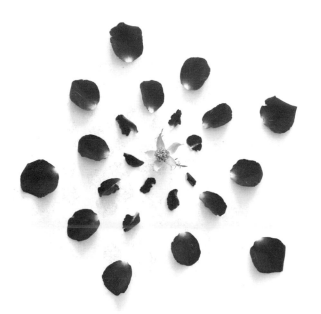

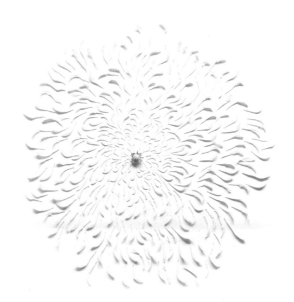

Paper Shades

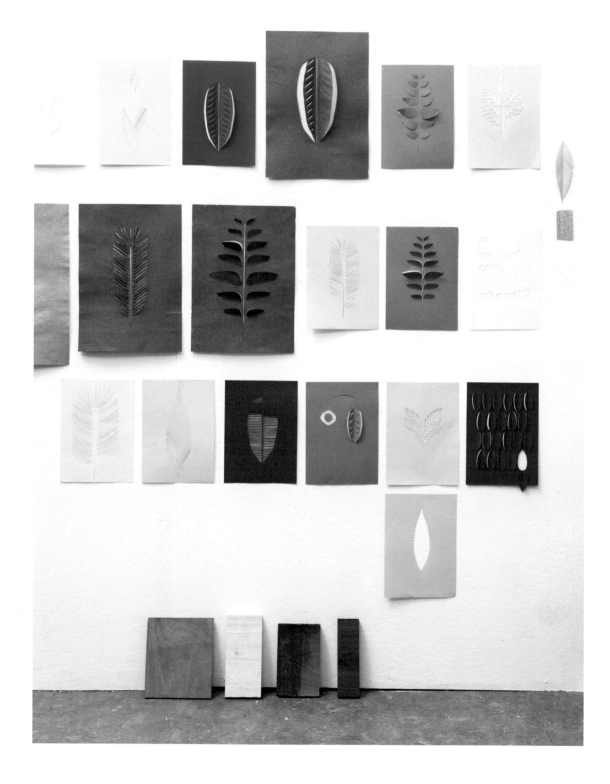

The Netherlands

Design Agency
Raw Color

Five carefully selected shades of wood are highlighted and observed down to the smallest fiber. The sawdust, originating from one plank, is transformed into a pile of paper. Combining the classical medium of handmade paper with the contemporary production technique of laser cutting the abstracted leafs of each tree type are cut out of the sheets. In this way the shadows reveal different shades on each piece.

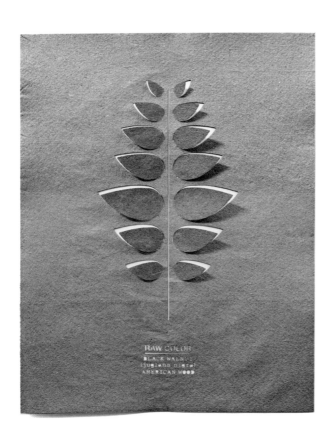

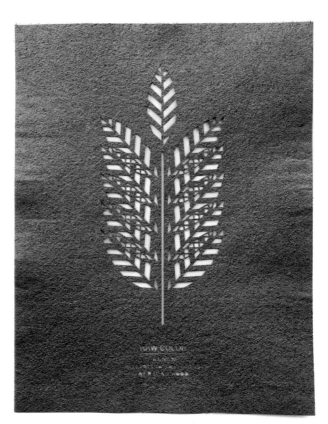

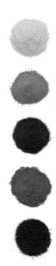

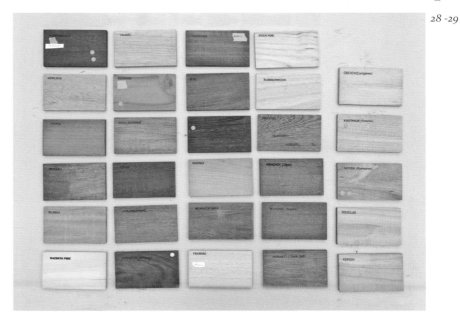

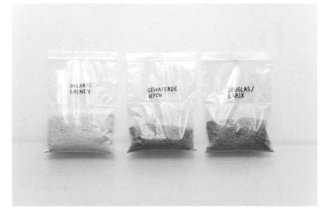

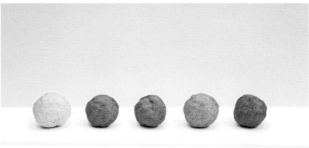

Chabur

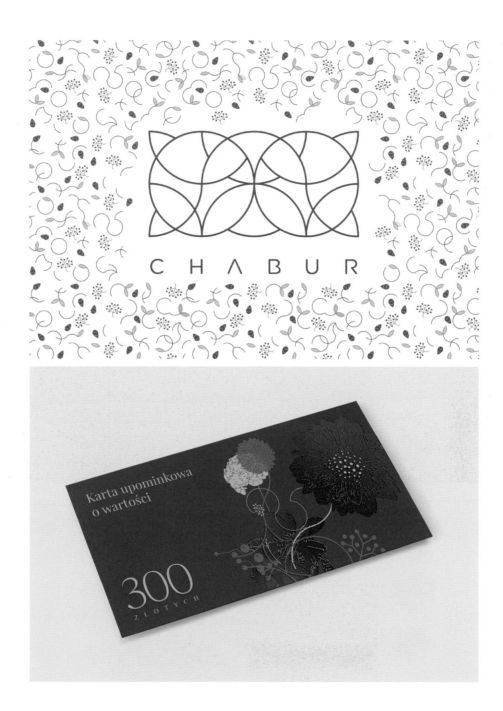

Poland

Design Agency
Heroes Design

Designer
Piotr Buczkowski

Client
Anna Rubach

Chabur is a lingerie shop. The designer was asked to create the logo and the e-commerce shop with the marketing elements including gift cards or packaging. This project reflects contemporary interest in the intersection of nature and women's curves. Modern patterns inspired by leaves complements the image and creates a visual key background for various media.

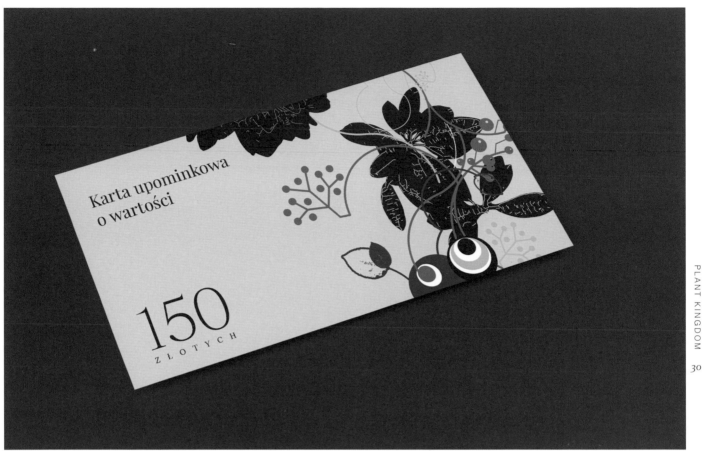

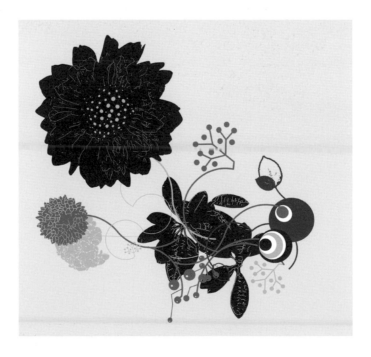

Tree of Tea

TREE OF TEA

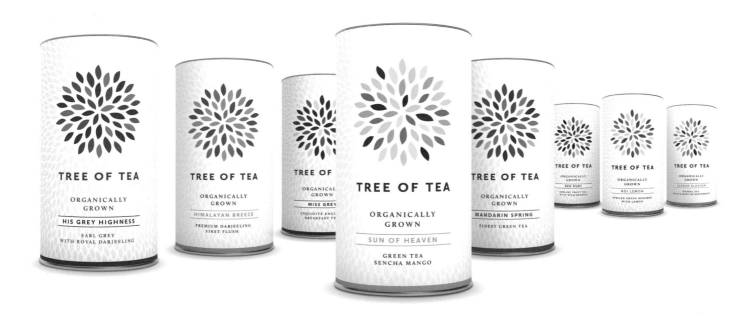

Germany

Design Studio
navarra.is

Designer
Christoph Herrmann

Client
Tree of Tea / mymuesli

Tree of Tea offers 8 kinds of high-class, loose leaf tea. In order to differentiate the selection of teas, each logo uses a color corresponding to the blend. So the Tree of Tea logo shows a tea plant from above as well as a small heap of the tea leaves. The leaf constellation of the logo is continued as a subtle pattern completely covering the round box.

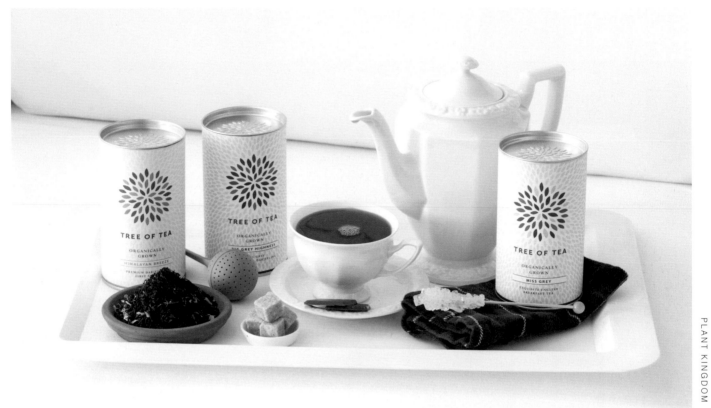

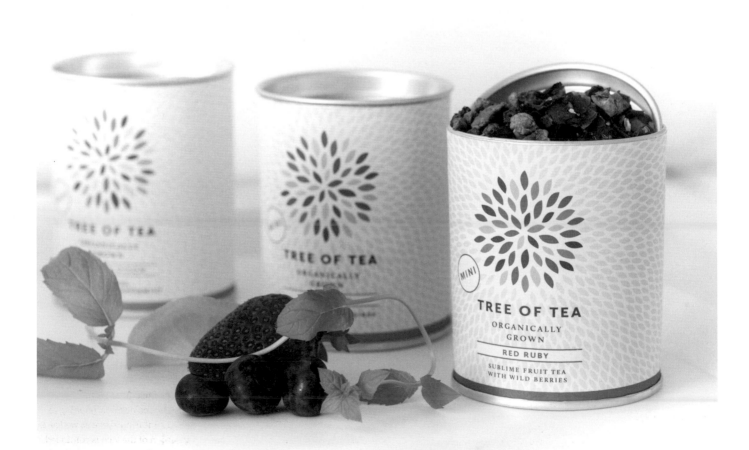

Natural Salads

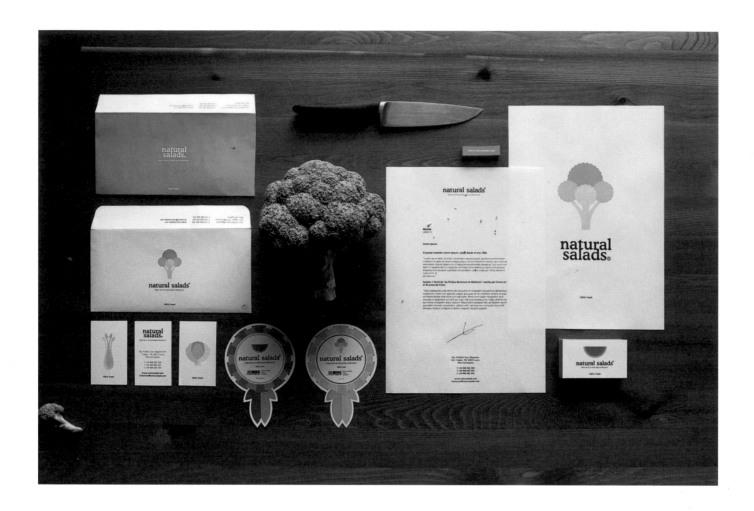

FRESH FRUIT & VEGETABLES ESPECIALIST

Spain

Design Agency
Studio Artsolut

Designer
Jose Ignacio Álvarez

Client
Natural Salads

This project created the visual identity for a company dedicated to the cultivation of celery, melons, lettuce and broccoli for sale in supermarkets and other establishments located in the European produce market. The little cards featuring the company's website were made with leftover scraps of paper.

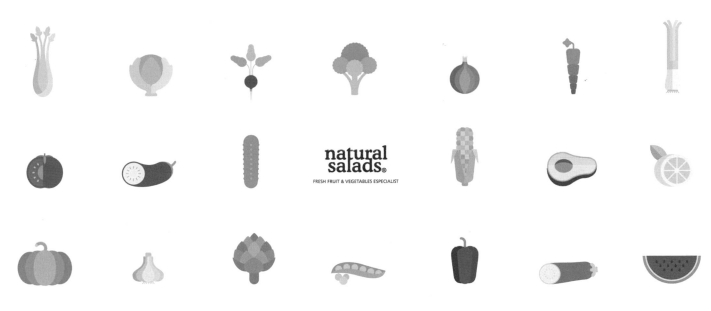

natural
salads®

FRESH FRUIT & VEGETABLES ESPECIALIST

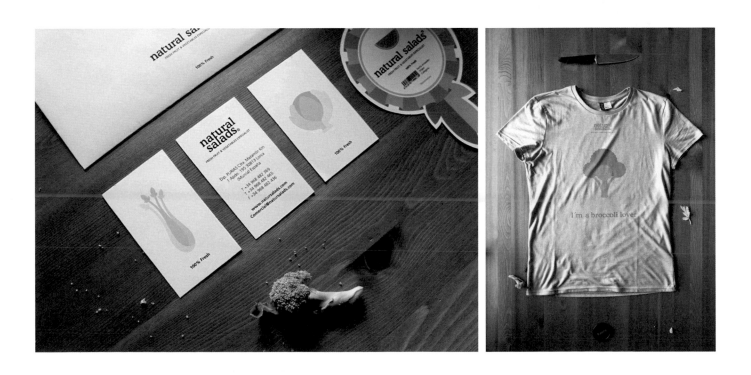

Fleur de Lune

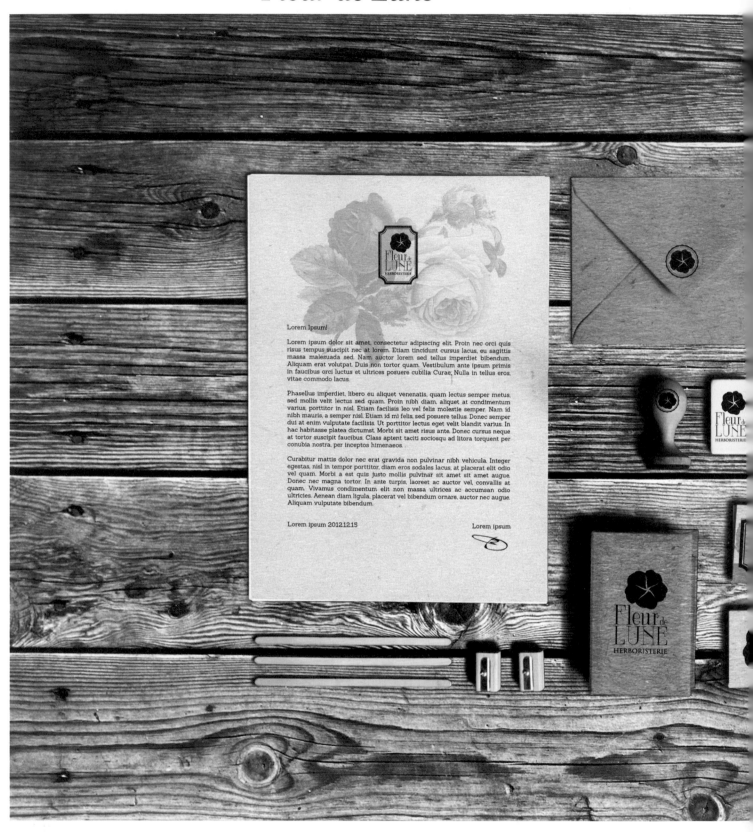

Italy

Designer
Carla Sartori

Client
Fleur de Lune - Herbalist's shop

"Fleur de Lune" is an herbalist's shop which needed new branding and new packaging. The designer got inspiration from traditional herbalist's shops with their thick wooden shelves, aromatic scents and the magic atmosphere surrounding these places. The logo was inspired by the name of the shop: Fleur de Lune (Moonflower). The flower is called that because it blossoms at night and it has a rounded shape like a full moon. The designer decided to feature a simplified shape of this flower over the lettering of the name like it was a moon in the sky.

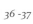

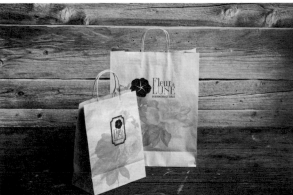

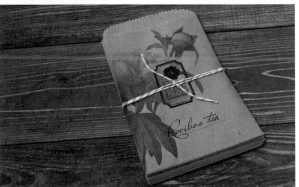

Yay Festival 2012

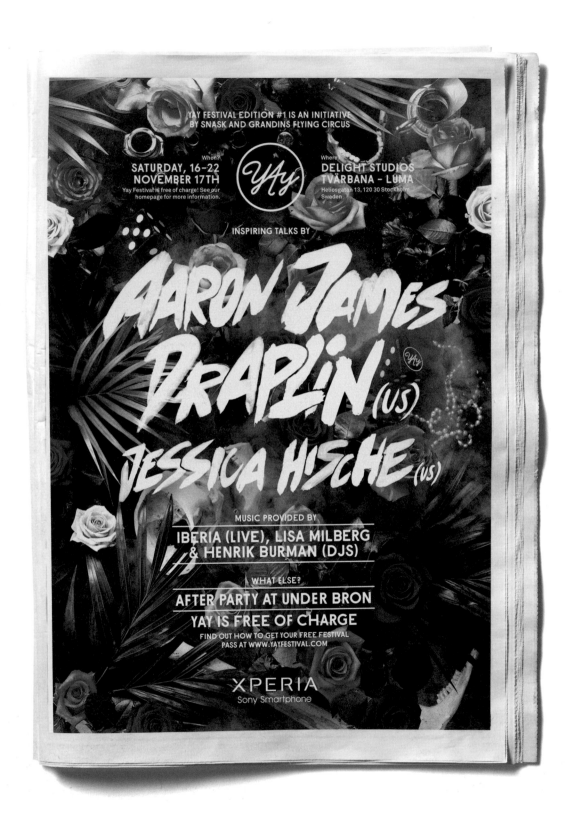

This project is the identity and branding for Yay Festival, an event featuring inspiring discussions, live music and great clubbing that brings people together . The use of vivid images of flowers and bold colors highlighted the concept of the event.

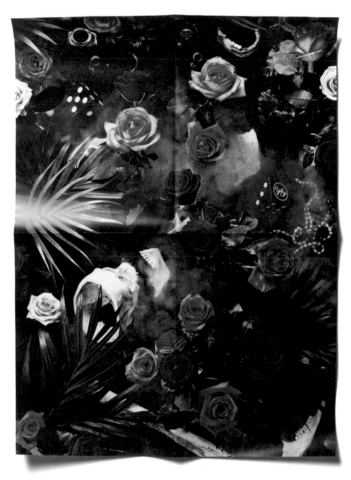

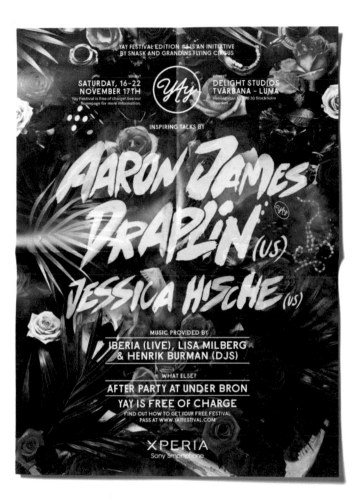

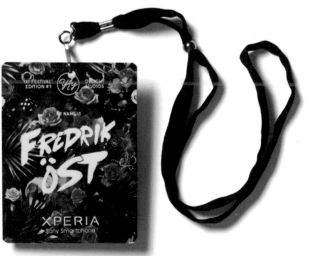

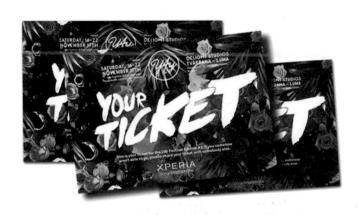

Logotype

Colors

Purple
R:201 G:119 B:240
C:33 M:58 Y:0 K:0

Blue
R:98 G:35 B:240
C:75 M:78 Y:0 K:0

Red
R:242 G:55 B:28
C:0 M:92 Y:100 K:0

Display Typography — Displ(Y)ay.otf

ABCDEFGHIJKL
MNOPQRSTUVW

Display Typography – Casablanca

ABCDEFG
HIJKLMN
OPQRSTU
VXYZÅÄÖ
1234567890
!?@#&=+−·,.:;

Body Text — Akkurat

A B C D E F G
H I J K L M N
O P Q R S T U
V X Y Z Å Ä Ö
1 2 3 4 5 6 7 8 9 0
! ? @ # & = + − · , . : ;

Lorem ipsum dolor sit amet, consectetur adipiscing elit. Ut tincidunt nunc mi, at mattis risus tempus eu. Etiam tempor pretium turpis, ac pharetra dolor vulputate eget. Sed malesuada sollicitudin libero, vel varius urna ultrices id. Maecenas malesuada mollis ligula et porttitor. Praesent consectetur, sapien pretium tristique dapibus, neque leo euismod massa, ut tempor sapien enim vel enim.

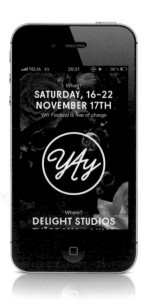

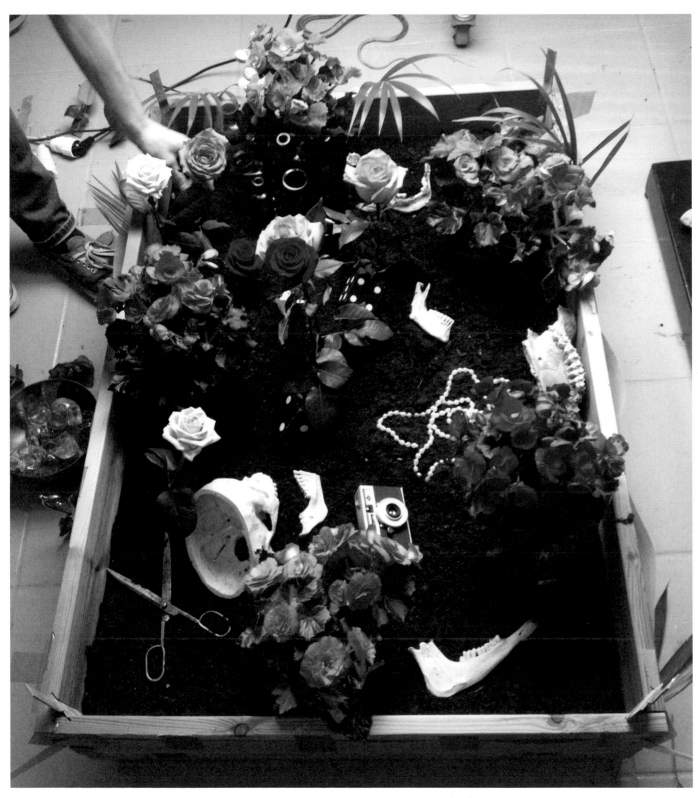

Centre d'Osteopatia i Teràpies Globals

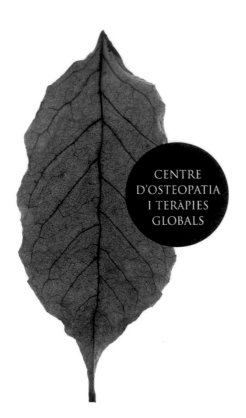

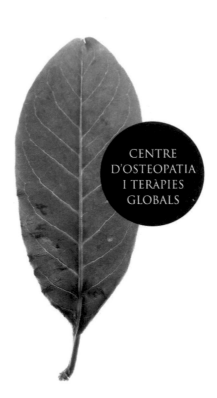

Spain

Designer
Estudi Conrad Torras

Client
Centre d'Osteopatia i Teràpies Globals

This is the corporate identity for Center for Osteopathy and Global Therapy (COTG). The underlying concepts of this project were the search for a natural equilibrium and the parallels between trees and the branching systems of the human body (e.g., the circulatory, lymphatic, nervous systems).

Ostheopaty emphasizes the interrelationship between all the different circuits of our body and believes that are all connected. The human body is formed and works like a tree. The internal structure of the leaves graphically represents trees and their connecting network. Every different type of leave represents a kind of human body. The final outcome is a very fresh, organic and calm personal identity that allows all kinds of applications.

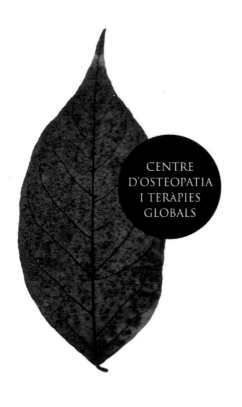

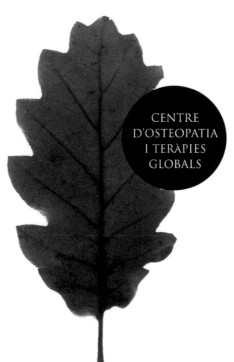

CENTRE
D'OSTEOPATIA
I TERÀPIES
GLOBALS

CENTRE
D'OSTEOPATIA
I TERÀPIES
GLOBALS

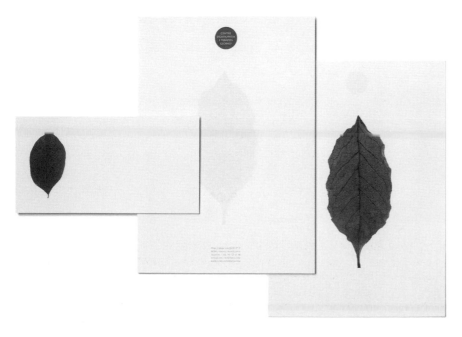

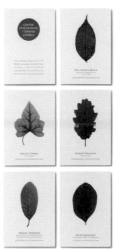

Floral Alchemy

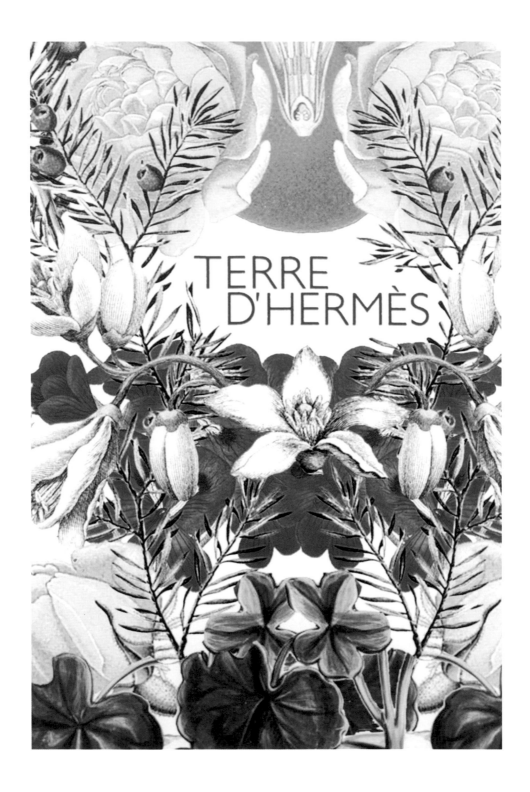

USA

Designer
Sixto-Juan Zavala

Each illustration is a digital collage assembled out of botanical illustrations. Each scent has specific notes that were visually represented and formed in the shape of the perfume bottle. Acqua di Parma Colonia Intensa's notes included citrus, aromatic spices, woods, and leather. Terre d'Hermes had Cedar, grapefruit, orange, gunflint, silex, pepper, rose, geranium, and benzoin. Miss Dior's notes were bergamot, gardenia, and patchouli.

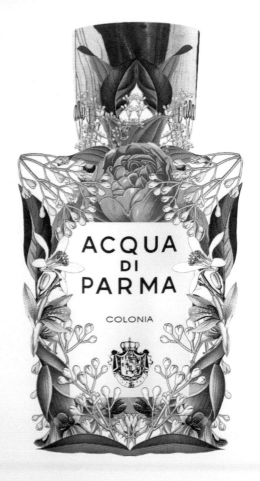

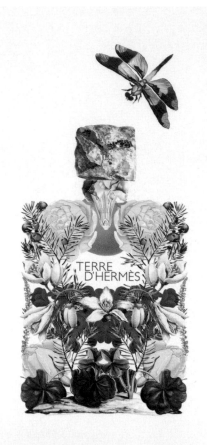

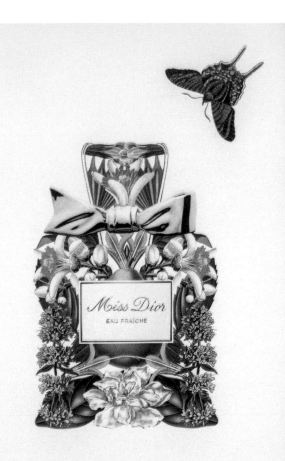

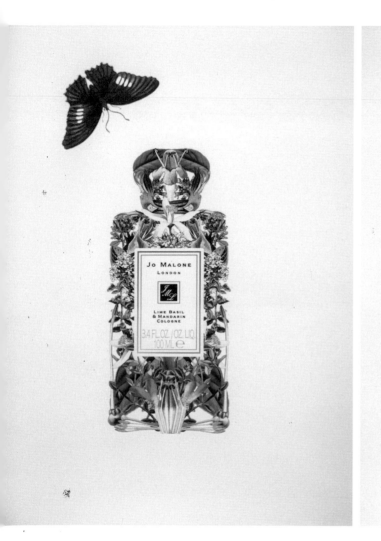

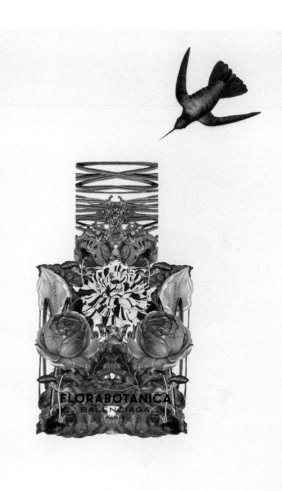

Legajny Tomato Farm

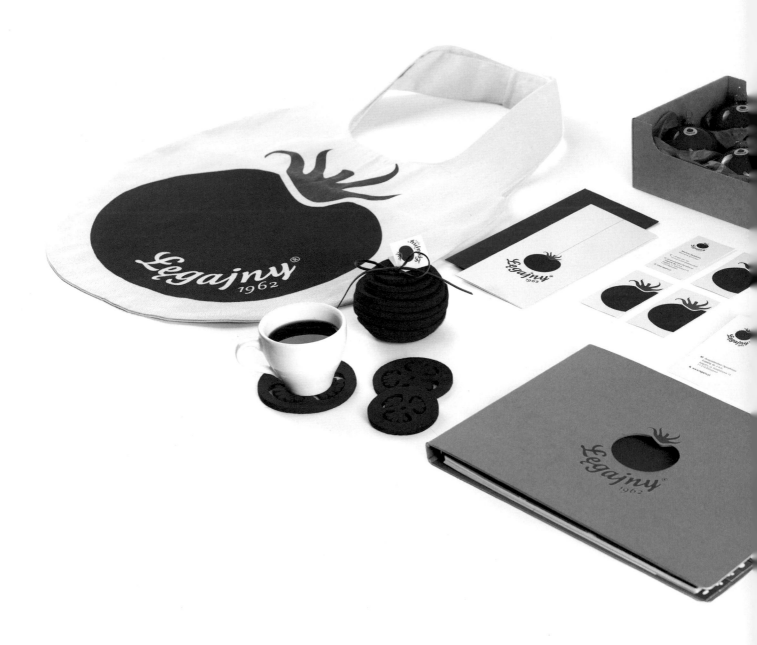

Poland

Design Agency
Monika Ostaszewska-Olszewska Studio and Para Buch

Designer
**Monika Ostaszewska-Olszewska, Zofia Konarska,
Katarzyna Minasowicz**

Łęgajny Tomato Farm is a local, Polish tomato producer. A traditional
image of a tomato is utilized and featured in the symbol of the company to
create the traditional look and a natural feeling. The traditional image of the
brand is emphasized to the use of natural materials including felt, cotton,
recycled paper, cardboard etc.

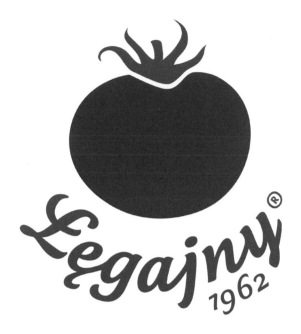

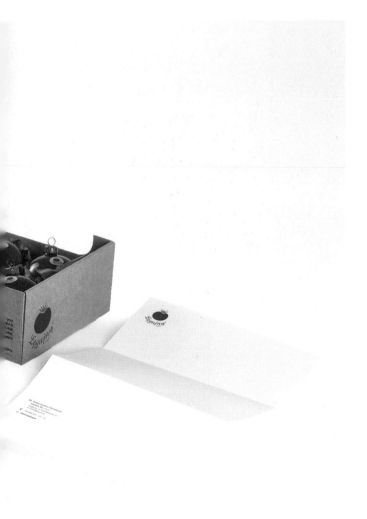

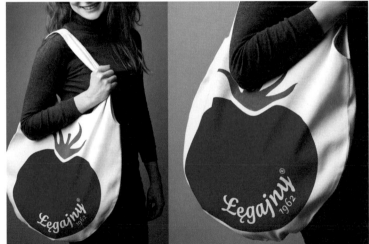

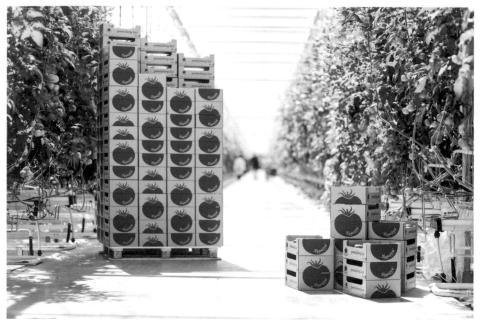

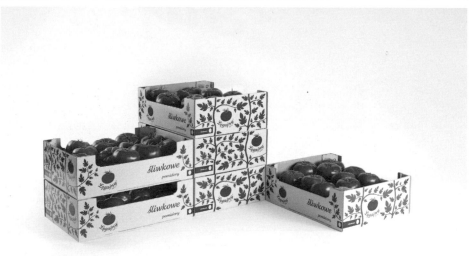

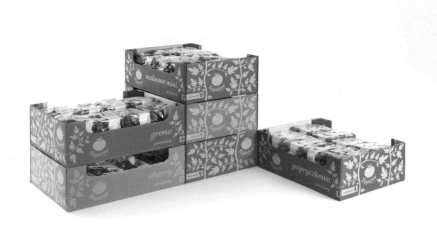

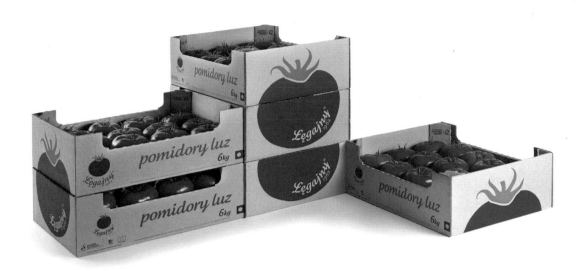

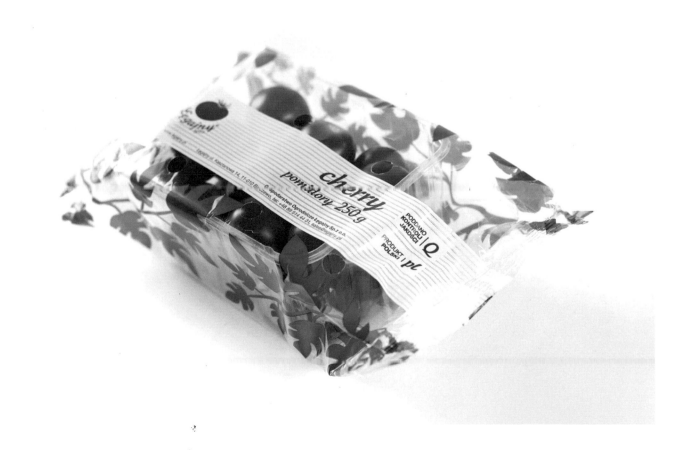

Bisztró83

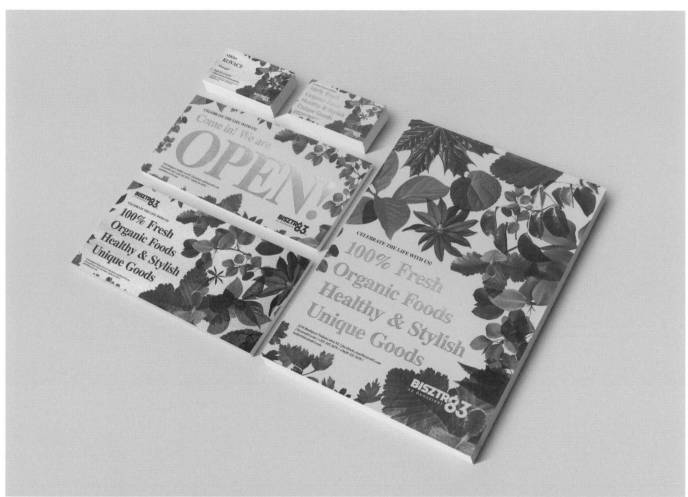

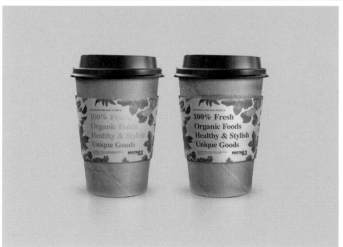

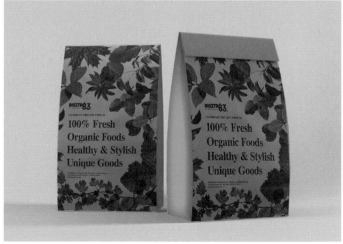

Hungary

Design Agency
Darkoo™ graphic design & art direction

Creative Director
Attila Horvath

Client
Bisztró83

Bisztró83—The Organic Island is a Hungarian eco food restaurant and shop in Budapest. The identity design elements were made from recycled materials (paper, wood, etc.). The designer designed a natural looking concept with plants and two additional brighter colors (turquoise and gold).

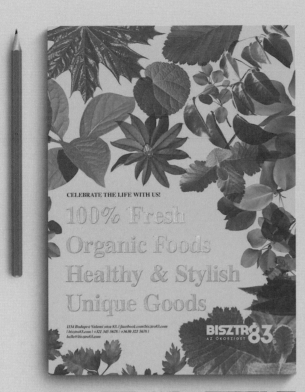

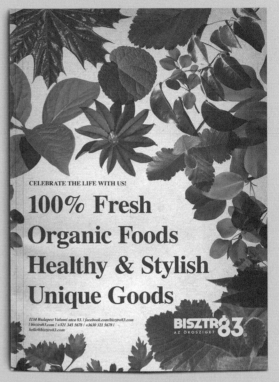

CELEBRATE THE LIFE WITH US!

100% Fresh
Organic Foods
Healthy & Stylish
Unique Goods

1134 Budapest Valami utca 83. | facebook.com/bisztro83.com
| bisztro83.com | +321 345 5678 | +3630 321 5678 |
hello@bisztro83.com

BISZTR83
AZ ÖKOSZIGET

CELEBRATE THE LIFE WITH US!

100% Fresh
Organic Foods
Healthy & Stylish
Unique Goods

1134 Budapest Valami utca 83. | facebook.com/bisztro83.com
| bisztro83.com | +321 345 5678 | +3630 321 5678 |
hello@bisztro83.com

BISZTR83
AZ ÖKOSZIGET

BISZTR83
AZ ÖKOSZIGET

CELEBRATE THE LIFE WITH US!

100% Fresh
Organic Foods
Healthy & Stylish
Unique Goods

CELEBRATE THE LIFE WITH US!

Come in! We are

OPEN!

1134 Budapest Valami utca 83. | facebook.com/bisztro83.com
| bisztro83.com | +321 345 5678 | +3630 321 5678 |
hello@bisztro83.com

BISZTR83
AZ ÖKOSZIGET

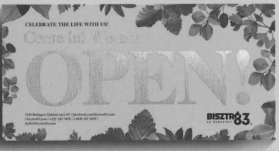

Color Cards

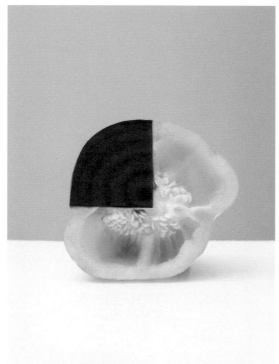 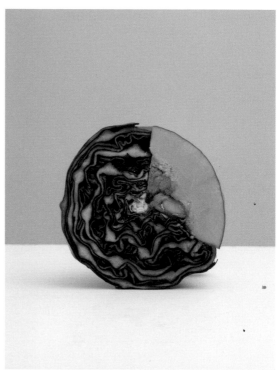

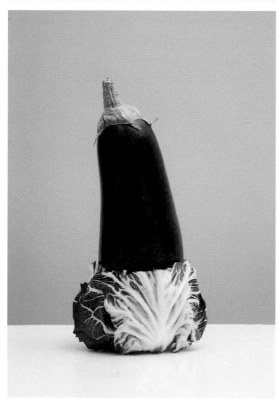 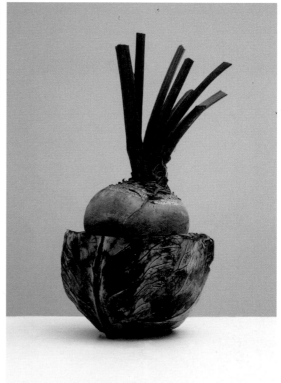

The Netherlands

Design Agency
Raw Color

This project was based on visual research about vegetables and their colors. Vegetables are broken down and purified to their visual essence: "raw color". The color is captured using processes to preserve their intensity on color cards. Categorized by shades and families a new map is created which shows their beautiful diversity. This project reinterprets the common vegetable and puts it into a new context.

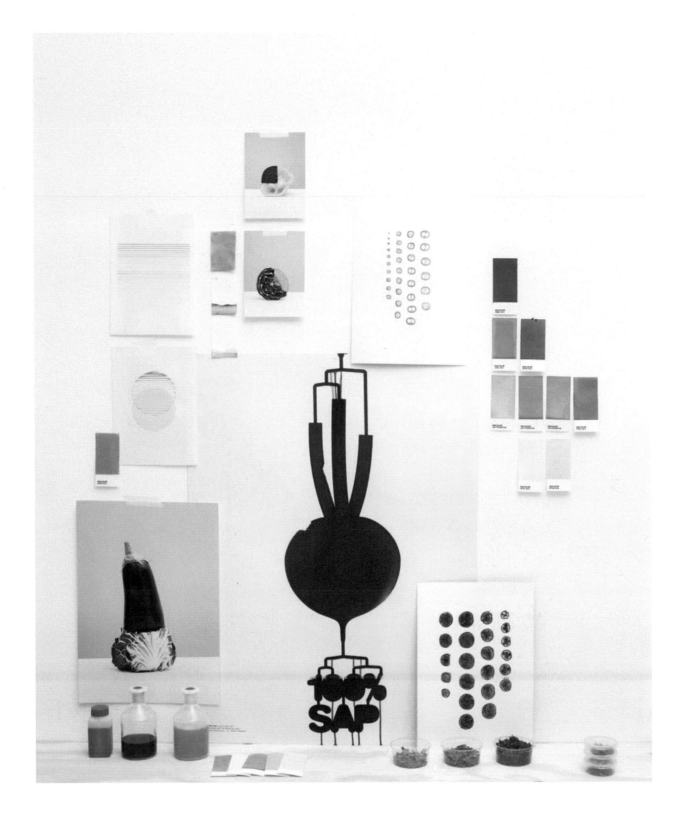

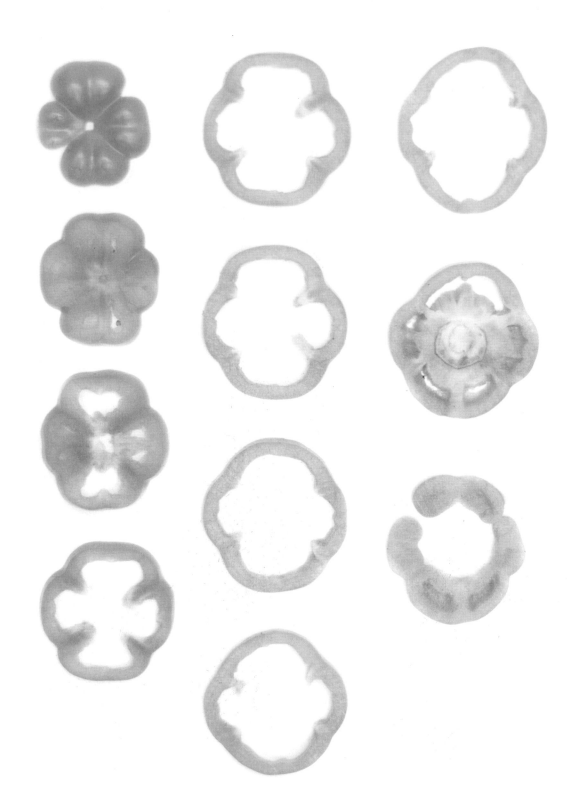

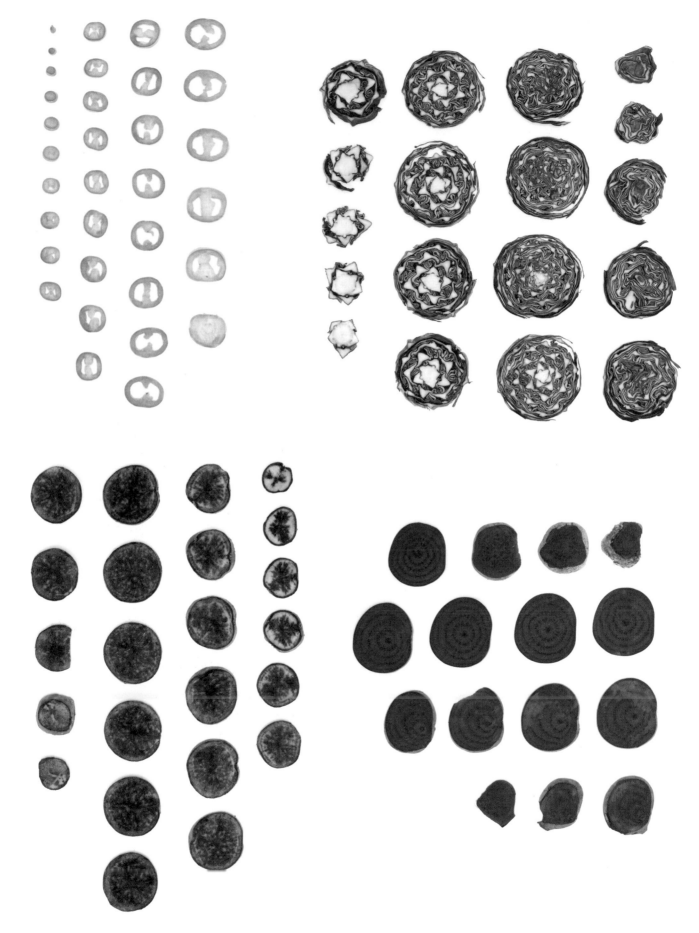

Hortus

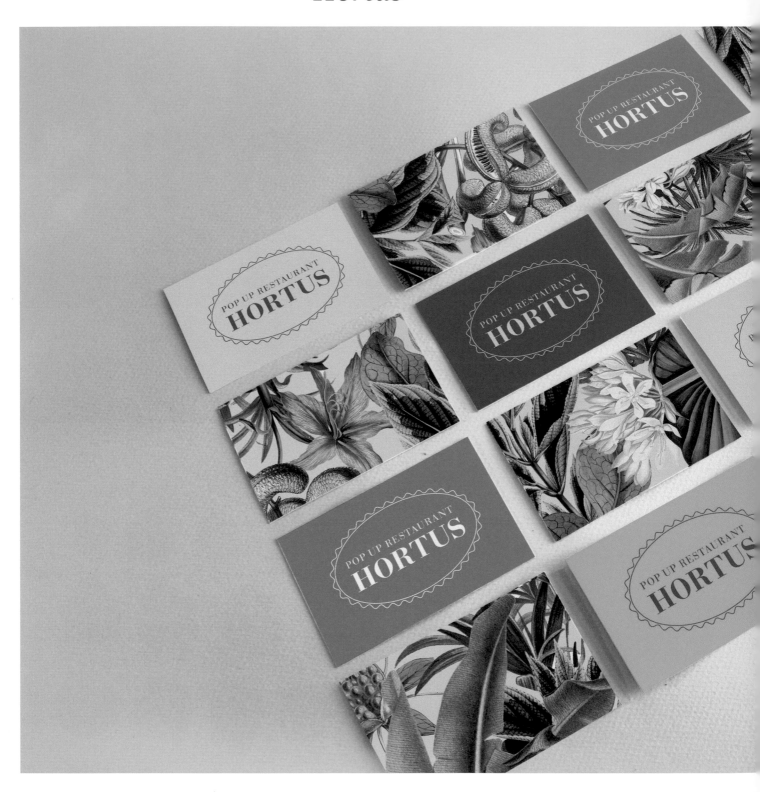

Hong Kong (P.R.C.)

Design Agency
Ariadna Vilalta Creative Studio

Designer
Ariadna Vilalta

Client
Alpro

This project was initiated to design an identity for a Pop Up Restaurant in Antwerp, Belgium. It was a green heaven that displayed different kinds of plants used for Alpro's products. The designers generated the illustration with vintage style drawings of plants, and combined them into a fresh and modern identity with strong colors.

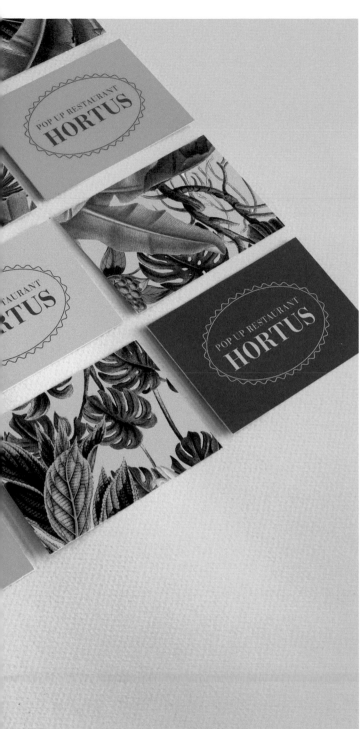

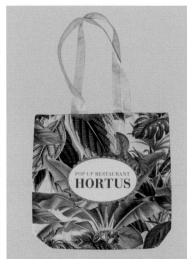

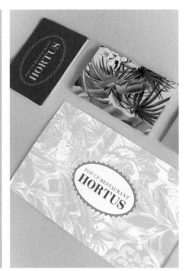

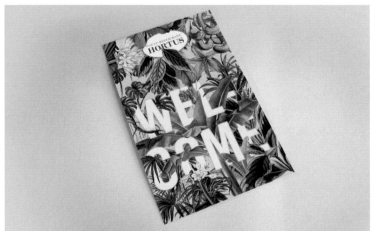

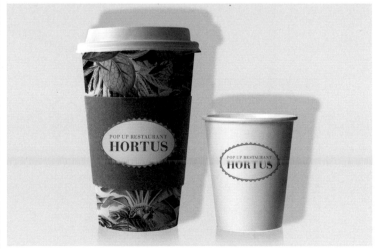

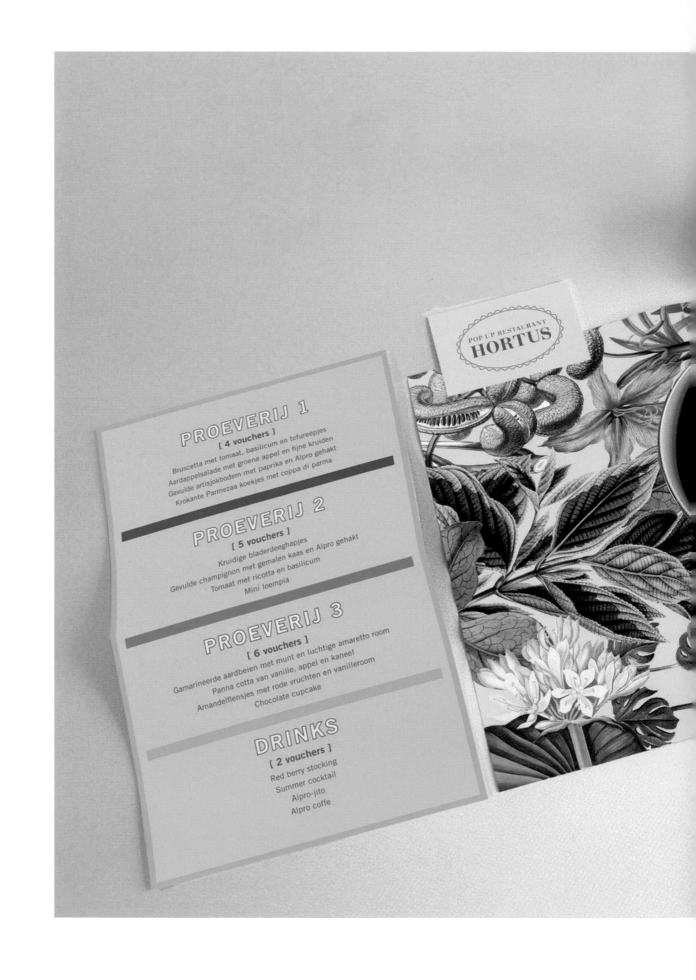

PROEVERIJ 1
[4 vouchers]
Bruscetta met tomaat, basilicum en tofureepjes
Aardappelsalade met groene appel en fijne kruiden
Gevulde artisjokbodem met paprika en Alpro gehakt
Krokante Parmezaa koekjes met coppa di parma

PROEVERIJ 2
[5 vouchers]
Kruidige bladerdeeghapjes
Gevulde champignon met gemalen kaas en Alpro gehakt
Tomaat met ricotta en basilicum
Mini loempia

PROEVERIJ 3
[6 vouchers]
Gamarineerde aardbeien met munt en luchtige amaretto room
Panna cotta van vanille, appel en kaneel
Amandelflensjes met rode vruchten en vanilleroom
Chocolate cupcake

DRINKS
[2 vouchers]
Red berry stocking
Summer cocktail
Alpro-jito
Alpro coffe

POP UP RESTAURANT
HORTUS

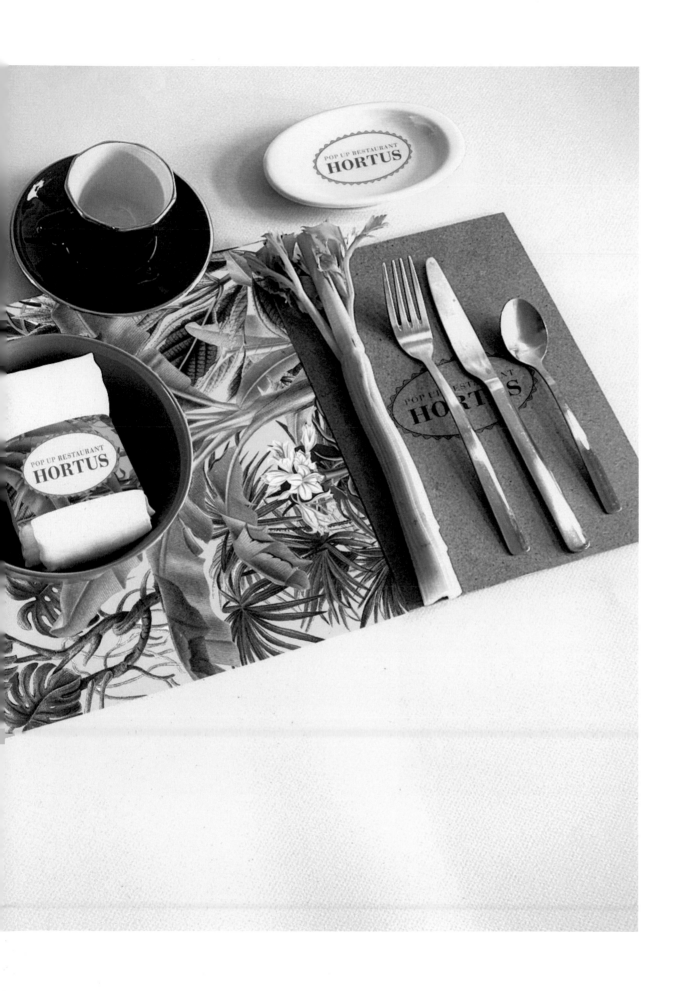

Blue Hill

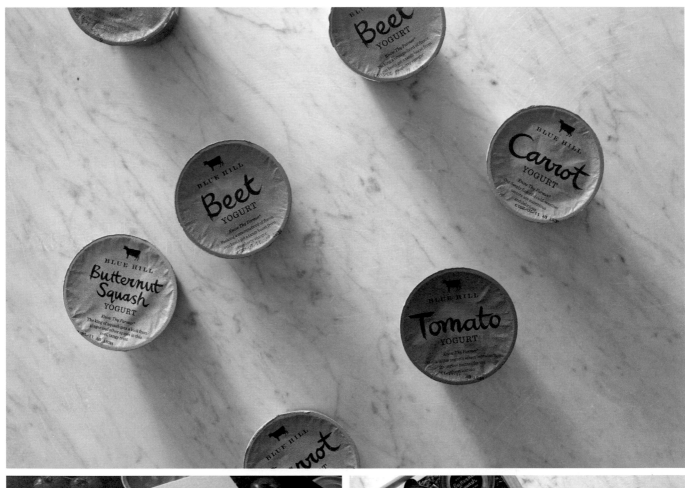

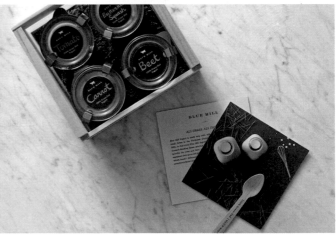

United States

Design Agency
Apartment One

Creative Director
Spencer Bagley, Liza Lowinger

Illustrator
Mary Woodin

Designer
Spencer Bagley

Apartment One worked with Mary Woodin to craft vegetable illustrations and brushstroke lettering for each flavor. The warmth of the illustrations and the cool slate struck a nice balance of authenticity and refinement. They designed a press kit package with a set of cards that told the story of the yogurts. The website takes viewers through the heritage of the Blue Hill Dairy Farm and tempts them with tasty flavor profiles.

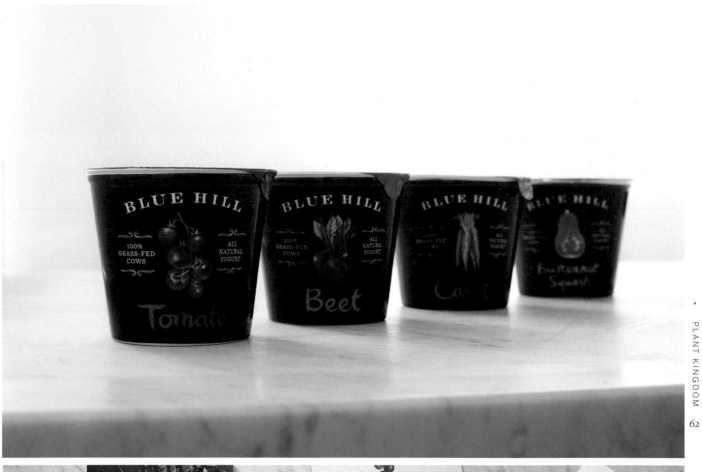

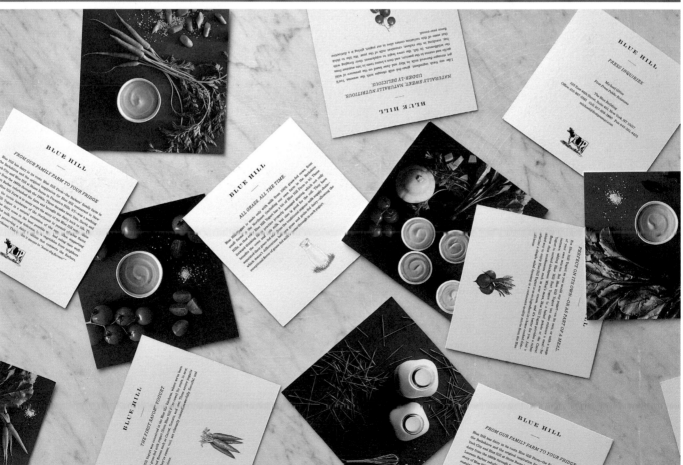

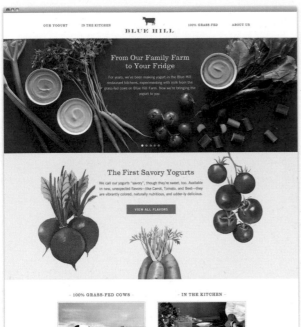

From Our Family Farm to Your Fridge

For years, we've been making yogurt in the Blue Hill restaurant kitchens, experimenting with milk from the grass-fed cows on Blue Hill Farm. Now we're bringing the yogurt to you.

The First Savory Yogurts

We call our yogurts "savory", though they're sweet, too. Available in new, unexpected flavors—like Carrot, Tomato, and Beet—they are vibrantly colored, naturally nutritious, and udder-ly delicious.

VIEW ALL FLAVORS

— 100% GRASS-FED COWS — — IN THE KITCHEN —

Blue Hill Yogurt is "all grass, all the time"—made only with milk from 100% grass-fed cows, from small, family-owned farms in the Northeast.

Blue Hill Yogurt is delicious as a stand-alone snack, or with your own mix-ins. (We've suggested some of our favorite combinations on the underside of each lid.)

LEARN MORE LEARN MORE

About Us

Blue Hill Farm—our family farm in the Berkshires, and the original inspiration for our Blue Hill restaurants—was a working dairy in the 1860s through the 1960s. Three decades later, we refurbished the farm and brought the dairy back to life.

LEARN MORE

Blue Hill has dairy in its roots. Blue Hill Farm, our family farm in the Berkshires, and the original inspiration for our Blue Hill restaurant in New York City and Blue Hill at Stone Barns in Pocantico Hills, NY... Learn more

Know Thy Farmer®

Yogurt
100% Grass-Fed
In the Kitchen
Recipes
Where to Buy

About Us
Contact us
Press Inquiries
Blue Hill Restaurants
Blue Hill Online Market

Stay Connected

Join our email list [Enter email] SEND

©2013 Blue Hill, Inc. | Terms & Conditions | Legal & Regulatory Compliance

Carrot

— WHAT'S UP DOC? —

Our deeply flavorful cold-weather carrots are nutritious and delicious.

WHERE CAN I FIND IT?

[Enter your zip code]

LET YOUR FRIENDS KNOW

Pin it Like Tweet

BLUE HILL
100% GRASS-FED COWS ALL NATURAL YOGURT
Carrot

INGREDIENTS
Pasteurized Whole Milk, Carrots, Water, Carrot Juice Concentrate, Sea Salt, Live Active Cultures.

NUTRITION FACTS

Serving Size	6oz (170g)	
Serving Per Container	1	
Calories	100	
Calories From Fat	40	

%Daily Value	Amount	%
Total Fat	4.5g	7%
Saturated Fat	2.5g	13%
Trans Fat	0g	
Cholesterol	15mg	5%
Sodium	230mg	10%
Total Carbs	11g	4%
Dietary Fiber	1g	5%
Sugars	8g	
Protein	4g	
Vitamin A		190%
Vitamin C		8%
Vitamin D3		0%
Calcium		15%
Iron		2%

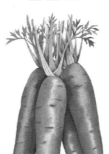

Blue Hill has dairy in its roots. Blue Hill Farm, our family farm in the Berkshires, and the original inspiration for our Blue Hill restaurant in New York City and Blue Hill at Stone Barns in Pocantico Hills, NY... Learn more

Know Thy Farmer®

Yogurt
100% Grass-Fed
In the Kitchen
Recipes
Where to Buy

About Us
Contact us
Press Inquiries
Blue Hill Restaurants
Blue Hill Online Market

Stay Connected

Join our email list [Email address] SEND

©2013 Blue Hill, Inc. | Terms & Conditions | Legal & Regulatory Compliance

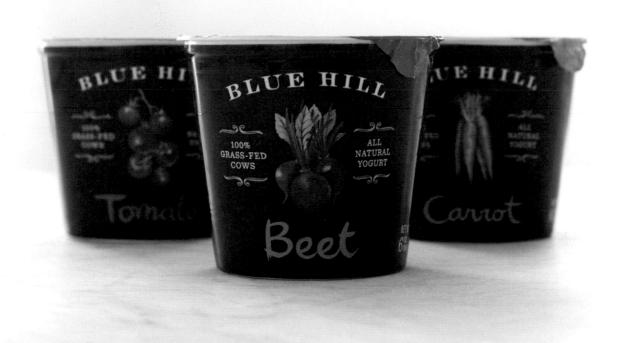

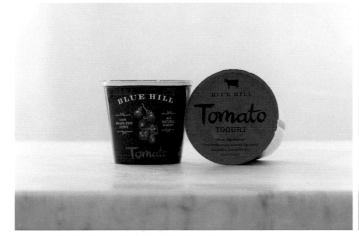

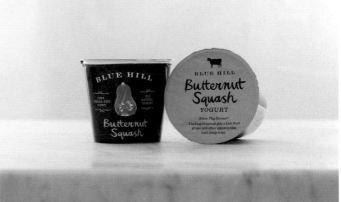

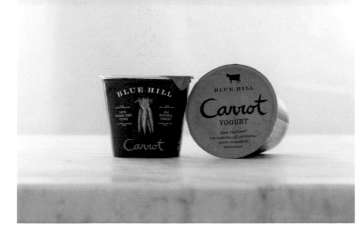

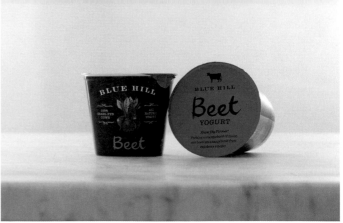

Egge Gard

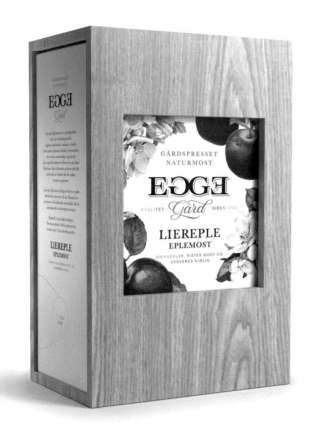

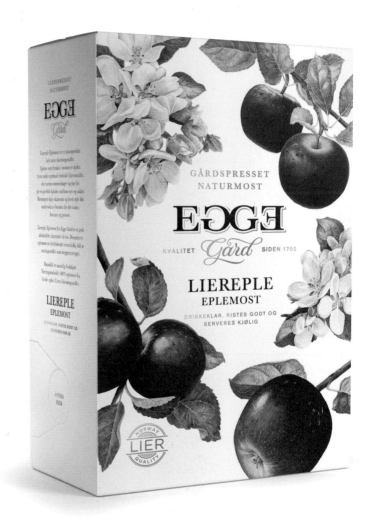

Norway

Design Agency
Strømme Throndsen Design

Creative Director
Morten Throndsen

Designer
Helene Havro

Client
Egge Gard

Fruits, berries and vegetables have been cultivated at Egge Gard for over three hundred years. Designers created a new visual identity and packaging solution for Egge Gard's range of apple-based juices and alcohol ranges that better reflect their high quality products: both natural and handmade. This helps to emphasize the brand, highlighting its significant heritage and experience. They utilized traditional hand drawn illustrations and a bright but natural color palette, enhanced with plenty of space to neatly tie together the values of the brand, the crafted nature of the drinks, and the natural goodness of the ingredients, in a clear and contemporary way. These details are complimented by the classic detail of the serif logotype, the flourishes of a script, and the premium expectations of a gold foil print finish.

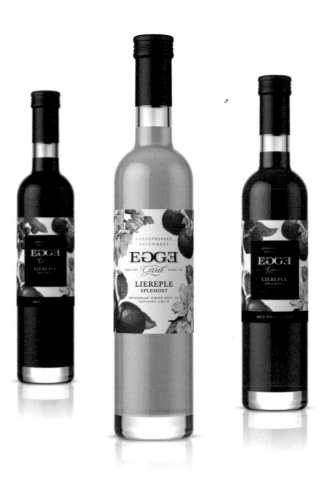

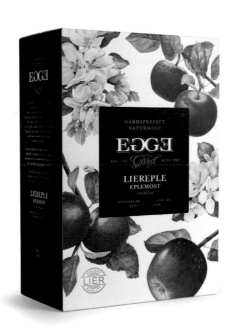

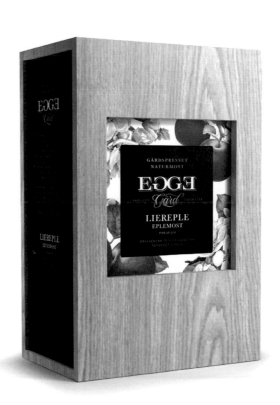

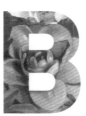

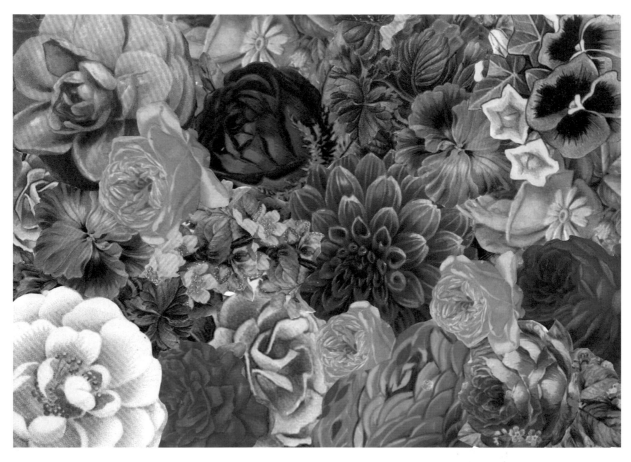

Spain

Design Agency
EPB – Espacio Paco Bascuñán

Designer
Bea Bascuñán, Albert Jornet

EPB studio has gone through many different stages and this project corresponds to the necessity of giving a new and fresh look to their space and identity. They have frequently utilized flower in nature, in fact their past identity was based on different types of orchids and their incredible characteristics. In addition they have a beautiful, green garden in their studio that is a constant inspiration for their projects and for this one in particular. This time they decided to take their inspiration from nature but in a more artificial way to make the identity more fresh and optimistic. This aspect of the identity was created by using cutout picture cards and stickers inspired in floral motifs to create their own compositions, one for each season.

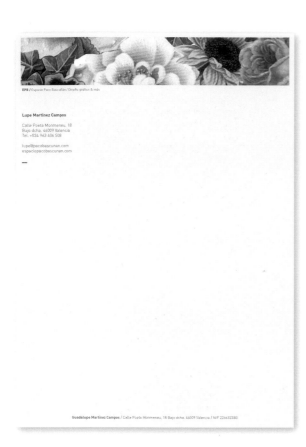

EPB / Espacio Paco Bascuñán / Diseño gráfico & más

Lupe Martínez Campos

Calle Poeta Monmeneu, 18
Bajo dcha, 46009 Valencia
Tel. +034 963 406 508

lupe@pacobascunan.com
espaciopacobascunan.com

Guadalupe Martínez Campos / Calle Poeta Monmeneu, 18 Bajo dcha, 46009 Valencia / NIF 22663238G

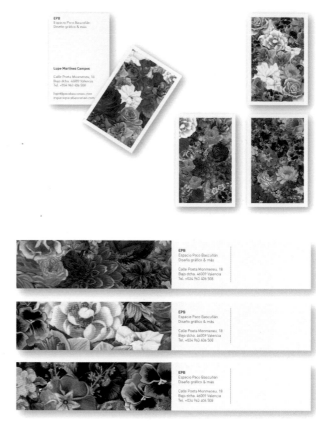

EPB
Espacio Paco Bascuñán
Diseño gráfico & más

Calle Poeta Monmeneu, 18
Bajo dcha, 46009 Valencia
Tel. +034 963 406 508

EPB
Espacio Paco Bascuñán
Diseño gráfico & más

Calle Poeta Monmeneu, 18
Bajo dcha, 46009 Valencia
Tel. +034 963 406 508

EPB
Espacio Paco Bascuñán
Diseño gráfico & más

Calle Poeta Monmeneu, 18
Bajo dcha, 46009 Valencia
Tel. +034 963 406 508

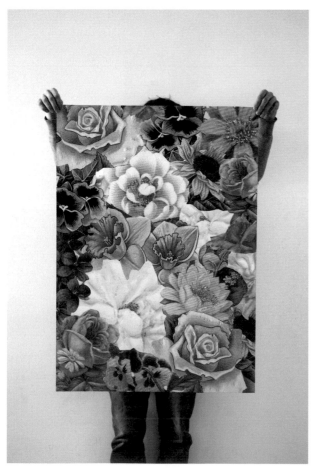

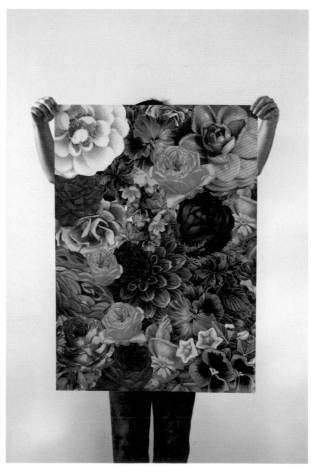

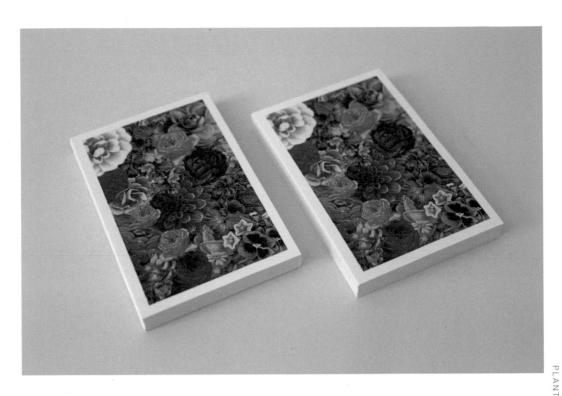

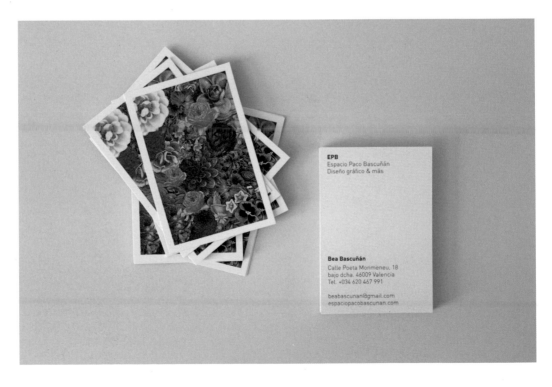

EPB
Espacio Paco Bascuñán
Diseño gráfico & más

Bea Bascuñán
Calle Poeta Monmeneu, 18
bajo dcha. 46009 Valencia
Tel. +034 620 467 991

beabascunan@gmail.com
espaciopacobascunan.com

White Hot Rocks

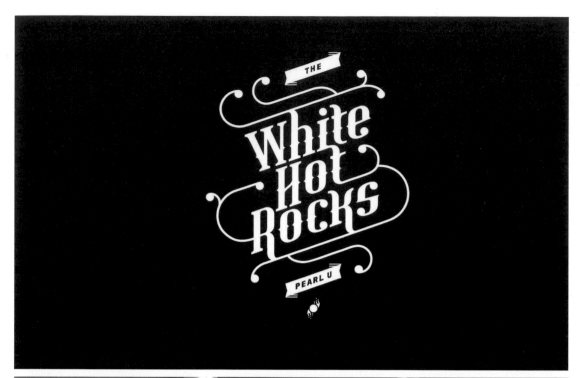

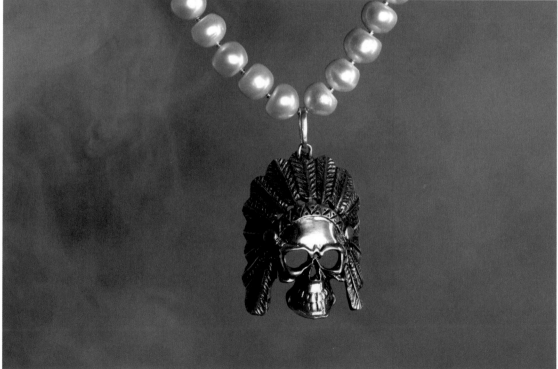

Russia

Design Agency
ARENAS® lab

Designer
Valeri Arenas

Client
White Hot Rocks

White Hot Rocks focuses on original jewelry pieces, contrasting precious stones, elegant pearls and bold skulls of people and animals, all cast from high quality silver. A series of surveys conducted for the jewelry line up the company to understand some of the preferences of their client base. Based on this market resource they focused on culture and consumer values, aimed at showcasing the characteristics of the brand. Those characteristics include the ability to live naturally and with taste, to combine cosmopolitism and individuality, formal simplicity and refined elegance, evident taste and tangible comfort. The designers chose roses because they are beautiful and have an aggressive nature. In addition, these flowers are well matched with images of skulls and White Hot Rocks jewelry.

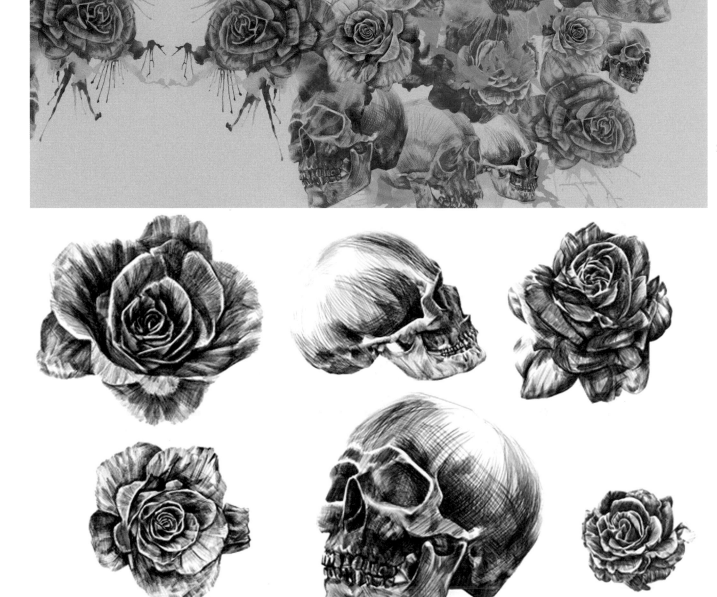

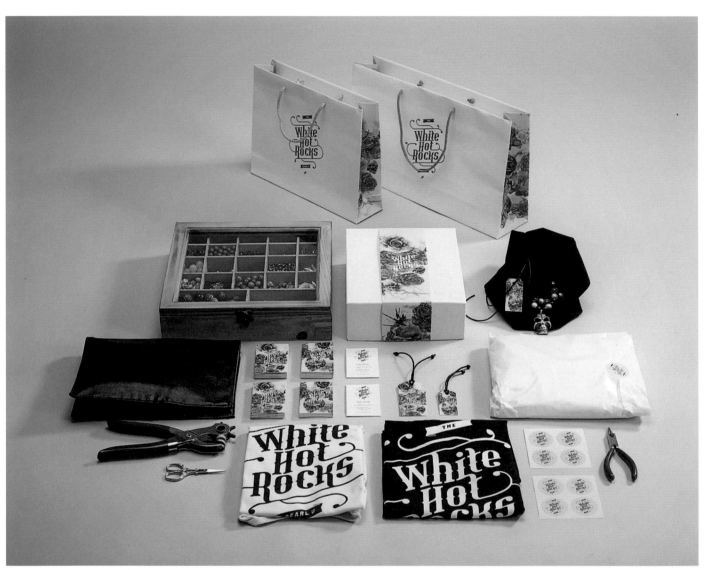

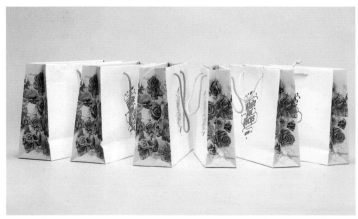

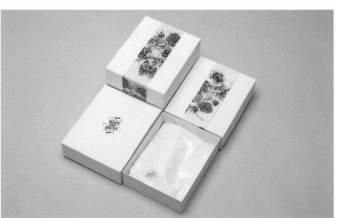

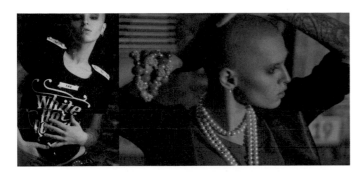

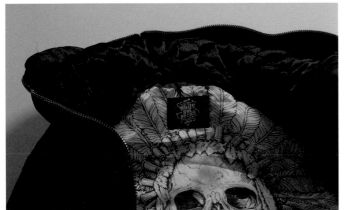

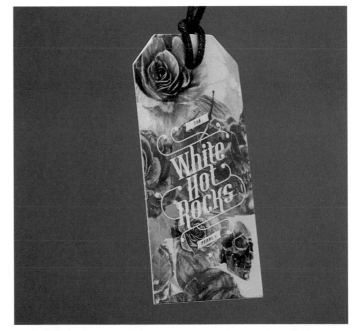

Atwood Blend

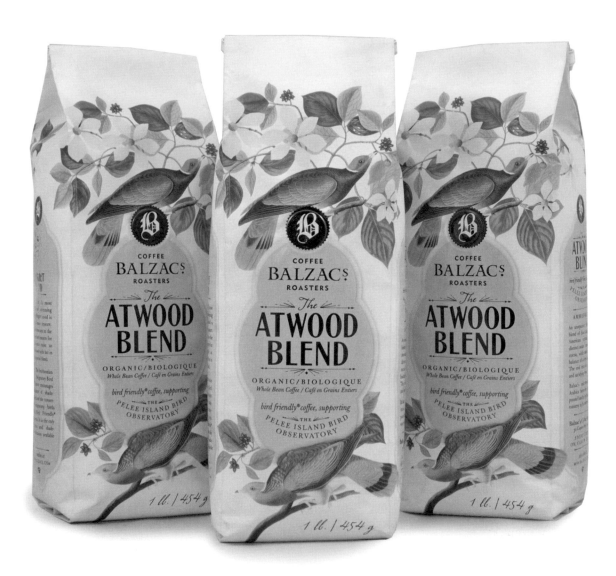

Canada

Design Agency
Chad Roberts Design

Designer
Chad Roberts

Client
Balzac's Coffee Roasters

The result of the collaboration between Balzac's Coffee Roasters and award-winning Canadian author Margaret Atwood, this design highlights their commitment to the environment and concern for avian ecosystems. The illustration was chosen to emphasize this important aspect of the product. By combining the stunning illustration with strong type, the new design has significant shelf presence that emotionally engages consumers.

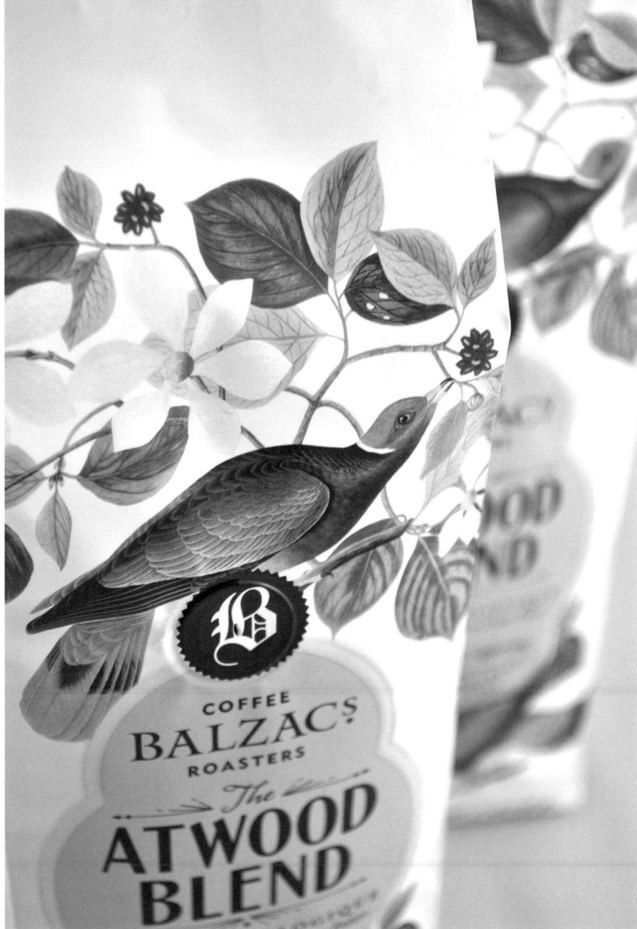

USA

Designer
Zachary Gibson

Sending out free copies of this project, the designer asked in return a picture of where the copy would be displayed whether it be a subway tunnel, or a frame in home. The goal is to initiate and encourage people to continue and persevere.

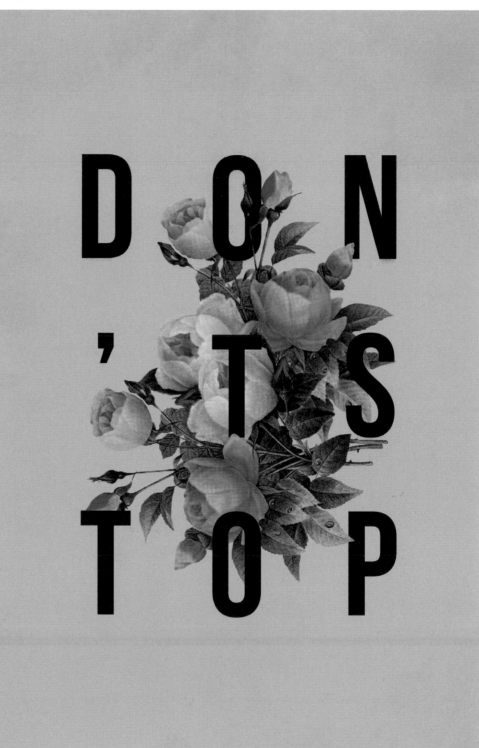

N S P

D O N ' T S T O P

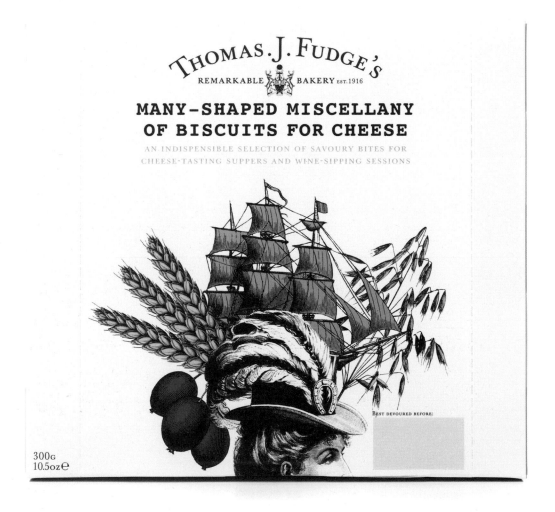

United Kingdom

Design Agency
Big Fish

Designer
Victoria Sawdon

Client
Thomas J Fudge's

"Thomas J Fudge's" is a Dorset-based family bakery. For almost 100 years, their biscuits had a loyal following. However, the market changed significantly since they started and there was a lot of competition from supermarket brands. The family felt their boxes were no longer standing out on shelves. Big Fish repositioned them to their rightful place as the finest biscuits available and changed their name from Fudges to Thomas J Fudge's Remarkable Bakery. Designers illustrated the packs with eccentric, Victorian imagery, including beautiful drawings of plants and flowers to emphasize the product ingredients and flavors, and topped them off with vibrant splashes of color.

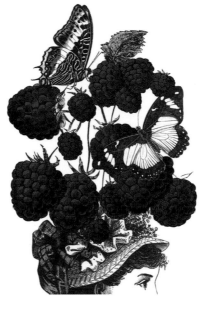

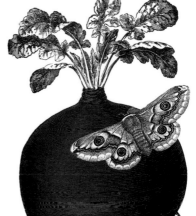

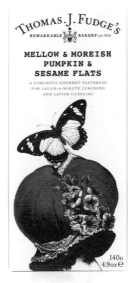

THOMAS. J. FUDGE'S
REMARKABLE ✦ BAKERY est.1916

MELLOW & MOREISH
PUMPKIN &
SESAME FLATS

A GORGEOUS GOURMET FLATBREAD
FOR LAUGH-A-MINUTE LUNCHING
AND LAVISH GUZZLING

140G
4.9oz ℮

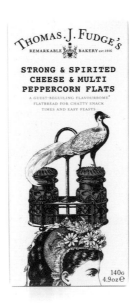

THOMAS. J. FUDGE'S
REMARKABLE ✦ BAKERY est.1916

STRONG & SPIRITED
CHEESE & MULTI
PEPPERCORN FLATS

A GUEST-BEGUILING FLAVOURSOME
FLATBREAD FOR CHATTY SNACK
TIMES AND EASY FEASTS

140G
4.9oz ℮

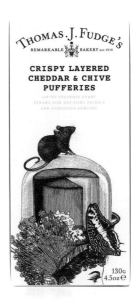

THOMAS. J. FUDGE'S
REMARKABLE ✦ BAKERY est.1916

CRISPY LAYERED
CHEDDAR & CHIVE
PUFFERIES

OH-SO-SPLENDID HERBY
STRAWS FOR DAY-LONG PICNICS
AND GORGEOUS GORGING

130G
4.5oz ℮

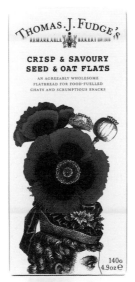

THOMAS. J. FUDGE'S
REMARKABLE ✦ BAKERY est.1916

CRISP & SAVOURY
SEED & OAT FLATS

AN AGREEABLY WHOLESOME
FLATBREAD FOR FOOD-FUELLED
CHATS AND SCRUMPTIOUS SNACKS

140G
4.9oz ℮

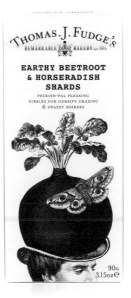

THOMAS. J. FUDGE'S
REMARKABLE ✦ BAKERY est.1916

EARTHY BEETROOT
& HORSERADISH
SHARDS

PECKISH-PAL PLEASING
NIBBLES FOR GOSSIPY GRAZING
& SNAZZY SOIREES

90G
3.15oz ℮

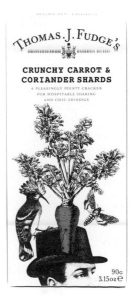

THOMAS. J. FUDGE'S
REMARKABLE ✦ BAKERY est.1916

CRUNCHY CARROT &
CORIANDER SHARDS

A PLEASINGLY POINTY CRACKER
FOR HOSPITABLE SHARING
AND CHIC SHINDIGS

90G
3.15oz ℮

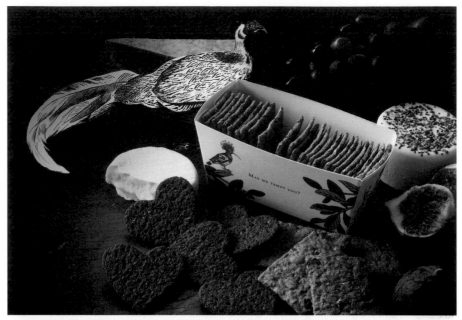

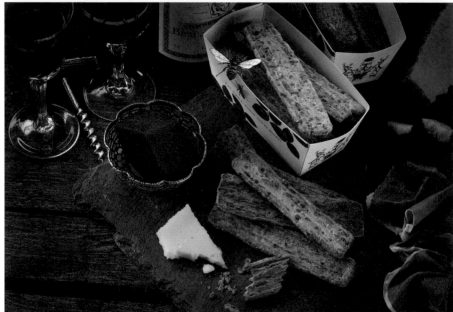

Thomas.J.Fudge's™
REMARKABLE ✦ BAKERY EST.1916

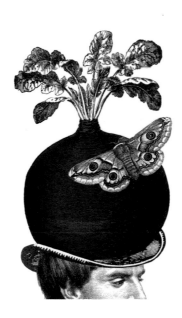
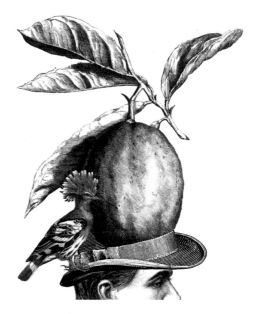

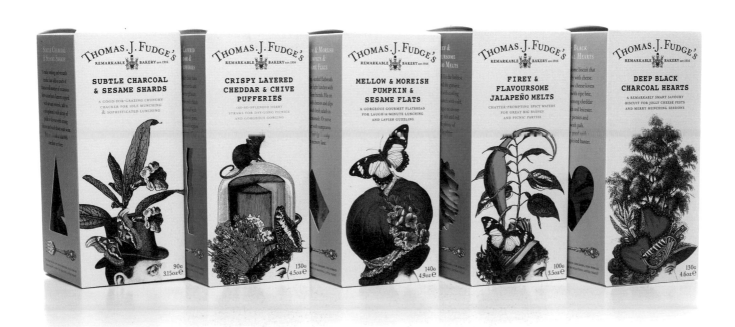

SUBTLE CHARCOAL & SESAME SHARDS

A GOOD-FOR-GRAZING CRUNCHY CRACKER FOR IDLE MUNCHING & SOPHISTICATED LUNCHING

90g
3.15oz ℮

CRISPY LAYERED CHEDDAR & CHIVE PUFFERIES

OH-SO-SPLENDID FIERY STRAWS FOR DAY-LONG PICNICS AND GORGEOUS GORGING

130g
4.5oz ℮

MELLOW & MOREISH PUMPKIN & SESAME FLATS

A GORGEOUS GOURMET FLATBREAD FOR LAUGH-A-MINUTE LUNCHING AND LAVISH GUZZLING

140g
4.9oz ℮

FIREY & FLAVOURSOME JALAPEÑO MELTS

CHATTER-PROMPTING SPICY WAFERS FOR GREAT BIG BASHES AND PICNIC PARTIES

100g
3.5oz ℮

DEEP BLACK CHARCOAL HEARTS

A REMARKABLY SMART SAVOURY BISCUIT FOR JOLLY CHEESE FESTS AND MERRY MUNCHING SESSIONS

130g
4.6oz ℮

New Frontier Group's
Annual Report 2012 - The Missing Link

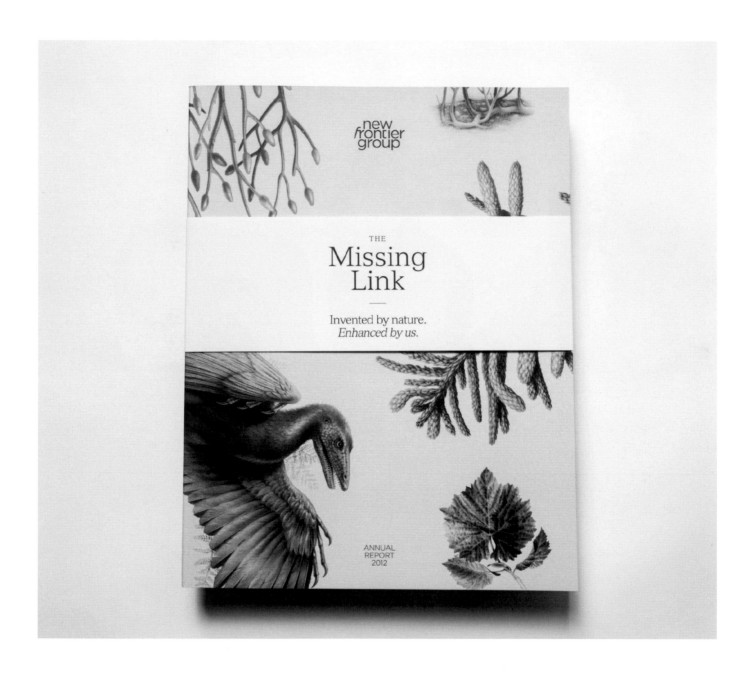

Austria

Design Agency
moodley brand identity

Designer
Nora Obergeschwandner

Illustrations/External
Thomas Paster, Roland Vorlaufer

Client
New Frontier Holding GmbH

New Frontier Group networks IT companies to think globally and act locally. It reaches across state borders and is very flexible. New Frontier Group's annual report 2012 shows how people at New Frontier Group develop missing link solutions and strategies for digital evolution. Moodley designed visual analogies based on prehistory. Significant examples of extraordinary moments of change in the past are compared to innovative solutions for digital transformations by companies today. The detailed, staged and hand-illustrated studies of nature reflect the imagery of historical and scientific publications and dominate the appearance of the annual report 2012.

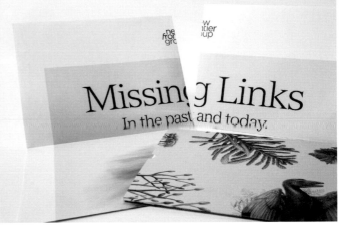

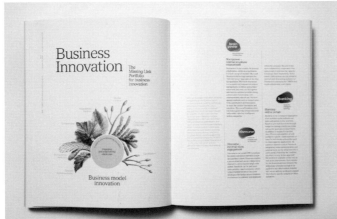

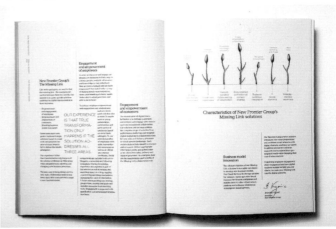

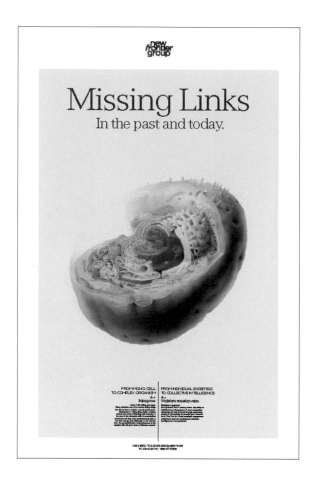

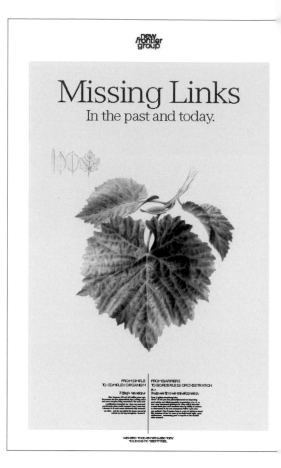

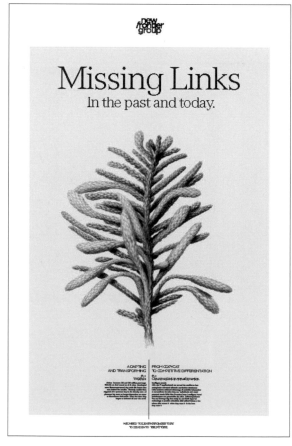

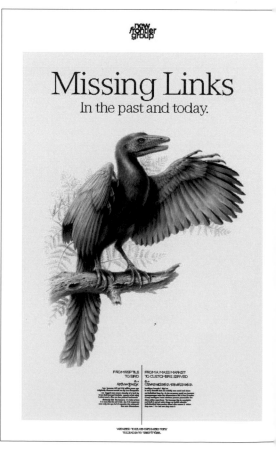

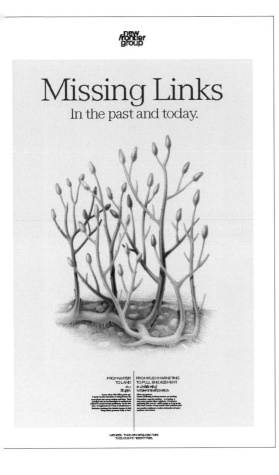

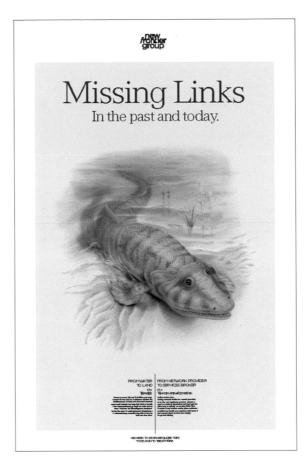

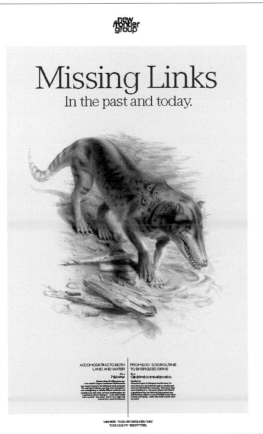

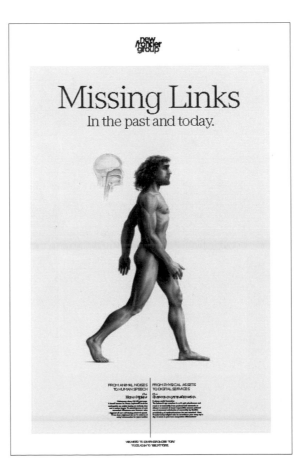

Domus China

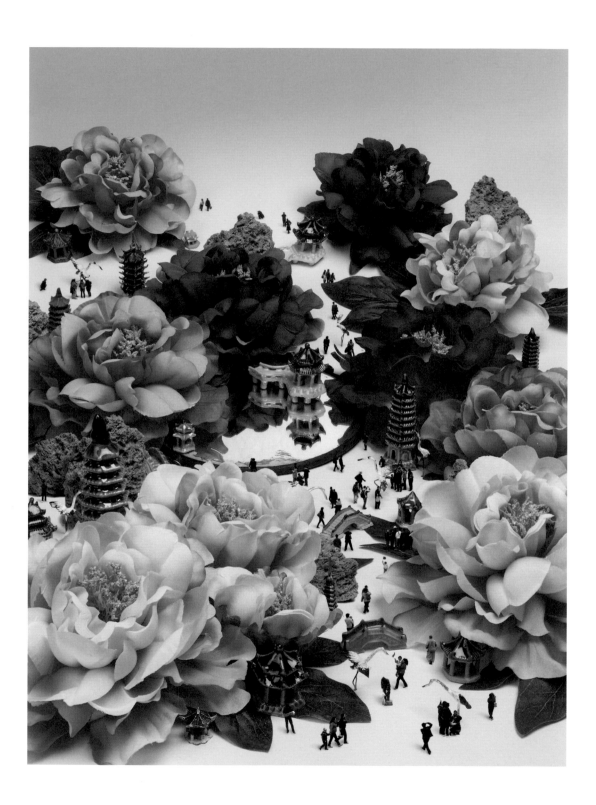

China

Designer
Gao Yunpeng

Client
Domus China

The designer chose peony silk flowers as the visual focus, integrating the flowers and small traditional decorative bonsai with numerous visitors to sketch an image of a bustling garden party which has rich multicolored decorations.

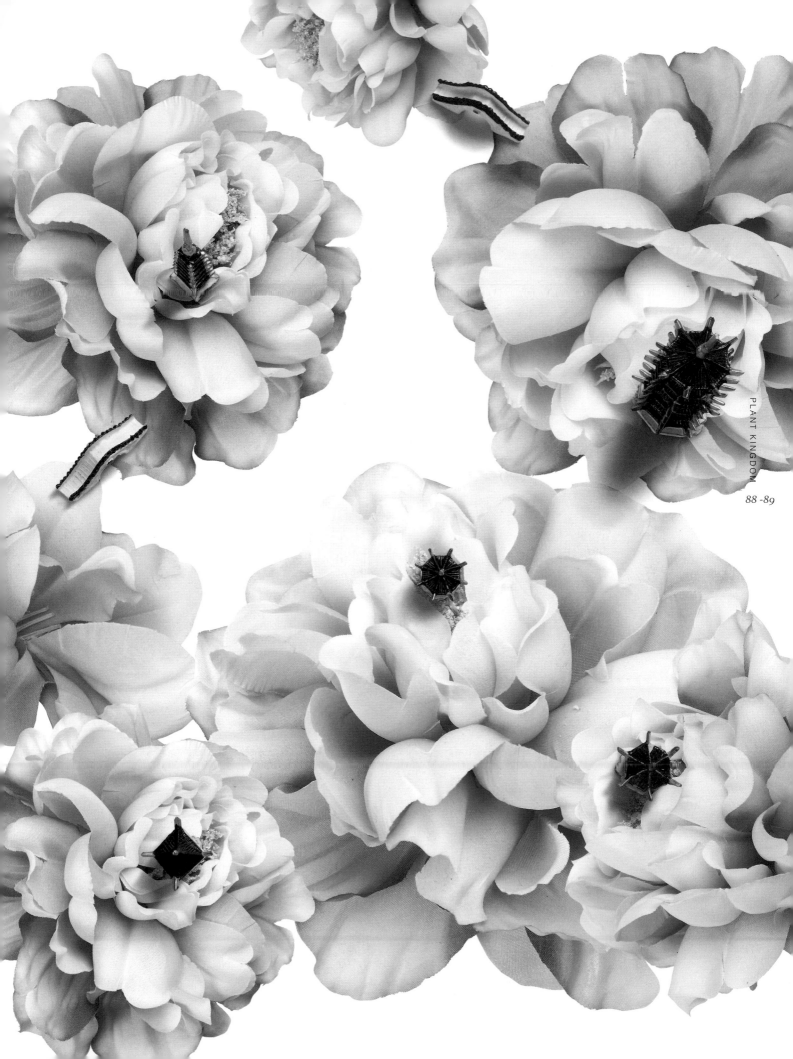

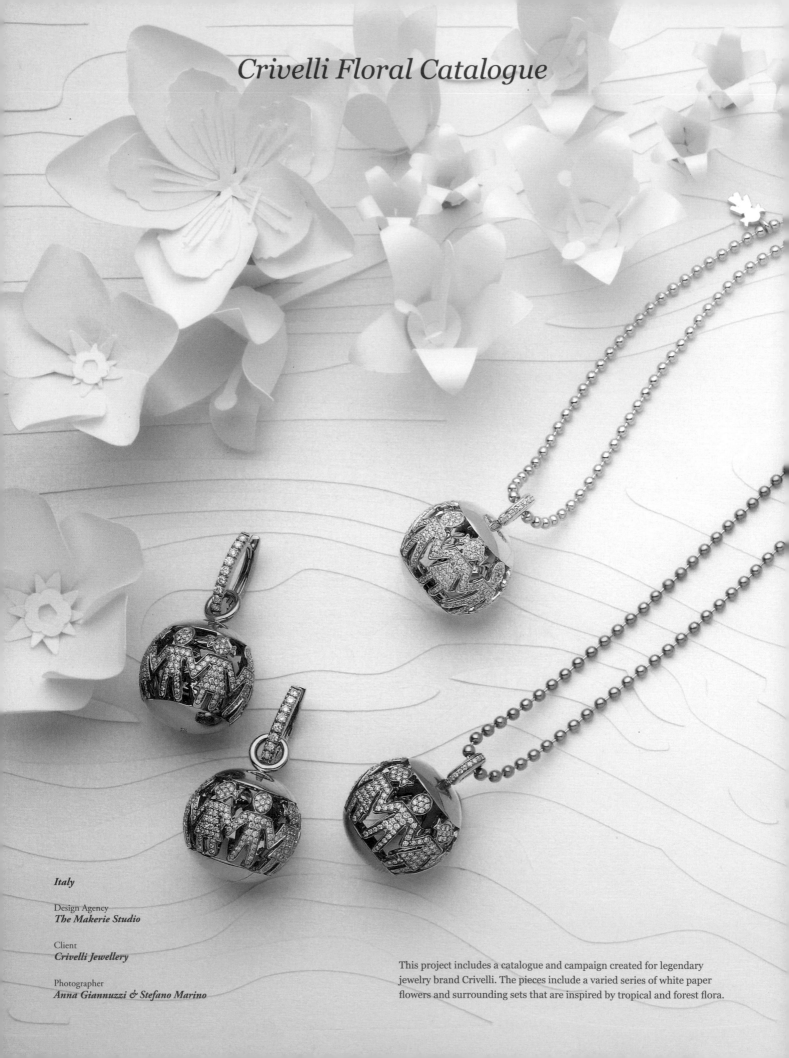

Crivelli Floral Catalogue

Italy

Design Agency
The Makerie Studio

Client
Crivelli Jewellery

Photographer
Anna Giannuzzi & Stefano Marino

This project includes a catalogue and campaign created for legendary jewelry brand Crivelli. The pieces include a varied series of white paper flowers and surrounding sets that are inspired by tropical and forest flora.

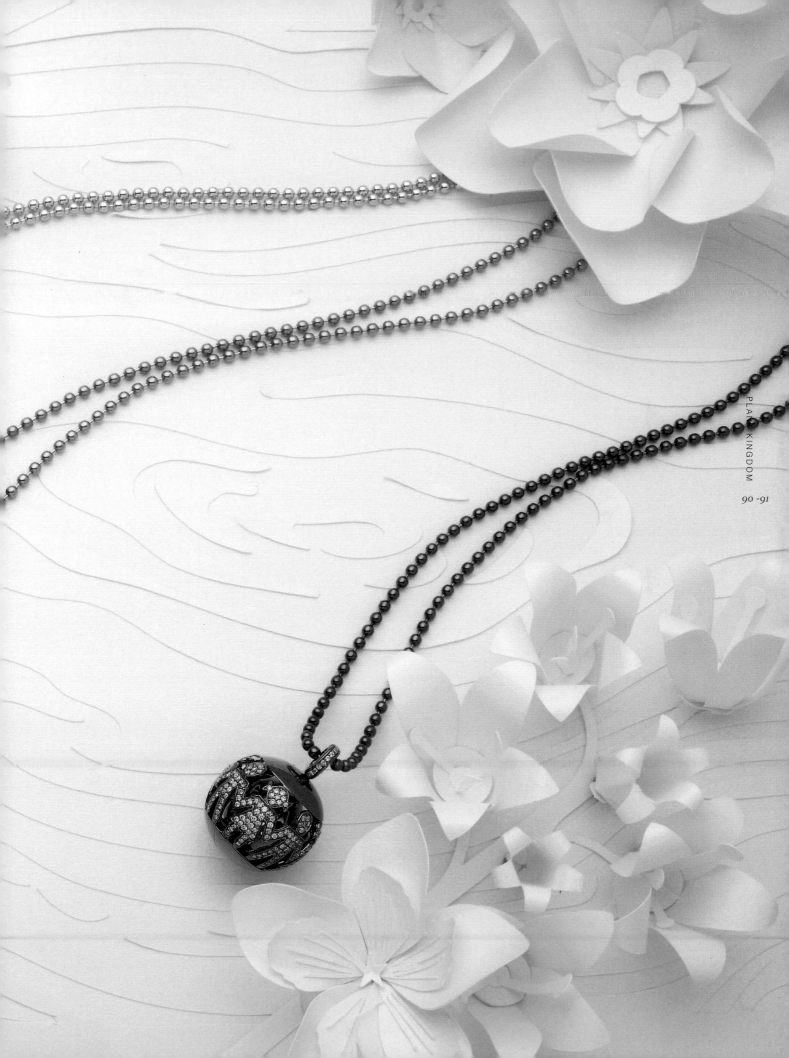

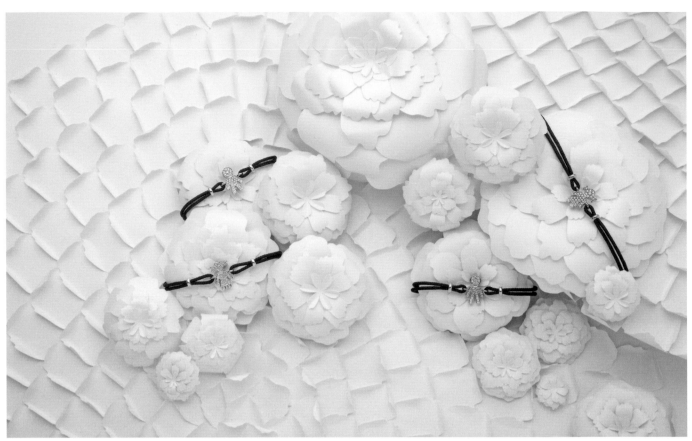

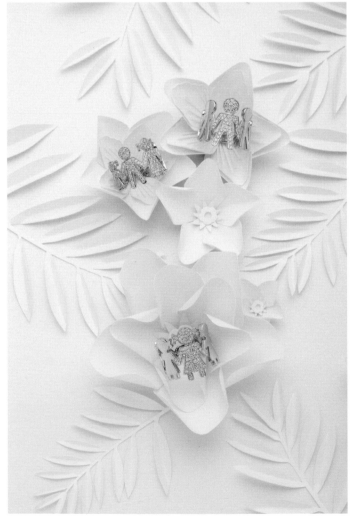

Ortology

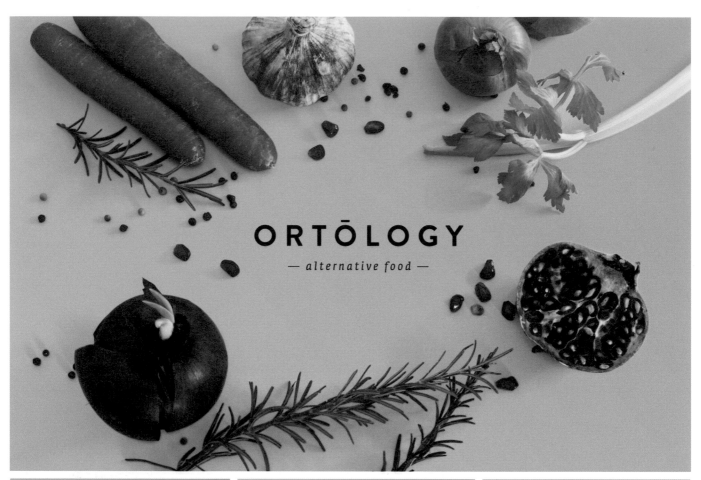

Italy

Designer
Francesca Sardigna

The designer attempted to redesign the identity of fruit and vegetables based on the principles of transparency and honesty while presenting the power of the product. The identity design was inspired by the authenticity of vegetables. That is why the designer looked for a scientific representation of vegetables but only using watercolor drawings, giving this project a tone more open to the imagination than the realism of photography.

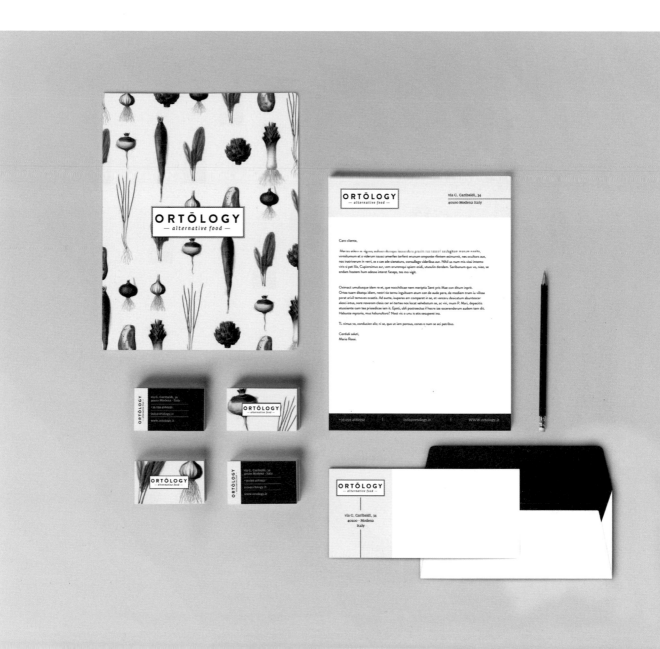

ICHIRIN

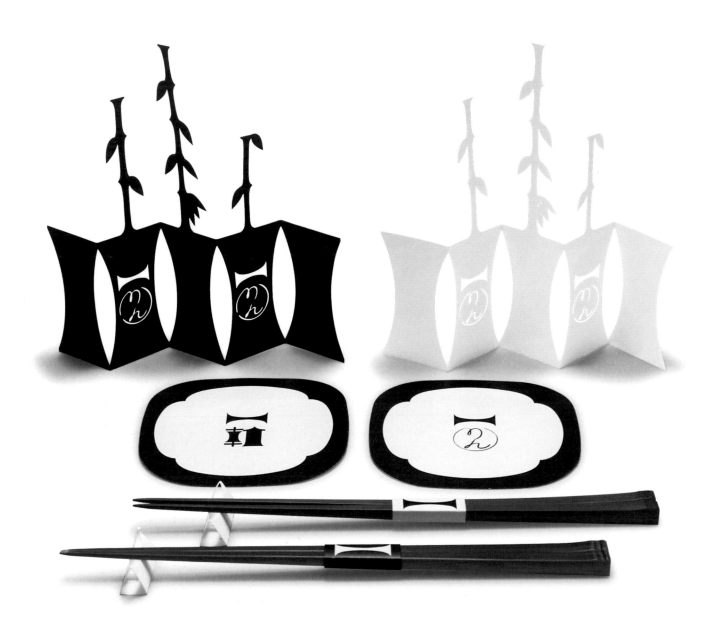

Japan

Design Agency
Tsushima Design Office

Designer
Hajime Tsushima, Yukiko Tsushima

Client
Hokushin factory

This project began with an environmental idea: reuse its end material. The bud vase "ICHIRIN" used the bamboo as its graphic motif. Accordingly, various designing elements are developed from the basic form. The wooden box reuses a scaffolding board that can be a gift package.

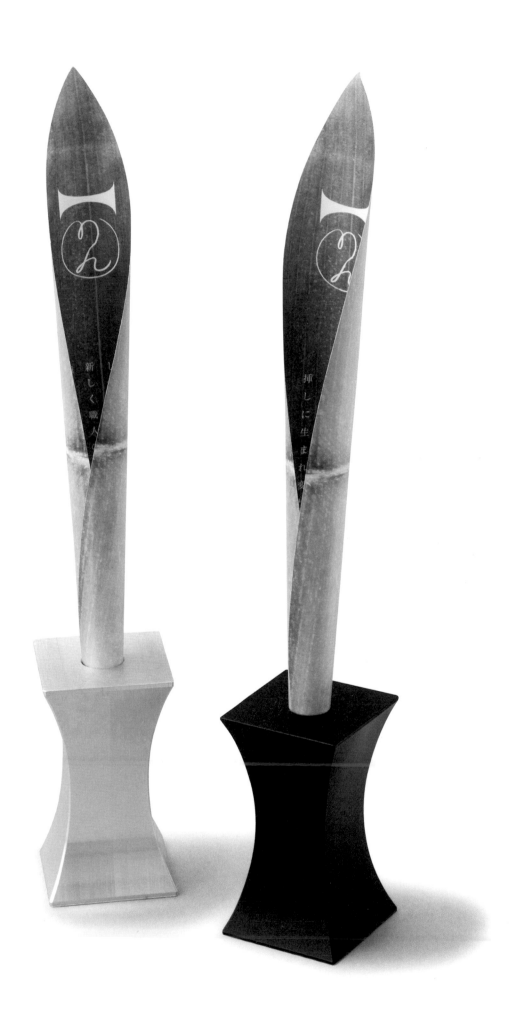

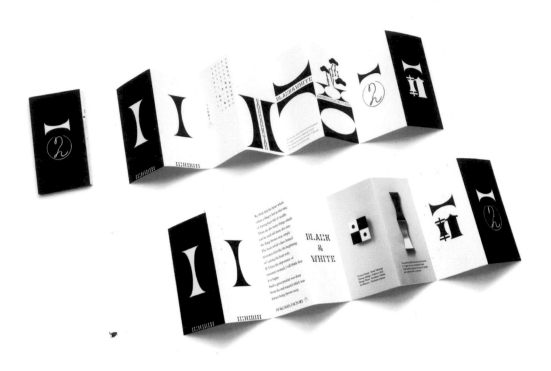

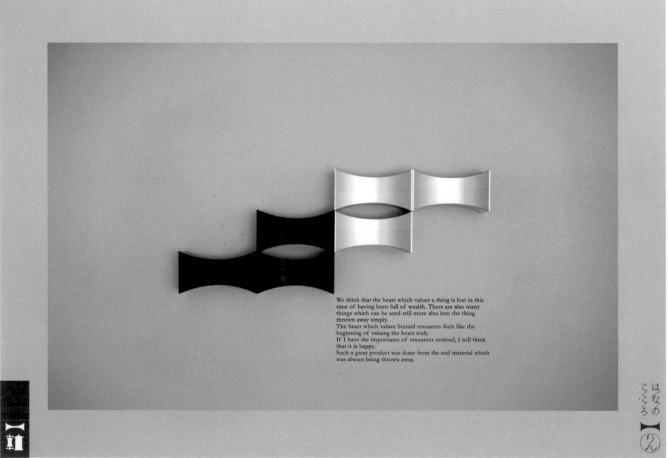

We think that the heart which values a thing is lost in this
time of having been full of wealth. There are also many
things which can be used still more also into the thing
thrown away simply.
The heart which values limited resources feels like the
beginning of valuing the heart truly.
If I have the importance of resources noticed, I will think
that it is happy.
Such a great product was done from the end material which
was always being thrown away.

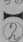

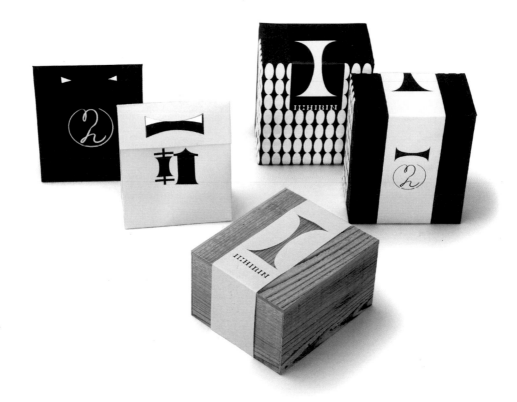

Giuseppe Giussani

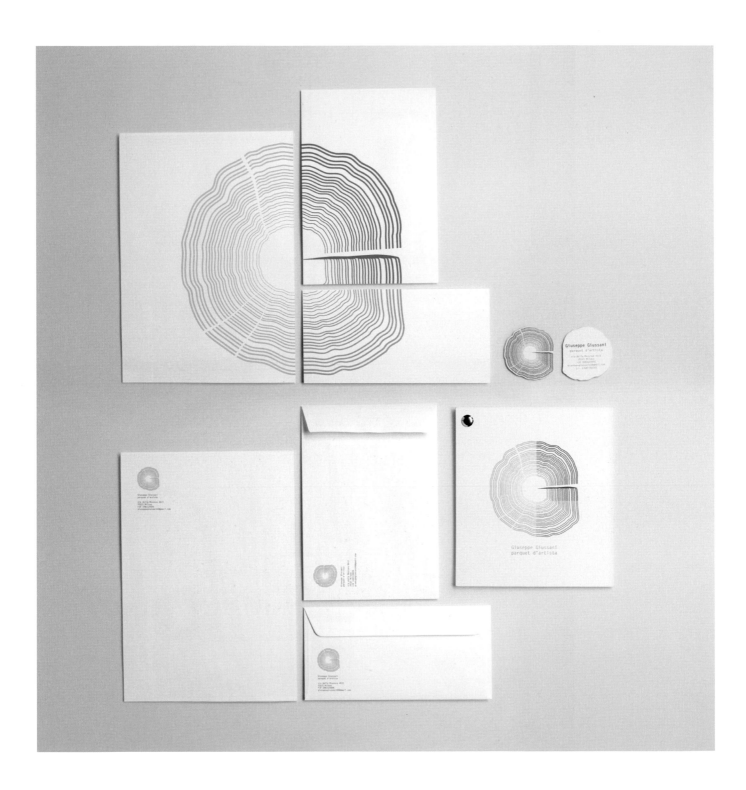

Italy

Studio
45gradi

Designer
Valentina Ferioli

Giuseppe Giussani is an Italian craftsman specialized in bespoke wood flooring. Everything starts from wood, so the idea was to combine the client's name and his raw material to create a personal brand identity. The result is an organic brand that represents the strong connection between the craftsman and his work.

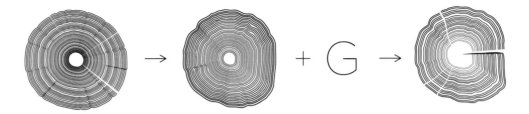

Giuseppe Giussani
parquet d'artista

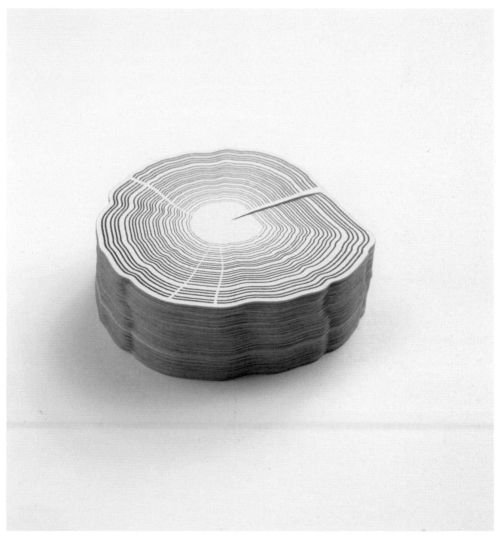

Romero+McPaul

Mexico

Design Agency
Anagrama

Client
Romero+McPaul

Romero+McPaul is a premium brand specializing in the sale and design of traditional English-style velvet slippers with a bright, trendy twist. For this project, the inspiration was heavily drawn from traditional English types and coat of arms mixed with the over-the-top luxuriousness of the Hamptons and its sailing and yacht club maritime lifestyle. The designers used a rosemary ("romero" in Spanish) not only as a reminder of its name but also as a reference to this herb's special nature since it only grows close to the sea.

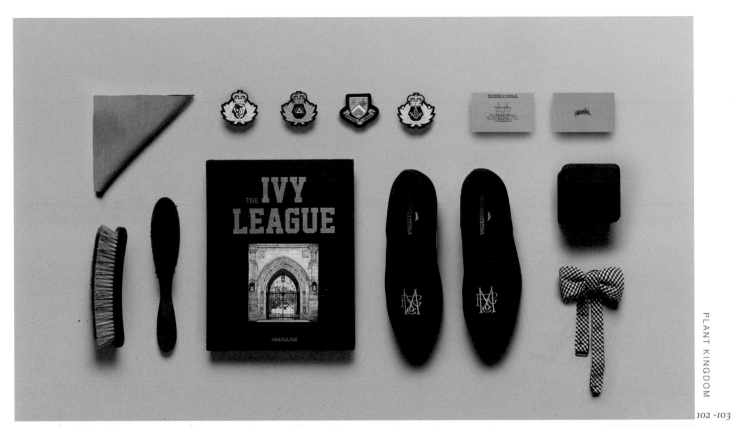

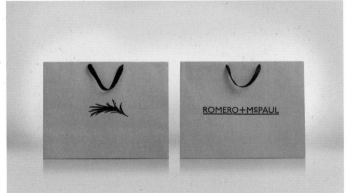

Artphy

The Netherlands

Design Agency
BURO RENG

Designer
Hans Gerritsen, Pascal Rumph

Client
Artphy

"Artphy" is a new center for modern art and philosophy, situated in the countryside of Groningen and surrounded by potato fields. The designers used the circle as a starting point. A circle is the symbol of the void, the infinity and the absolute freedom, bound by nothing. The circle brings you back to yourself. The circle has no beginning, no end. The circle is the base of the soul and also the symbol of eternity. In Buddhism, the circle symbolizes the harmony between all spiritual forces: yin and yang, black and white, good and evil.

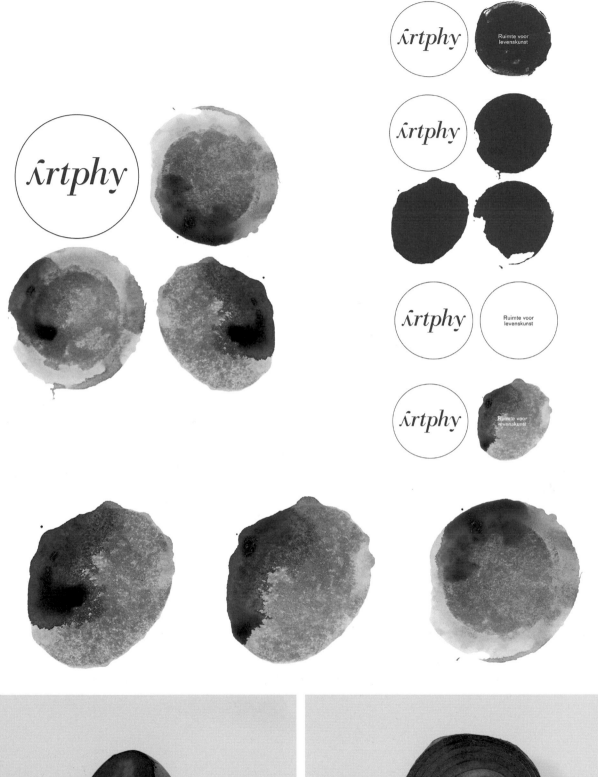

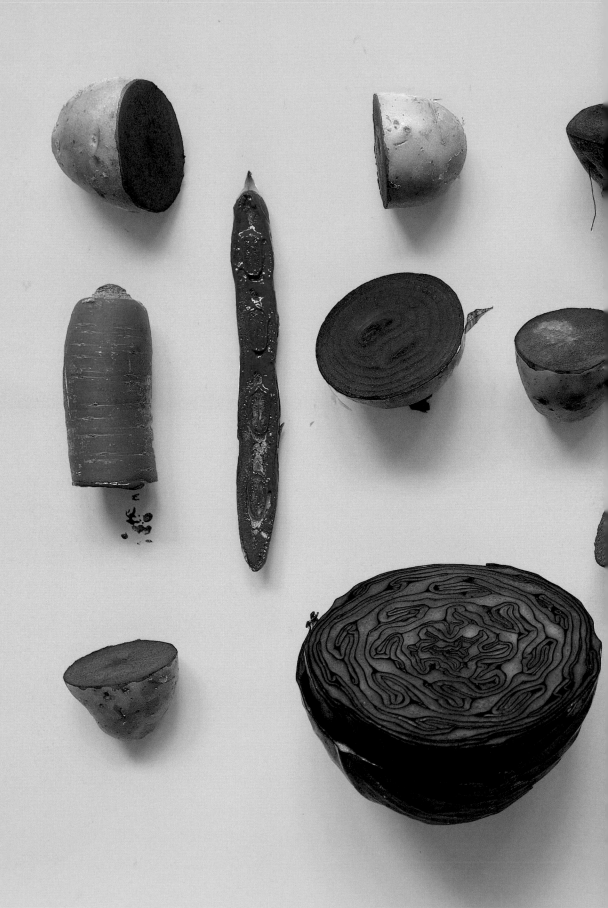

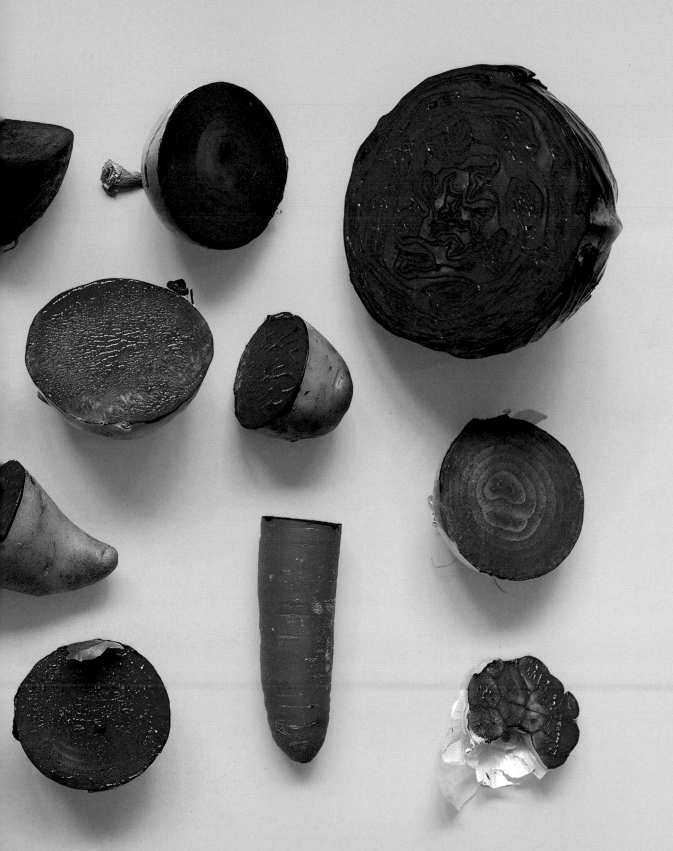

Chamcha

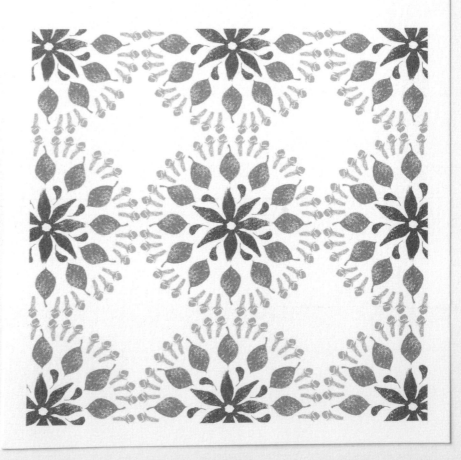

Japan

Design Agency
ANONIWA

Designer
Naoto Kitaguchi

Client
Chamcha

The owner of the Asian Restaurant "Chamcha" gives the impression of a sun-tanned, organic-type person—a wonderful, kind, and delicate woman. "Something that has been used for many years, with a faded color, so that an elegance of values is held dear," was conceived as her logo's identity. Her logo was chosen as a plate with lots of food heaped on, with the ingredients the sun, water, and flowers drawn within. Like accessories that have been used for many years, the designer aimed for a deep expression in tandem with an organic impression. The silhouette of various spices used in Chamcha's cooking were decoratively arranged for the graphic pattern. "While giving thanks for the blessings of nature, we send to you our bounty: food".

ha

小畑 菜穂子

NAHOKO
OBATA

〒530-0047　大阪市北区西天満5-3-9
Tel ＞ 06・6364・5557
Cel ＞ 090・1485・4072
Mail ＞ bhu-naho@sakai.zaq.ne.jp
Open ＞ 11:30〜 / Close ＞ 日曜・祝日

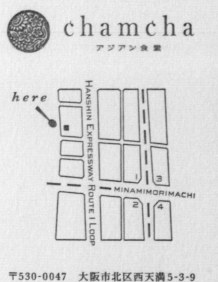

chamcha
アジアン食堂

here

HANSHIN EXPRESSWAY ROUTE 1 LOOP

MINAMIMORIMACHI

1 3
2 4

〒530-0047　大阪市北区西天満5-3-9
Tel　06・6364・5557
Open ＞ 11:30〜 / Close ＞ 日曜・祝日

Laouta Natural Soaps

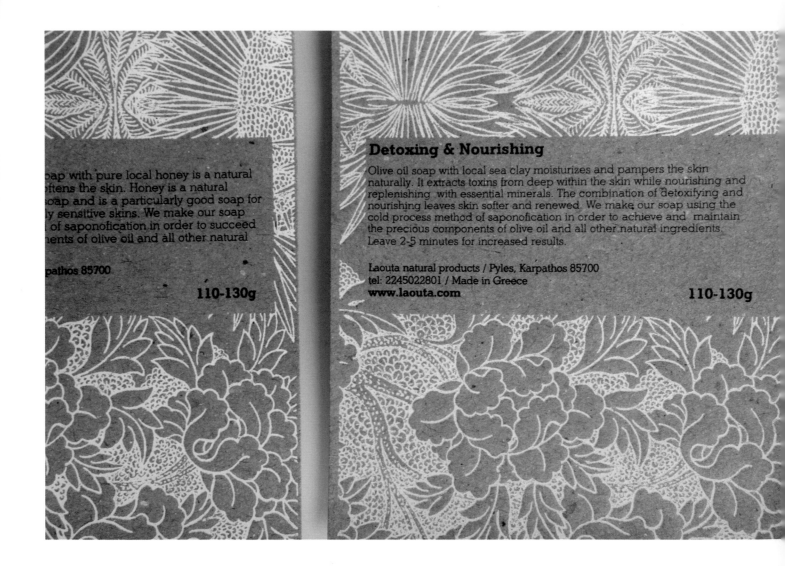

oap with pure local honey is a natural
ftens the skin. Honey is a natural
soap and is a particularly good soap for
y sensitive skins. We make our soap
of saponofication in order to succeed
nents of olive oil and all other natural

pathos 85700

110-130g

Detoxing & Nourishing

Olive oil soap with local sea clay moisturizes and pampers the skin
naturally. It extracts toxins from deep within the skin while nourishing and
replenishing with essential minerals. The combination of detoxifying and
nourishing leaves skin softer and renewed. We make our soap using the
cold process method of saponofication in order to achieve and maintain
the precious components of olive oil and all other natural ingredients.
Leave 2-5 minutes for increased results.

Laouta natural products / Pyles, Karpathos 85700
tel: 2245022801 / Made in Greece
www.laouta.com

110-130g

Greece

Design Agency
AR Design Studio

This is a packaging design for a Greek Handmade extra virgin olive oil soaps
from Karpathos, Laouta natural soaps.

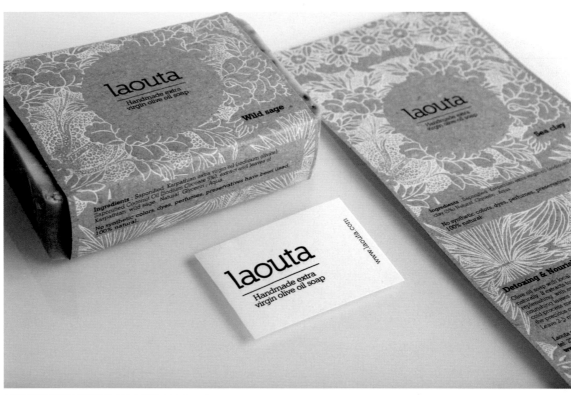

Cilsoie Private Bijoux

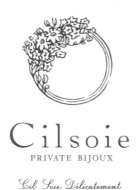

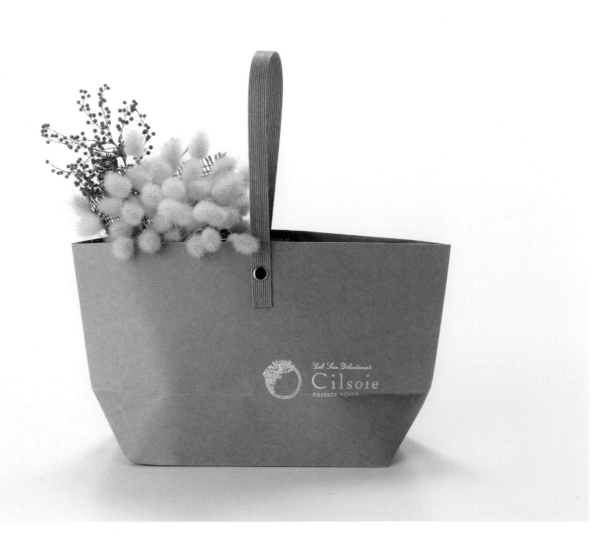

Japan

Design Agency
ANONIWA

Designer
Naoto Kitaguchi

Client
Cilsoie

"Cilsoie Private Bijoux" is a handmade accessory brand. Designers included the feeling of the intricate, careful handiwork that is demonstrated by Cilsoie's delicate accessories in this logo. For the symbol, the pleasure of the changing of the seasons including memories of picking flowers blooming on the roadside is featured with a flower coronal weave. Together they paint a picture of a brand that provides a sense of spiritual happiness in the love of plants, the natural enjoyment of the slow passage of time, and the beauty of remembering a "do-nothing" day. Making a shopping bag with one handle in a shape like a basket, gives the brand a certain "weltanschauung".

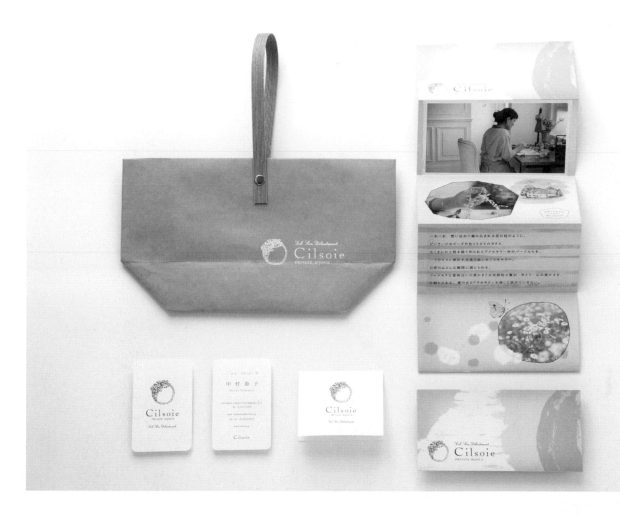

Better With Flowers

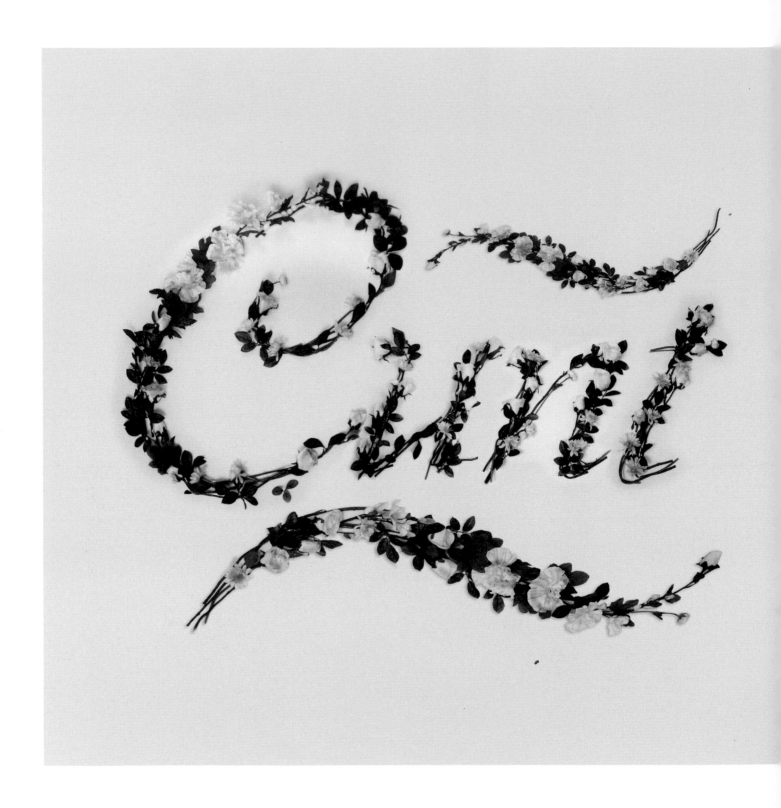

Brazil

Designer
Antonio Rodrigues Jr

The basic concept of this project is that whatever you have to say will sound better if you say it with flowers, at least it will look better. The offensiveness has been weakened by the gracious flowers and the warm colours. However the designer has used plastic flowers because they add a perfect touch to the project.

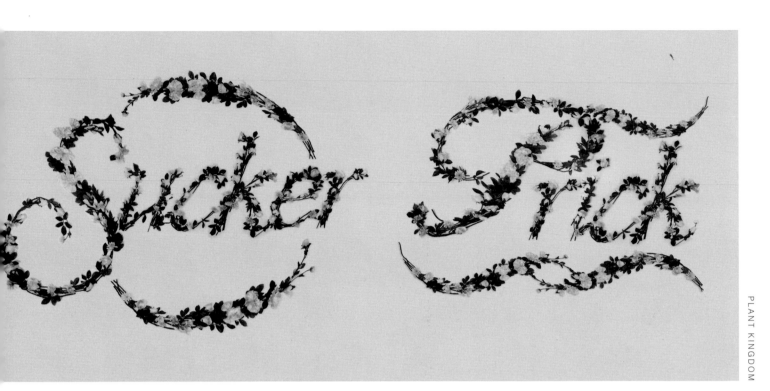

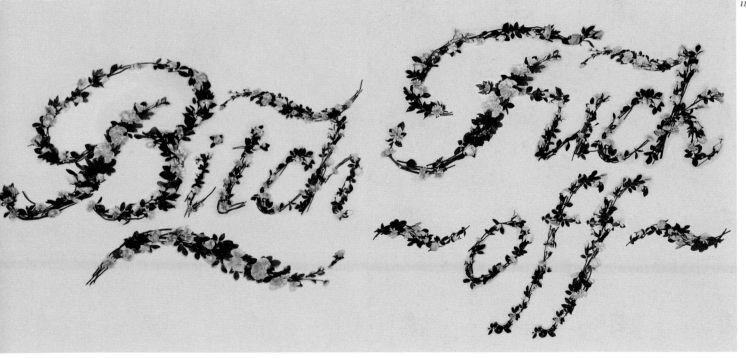

Floral Alphabet

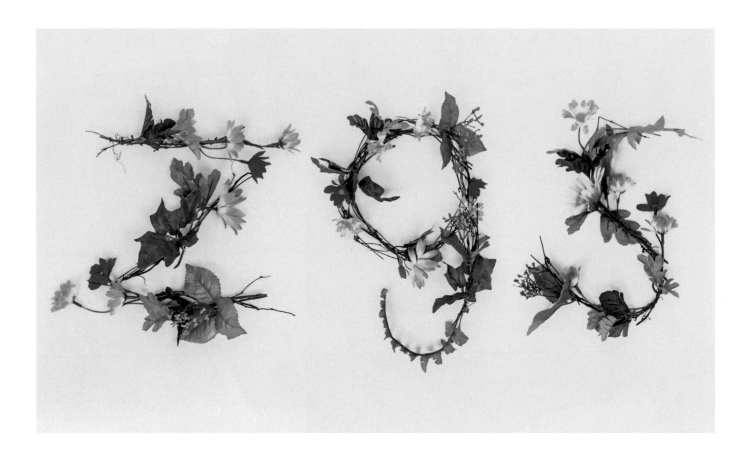

United States

Designer
Anne Lee

This handcrafted alphabet was inspired by the beauty of nature and made with flowers.

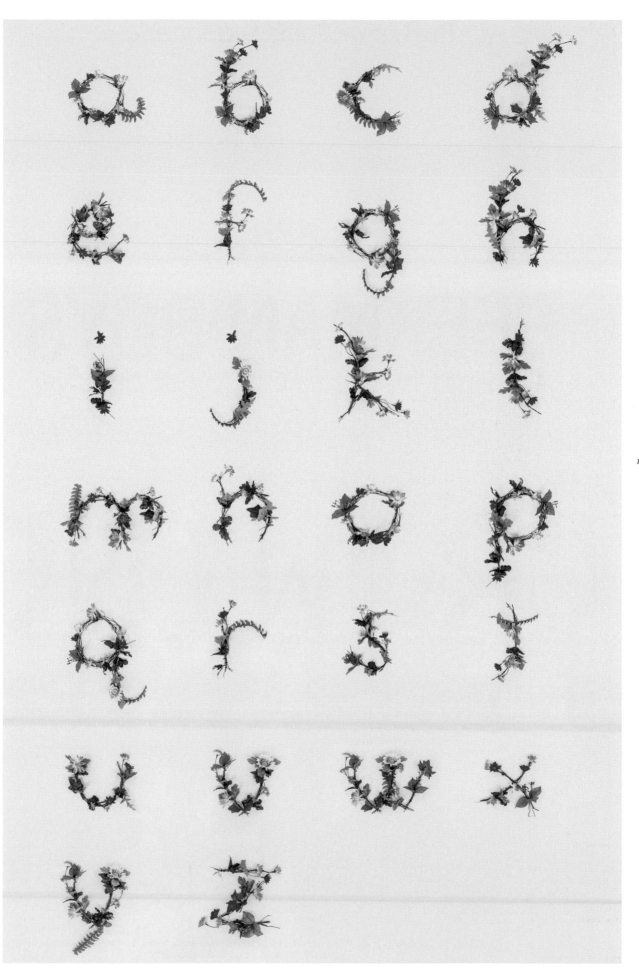

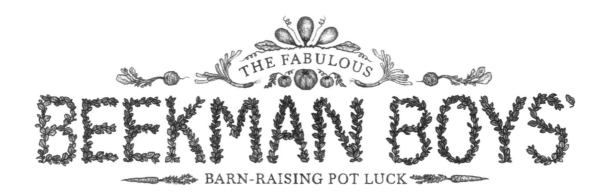

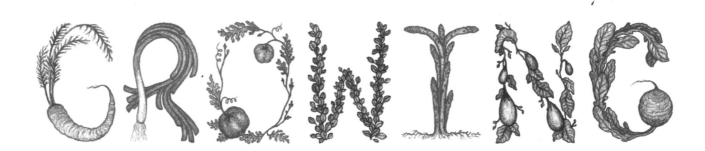

United States

Art Director
Courtney Waddell

Illustrator
Sasha Prood

Client
Food & Wine Magazine

These hand-drawn titles were created in 2011 at the request of Food & Wine Magazine, for their August issue. "Growing" opened the contents page and "Beekman Boys" opened a feature describing a farming duo.

Spring/Summer 2011 Promotional Lettering

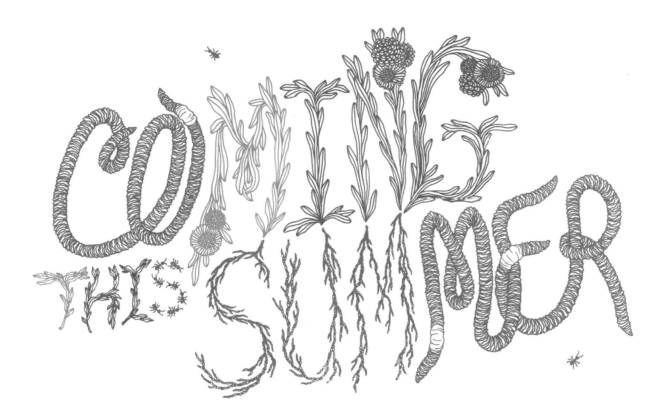

United States

Illustrator
Sasha Prood

This hand-inked lettering was created in 2011 for the designer's self-promotion project. "Coming This Summer" was placed on the landing page of the designer's online store, the Print Shop. "Love Me Do" was printed onto postcards to promote the store.

Birds Obsessed

This hand-inked illustration was created at the request of Migrate Magazine, as a contribution to their twelfth issue themed "Obsess".

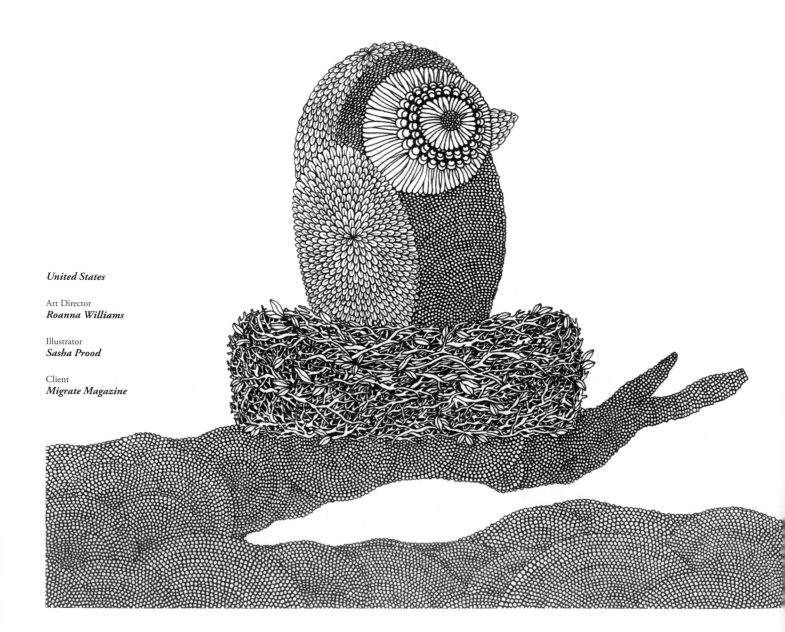

United States

Art Director
Roanna Williams

Illustrator
Sasha Prood

Client
Migrate Magazine

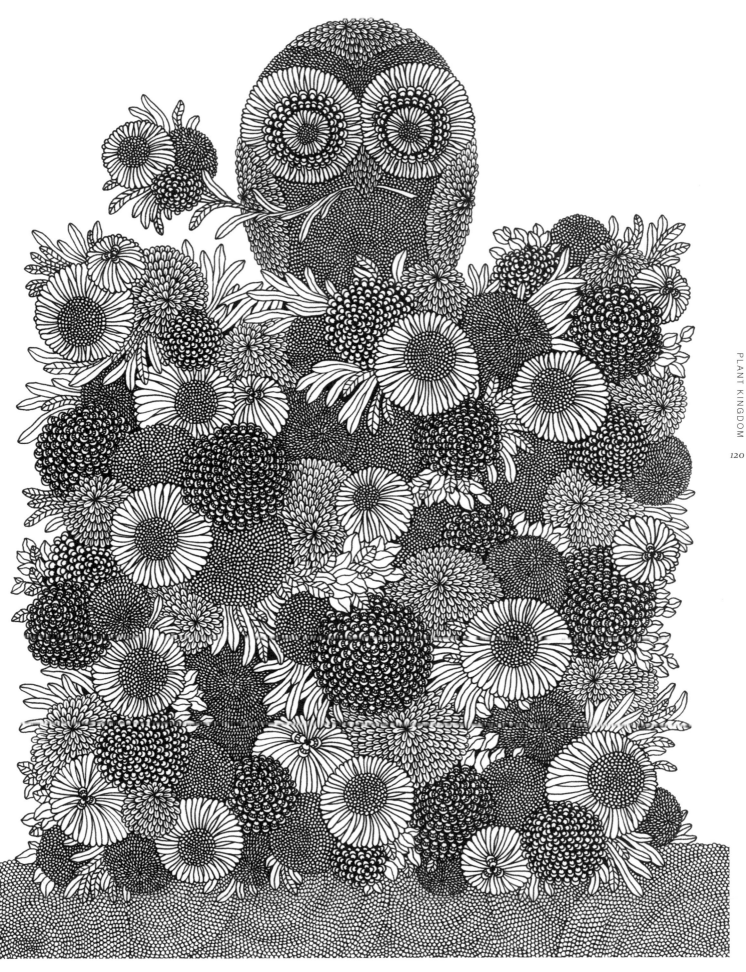

Botanica Caps Poster

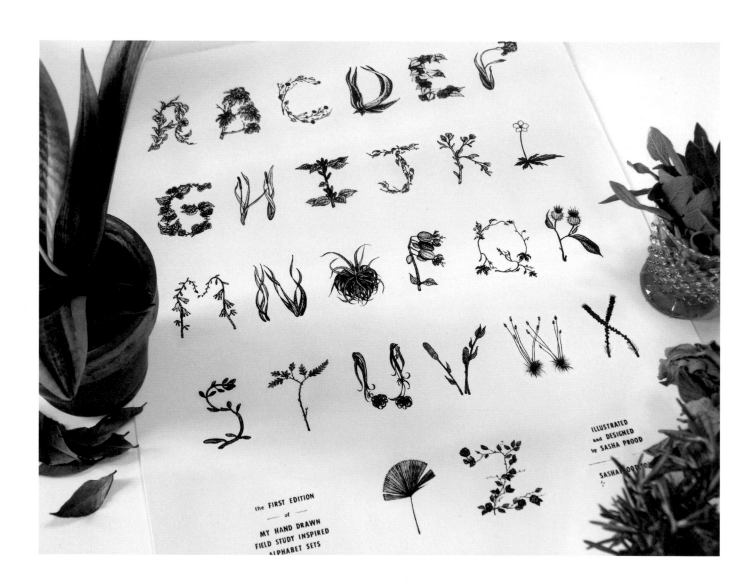

United States

Illustrator
Sasha Prood

This hand-drawn alphabet was inspired by nature, particularly botanical life.

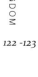

the FIRST EDITION
—— of ——
MY HAND DRAWN
FIELD STUDY INSPIRED
ALPHABET SETS

ILLUSTRATED
and DESIGNED
by SASHA PROOD

SASHAPROOD.COM

Glutton for Life Alphabet

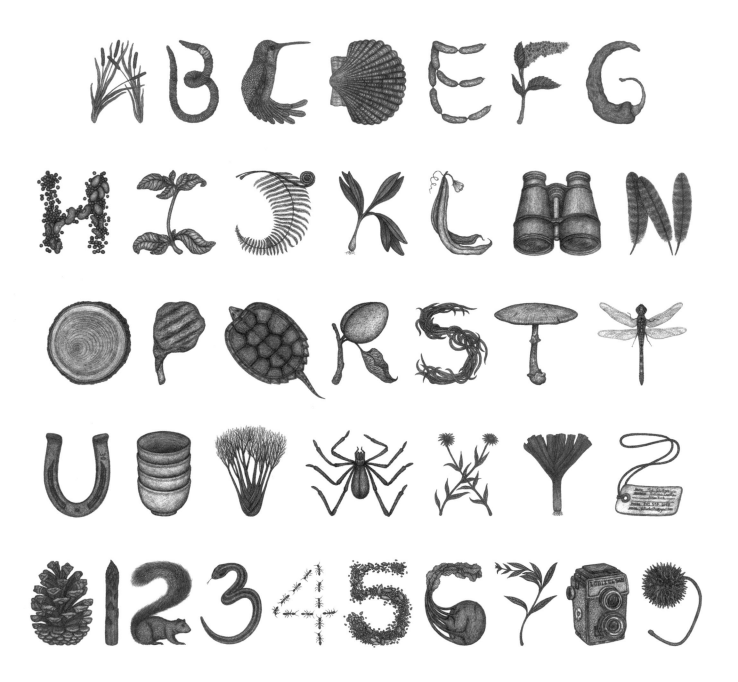

United States

Creative Director
Alex Lin

Illustrator
Sasha Prood

Client
Glutton for Life & Studio Lin

This hand-drawn alphabet was created at the request of Studio Lin, for incorporation into Glutton for Life's website redesign. The illustrator was commissioned to create a set of characters to be used across the site as both decorative and informative elements. She developed these characters, using inspiration from various items discussed throughout GFL's articles.

Peas

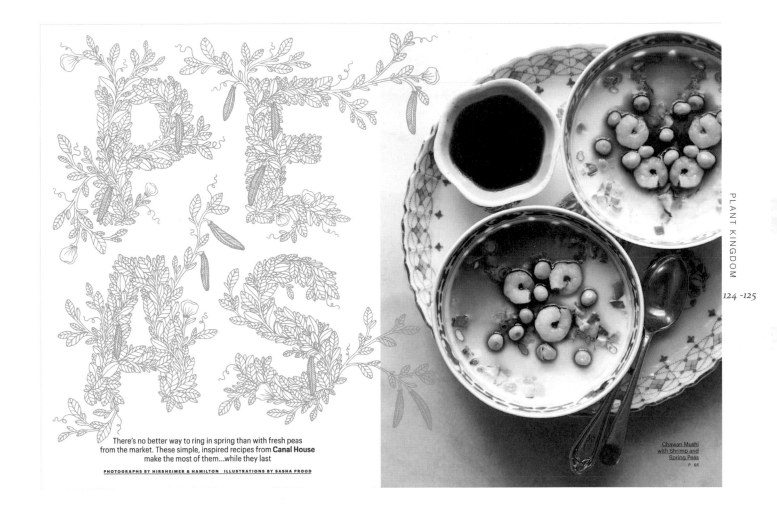

There's no better way to ring in spring than with fresh peas from the market. These simple, inspired recipes from **Canal House** make the most of them...while they last

PHOTOGRAPHS BY HIRSHEIMER & HAMILTON ILLUSTRATIONS BY SASHA PROOD

Chawan Mushi
with Shrimp and
Spring Peas
P. 86

United States

Creative Director
Alex Grossman

Illustrator
Sasha Prood

Photographer
Hirsheimer & Hamilton

Client
Bon Appétit Magazine

This hand-inked title was created in 2013 at the request of Bon Appétit Magazine to be used as the opener of their spring-inspired "Peas" feature. In this title art, the once "tame" pea plant begins to overtake the page, sprouting out of its letterforms and pushing its way across the spread.

Typographic flowers

Portugal

Designer
Maria do Carmo Louceiro

Client
ESAD – Matosinhos

The goal of the project was to create a handmade typography with objects that surround us, so the designer chose flowers as the main element of the design to convey calm and peace.

Coca i Fitó negre wine

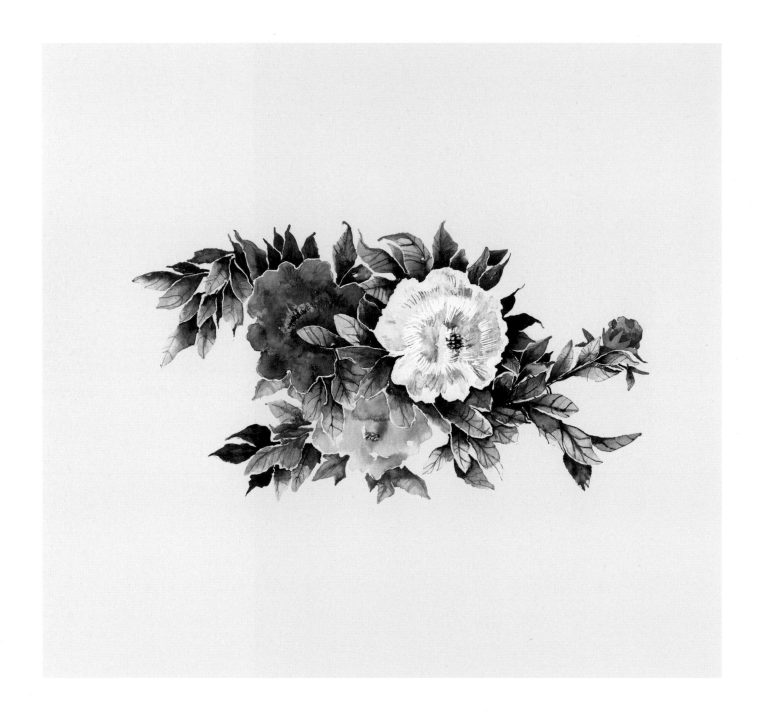

Spain

Design Agency
Atipus

Designer
Javier Suárez

Client
Celler Coca i Fitó

Coca I Fitó is a signature wine with contemporary and cosmopolitan qualities that accent high status in the international market. It is also a new concept of wine with very special nuances that have been added by the winemaker.

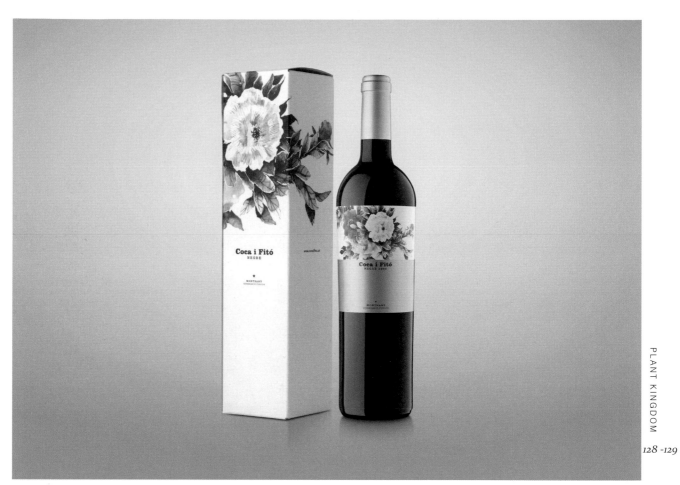

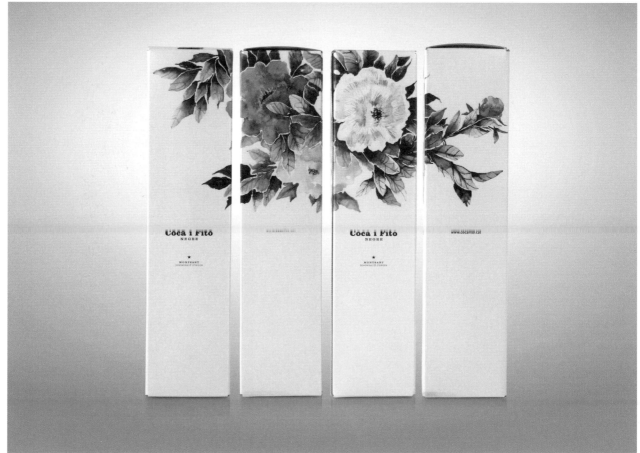

JASPI blanc

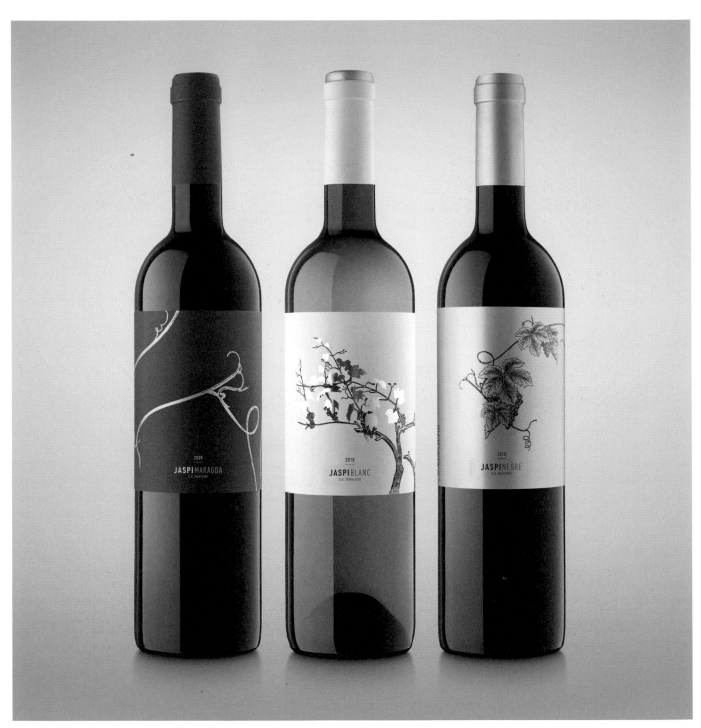

Spain

Design Agency
Atipus

Designer
Javier Suárez

Client
Coca i Fitó

The "blanc" is a white wine variety of the JASPI collection. This classic feel of the vineyard has a fresh character with a touch of wood. This is the idea that the label wants to communicate. Special attention to the leaves gives the label a touch of freshness and color.

Èlia, aromatic olive olis

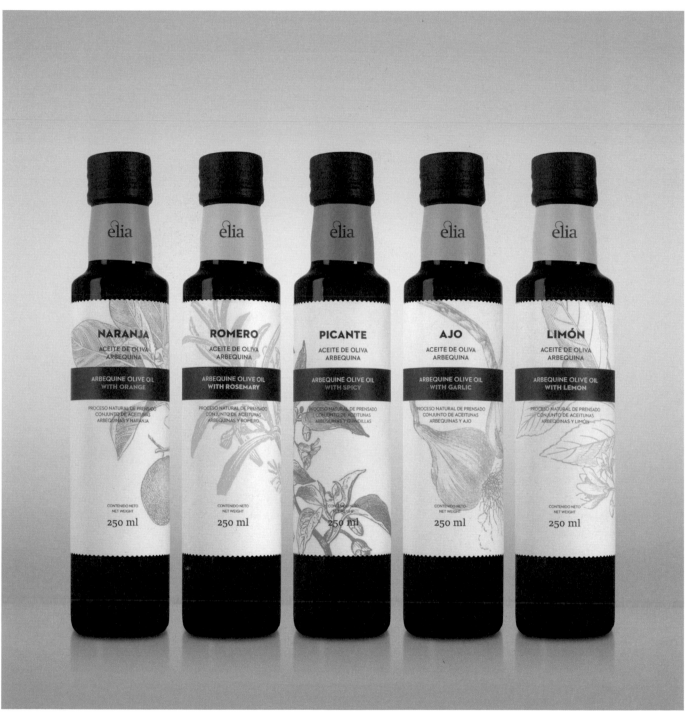

Spain

Design Agency
Atipus

Designer
Javier Suárez

Client
La Masrojana

This is the identity for a new brand of olive oils and other olive based products. Èlia is a feminine name, from the Greek word "ελιά" (olive). In accordance with its name, a subtle feminine touch has been given to both the brand (with the typographic game of the logotype) and the packaging itself.

Humiecki & Graef Porcelain Edition

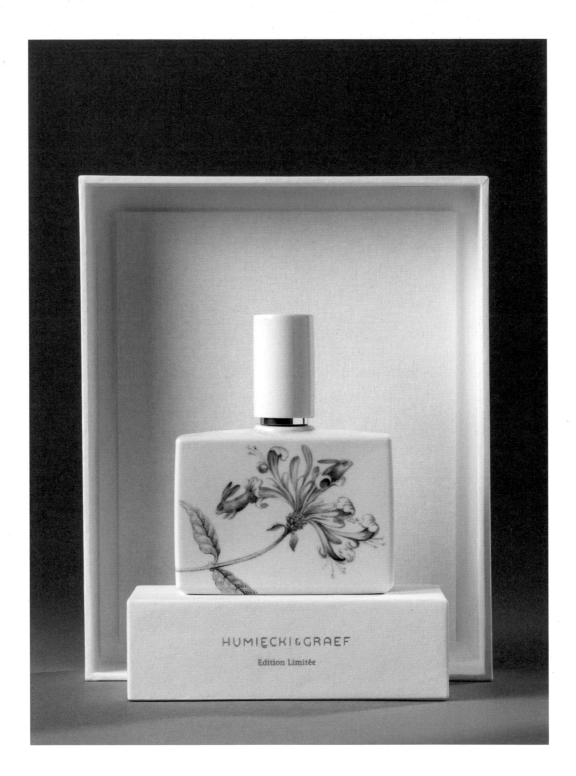

Germany

Design Agency
BEL EPOK

Designer
Stephanie Herse

Client
Humiecki & Graef

Throughout the history of European culture, flowers have always had symbolic meanings, which could be traced back to Christian traditions and had been transferred into the secular sphere over time. Thus most flowers symbolize something and are used as a sort of code in pictures – signs to convey or underscore a specific message.

Bel Epok applied this idea and tradition to this special limited edition in porcelain. A specific flower with a symbolic significance was chosen for each perfume. Instead of relating the exact ingredients or smell of the scent, the flower was used to communicate the conceptual idea behind each perfume.

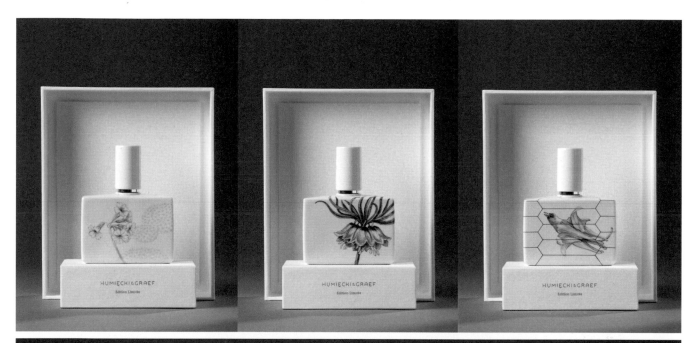

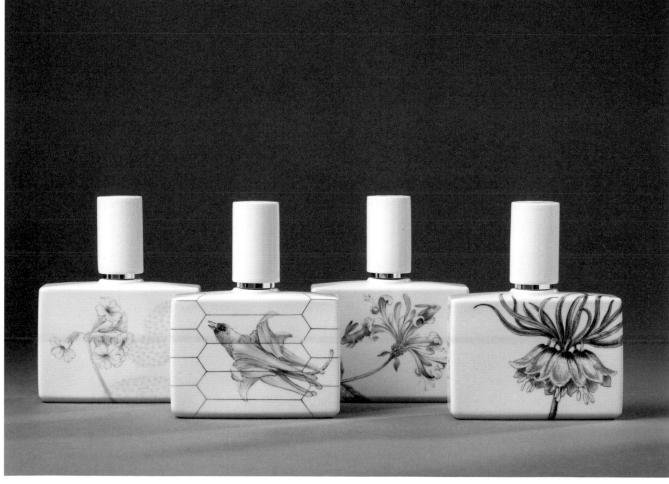

Body Nordic

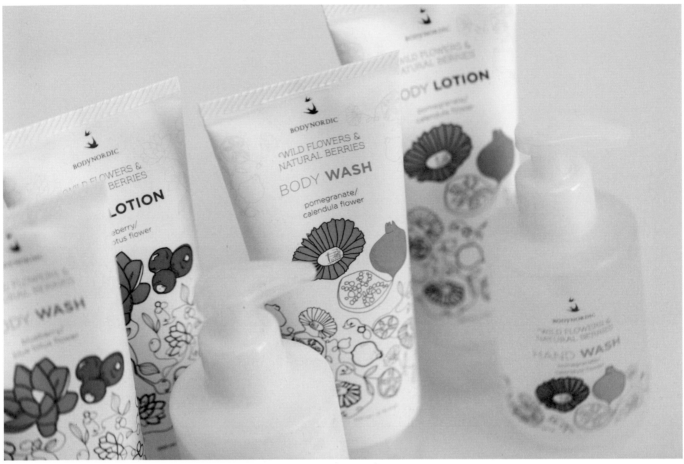

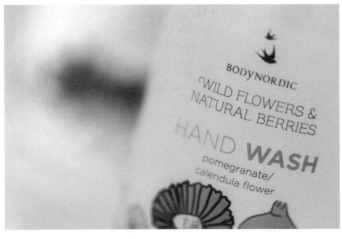

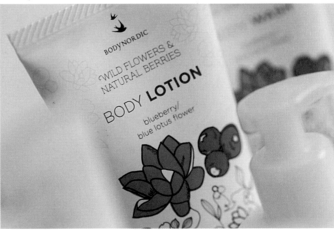

Denmark

Design Agency
Bessermachen Design Studio

Designer
Kristin Brandt

Client
Body Nordic

Bessermachen developed the packaging design, for Body Nordic Body Wash which captures the nature and beauty of the product itself. Bessermachen loves when design is more than just a shape. Graphic can be a powerful form of communication and packaging is a medium itself. Therefore the designers wanted to incorporate the key values of Body Nordic in the visuals.

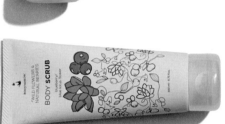
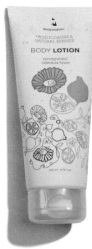

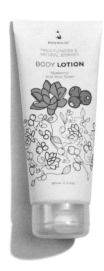
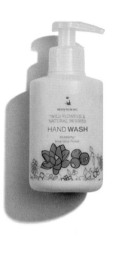

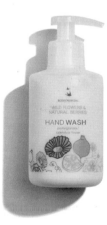

Bilpin Cider Co.

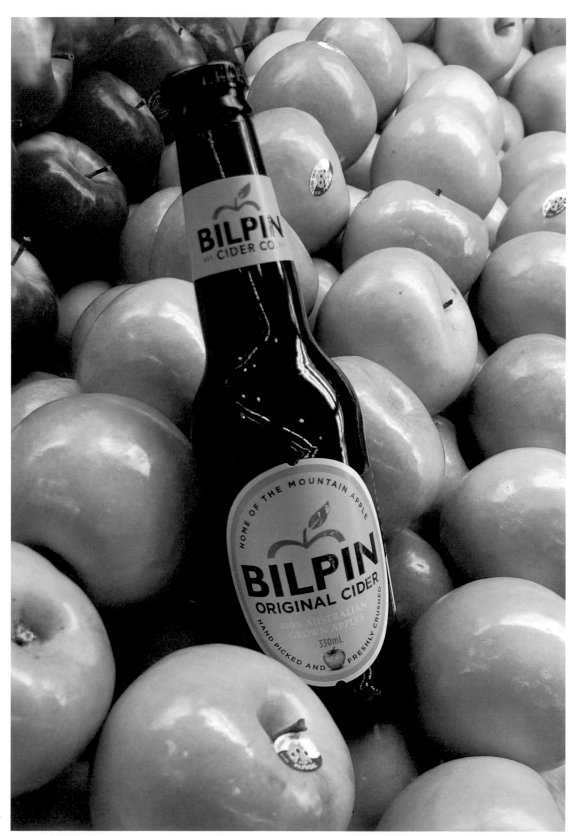

Australia

Design Agency
Boldinc

Creative Director
Jon Clark

Designer
Jarrod Robertson

Client
Bilpin Cider Co.

Hand-picked and freshly crushed apples were grown in the orchards that surround the township. A vibrant Granny Smith green color scheme combined with a quaint, farmer's market layout, Bilpin Cider represents the new breed of Australian cider.

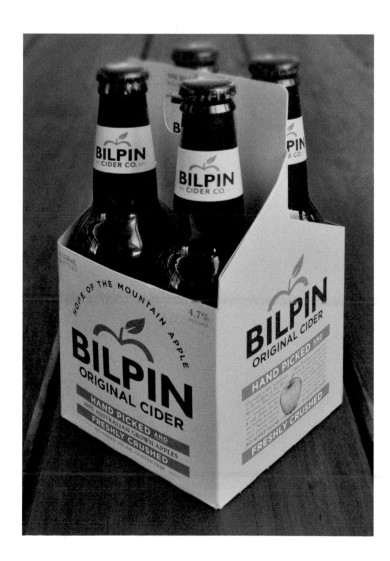

Tetley Infusions and Green Tea

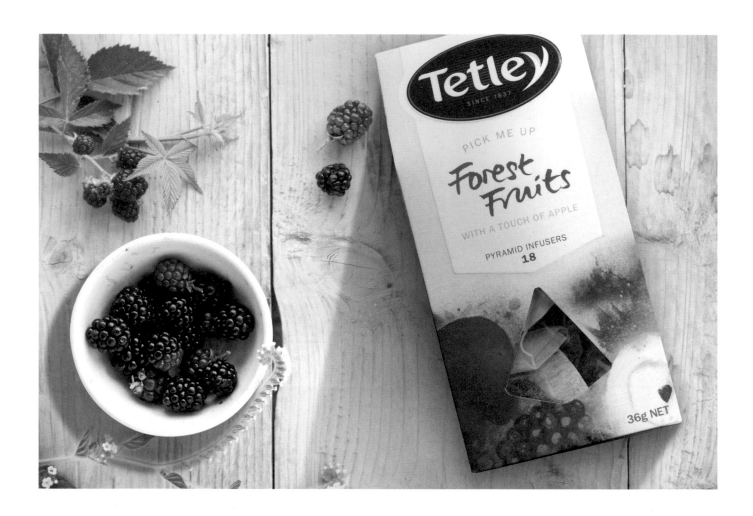

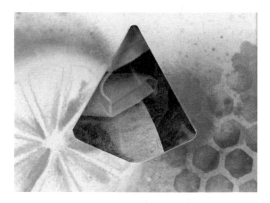

Australia

Design Agency
Boldinc

Creative Director
Jon Clark

Designer
Pam Partridge

Client
TATA beverages

As part of a complete redesign of the Tetleys product range, Green Tea & Herbal Infusions added a more natural selection of products to their portfolio. Observing how fruits, herbs and spices infused into water provided the inspiration of the design. The designers drew parallels with the natural aesthetic of watercolor painting, using a fusion of watercolors and inks saturating the paper to bring the ingredients to life. The design captures the simplicity and natural feeling of the products by combining a natural board finish, with the graphic element depicting a teabag near a pyramid-shaped window.

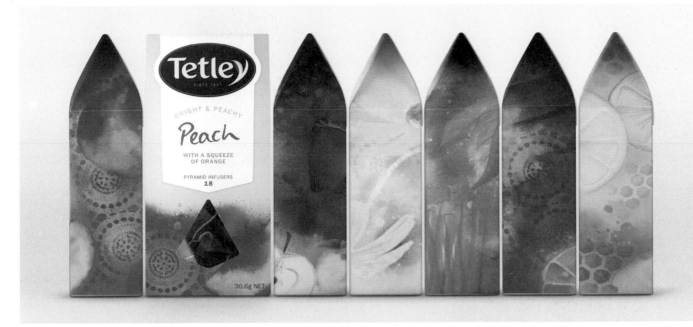

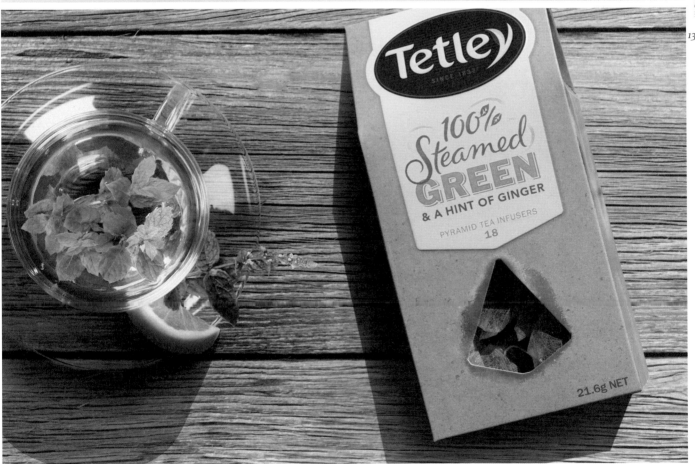

Olvi

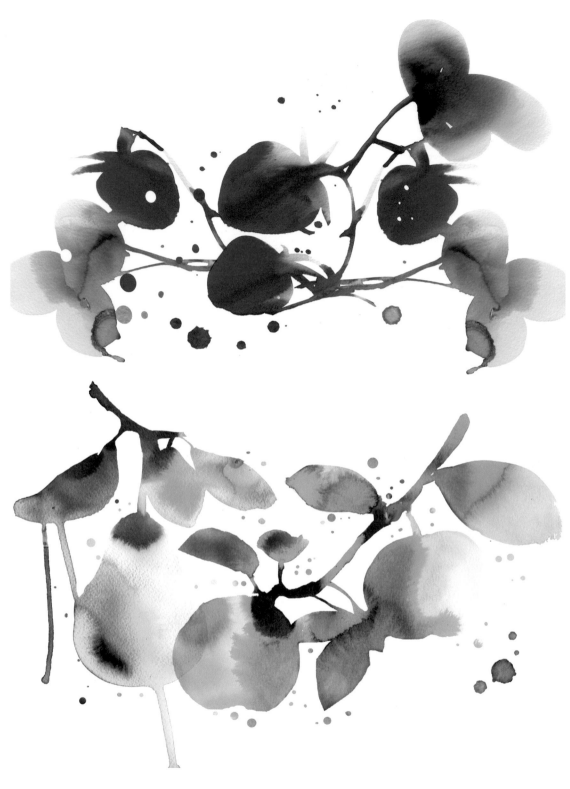

Finland

Design Agency
Bond Creative Agency

Designer
Marko Salonen

Client
Olvi

Olvi is an independent, Finnish brewery. Bond redesigned a selection of ciders with full white base color and fresh juicy illustrations by Stina Persson. The aim was to have a strong shelf impact with natural and pure design, which stands out from many competitors' green bottles.

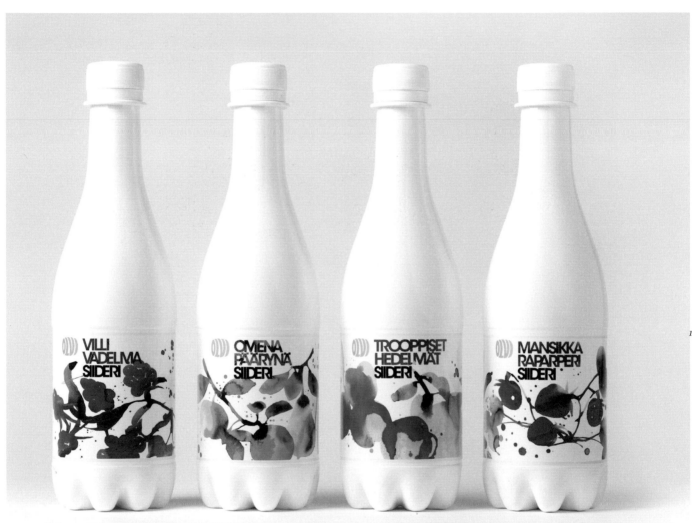

Tea Talk

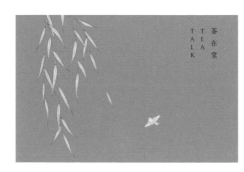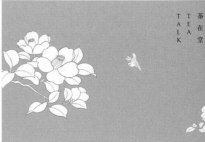

China

Design Agency
Cocoon Design

Designer
Yuning Chen, Zhihong Chen

Client
Tea Talk

The unique characteristics of each type of tea are represented by willow, jasmine, orchids and bamboo. This interpretation was inspired by the literary quote: "spring was gone but flowers are still around, people came but birds did not scare."

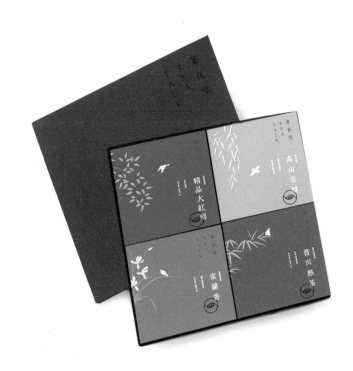

Health Tea

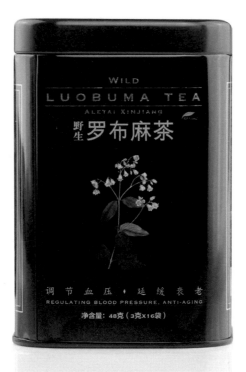

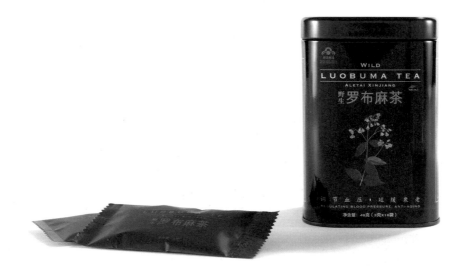

China

Design Agency
Cocoon Design

Designer
Yuning Chen, Zhihong Chen

Client
JKL

JKL had a project developed for the launch of its first wave of health care products: black bitter barley and wild dogbane tea. The designers featured Sichuan buckwheat (Black Tartary Buckwheat from Daliangshan, China) and Gobi Altay wild dogbane (from the Taklamakan Desert and Aletai, China), using textbook illustrations to convey the effectiveness of the product.

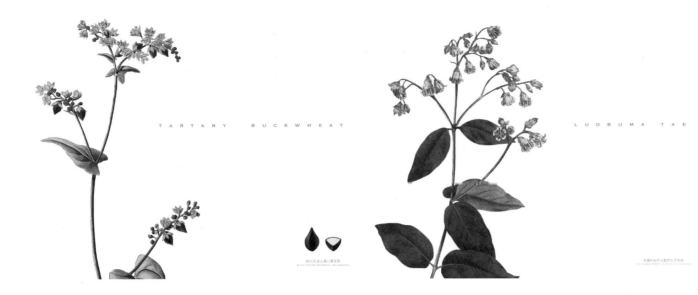

TARTARY BUCKWHEAT

LUOBUMA TAE

四川大凉山黑苦荞
Black Tartary Buckwheat·Daliangshan

华国四处市太乾沙六罗网唐
Tea Luobuma Maeer · Dadoudaoxvmen

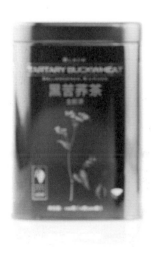

Andevine

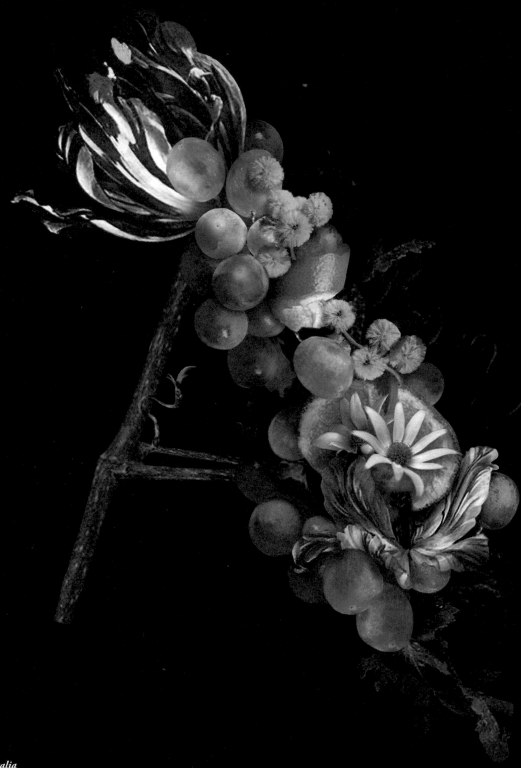

Australia

Design Agency
Co Partnership

Designer
Zoe Green

Client
Andevine Wines

Andevine is a boutique wine brand created for Hunter Valley winemaker Andrew Leembruggen. As a signature wine it was important for the design to reflect Andrew's brand story including his Dutch ancestry and Australian upbringing. The labels are illustrated with the national flowers of Holland, Australia and the state flower of New South Wales, creating a memorable letter "A" in the style of the Dutch masters.

The Living Botany Museum

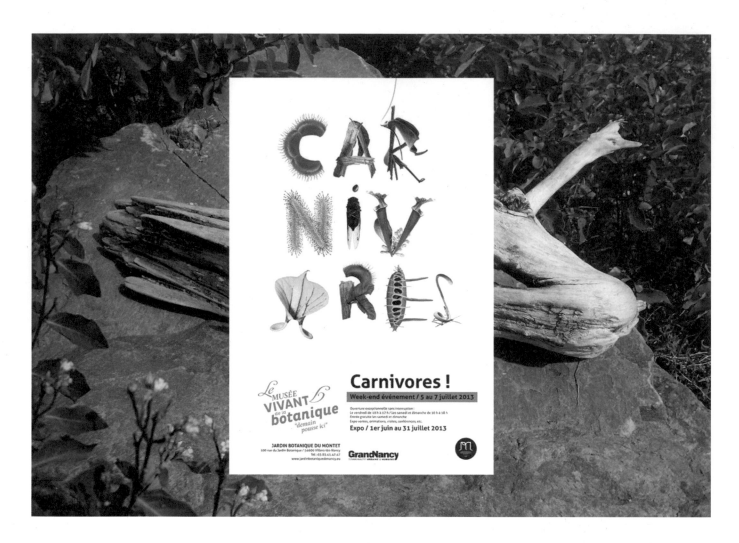

France

Design Agency
Shebam

Client
Conservatoire et Jardins Botaniques de Nancy

The Living Botany Museum is a place that features unique scientific culture and is renowned for its beautiful collections. Shebam studio created the visual identity as well as flyers, posters, and various graphics for the promotion of the Living Botany Museum.

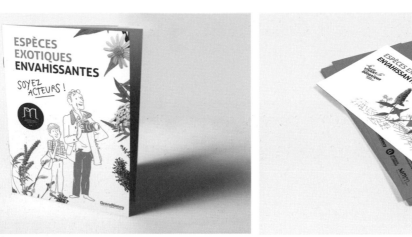

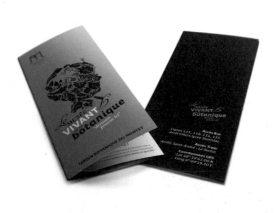

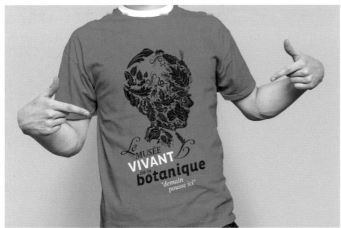

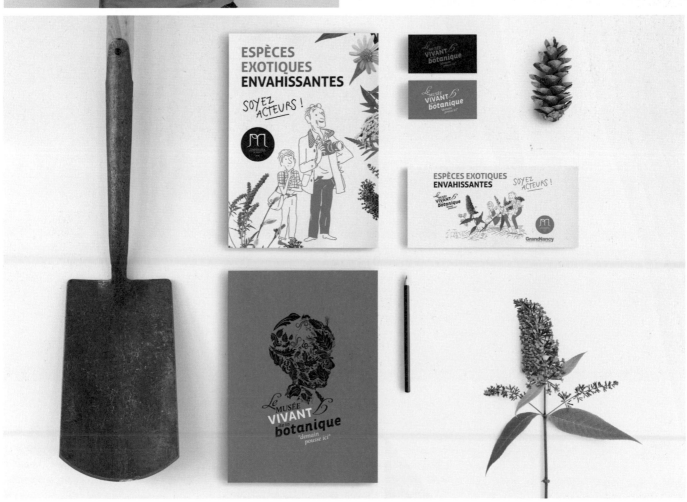

Olive Oil

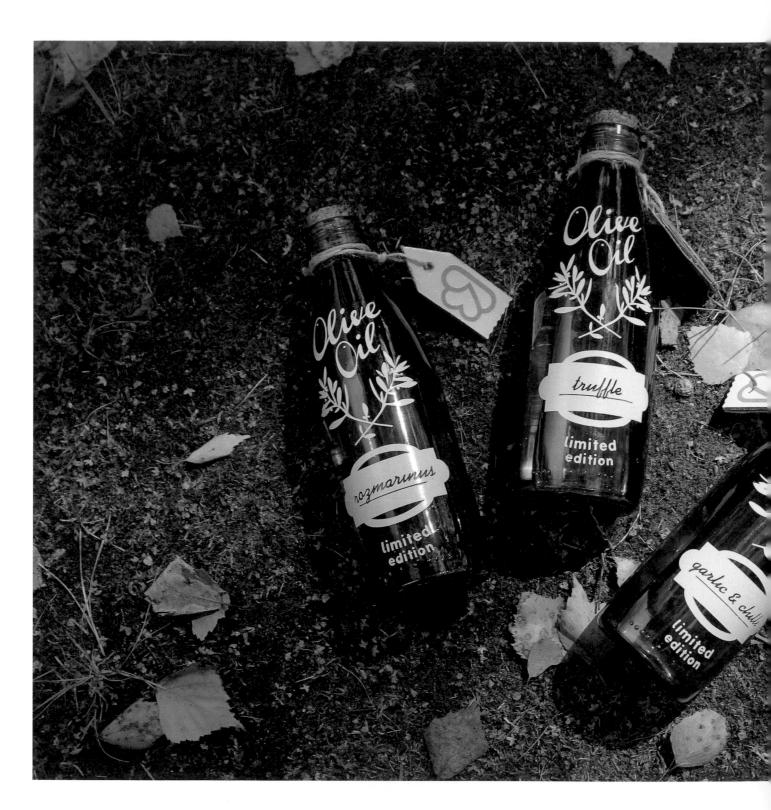

Poland

Designer
Gaba Jordan

Client
Mat Cloud

This project's design was inspired by countryside holidays, summer herbs from the garden and Mediterranean cuisine. The designer fused little, rounded, green bottles and discrete corks with a color graphic. This application was created using a hand-made stencil and a color paint. Each bottle is wrapped with a linen cord with paper tag. Extra virgin olive oil inside the bottles was made from the first cold-press of the olives, fused with a subtle note of garlic with a scent of Rosemary and chili, truffle and love, which gives it an extraordinary taste.

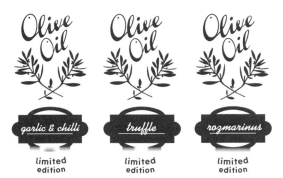

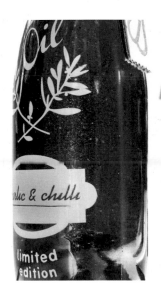

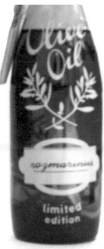

Let's Grow

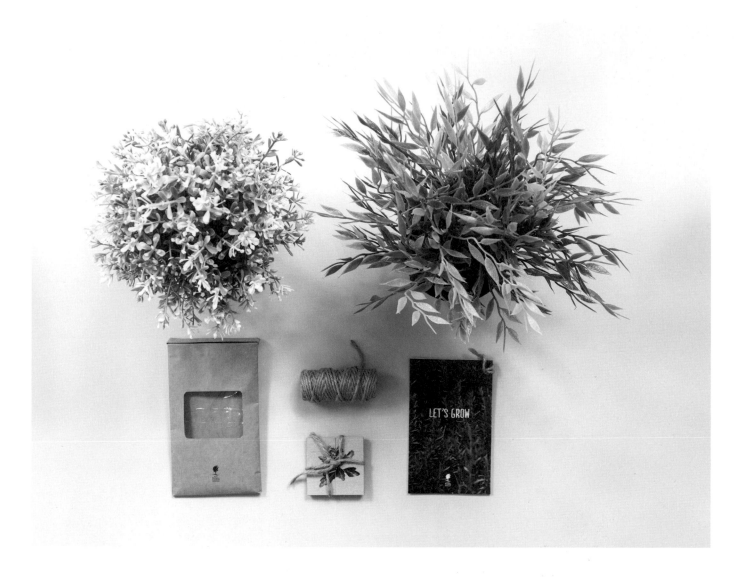

Australia

Designer
Dolp Lau

This project is a promotional catalogue for the Royal Botanic Gardens that provides the reader an introduction to native water-rise plants in Australia.

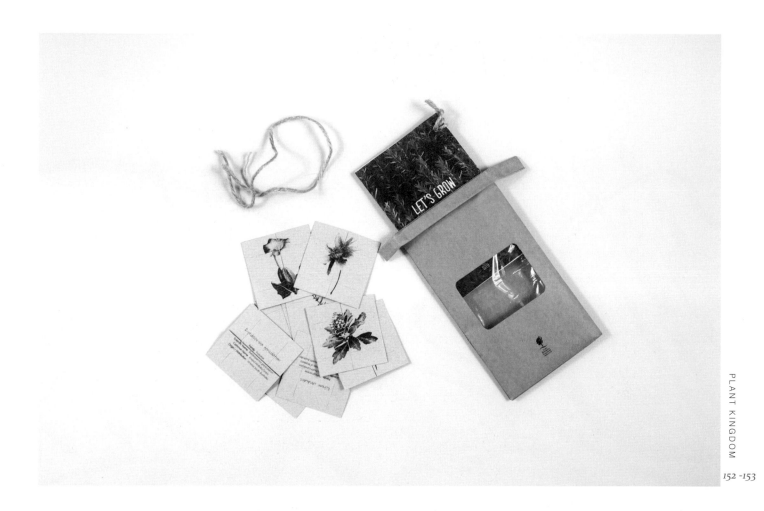

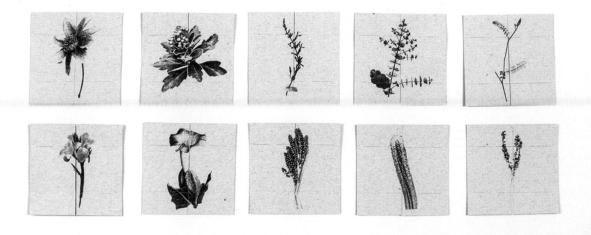

The Decemberists - twigs

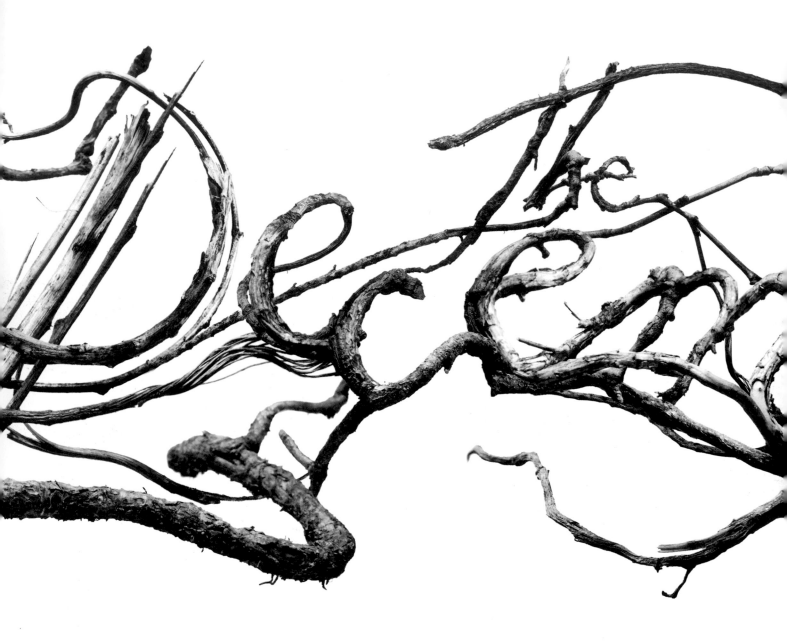

The De
with Justi

Apri
Calv
Grand

Artwor

UK

Design, Art Direction & Photography
Sean Freeman

Design Firm
THERE IS Studio

Client
Another Planet Entertainment

Special edition concert poster for the band The Decemberists made out of twigs.

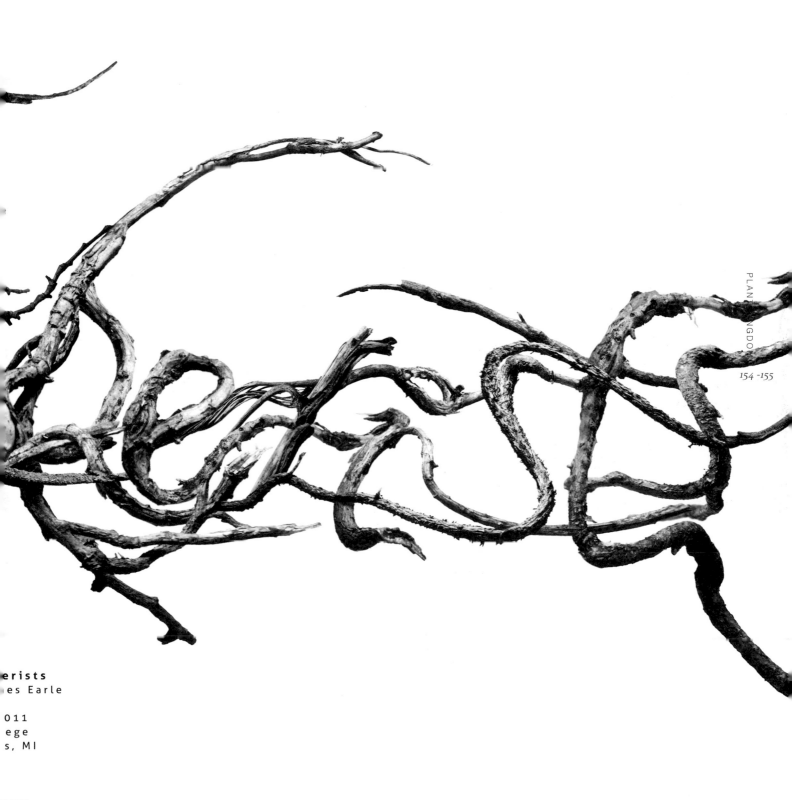

erists

es Earle

011

ege

s, MI

eeman

Shajarah

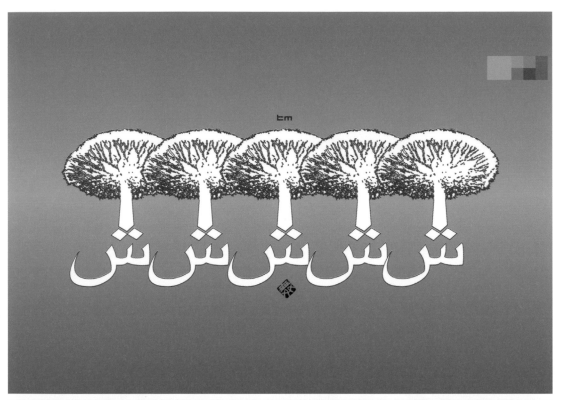

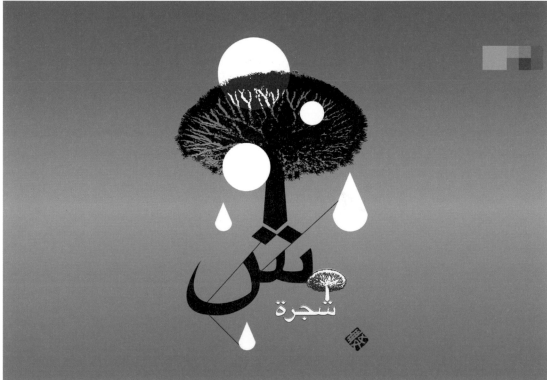

Japan

Designer
Maykol Medina (MaMe Creative Beans)

Shajarah (or Shajaratun) means "tree" in Arabic. The designer tried to express it through the tree image by graphics, combining it into a symbol to convey its meaning for people who do not know Arabic.

Ki Ki Ki

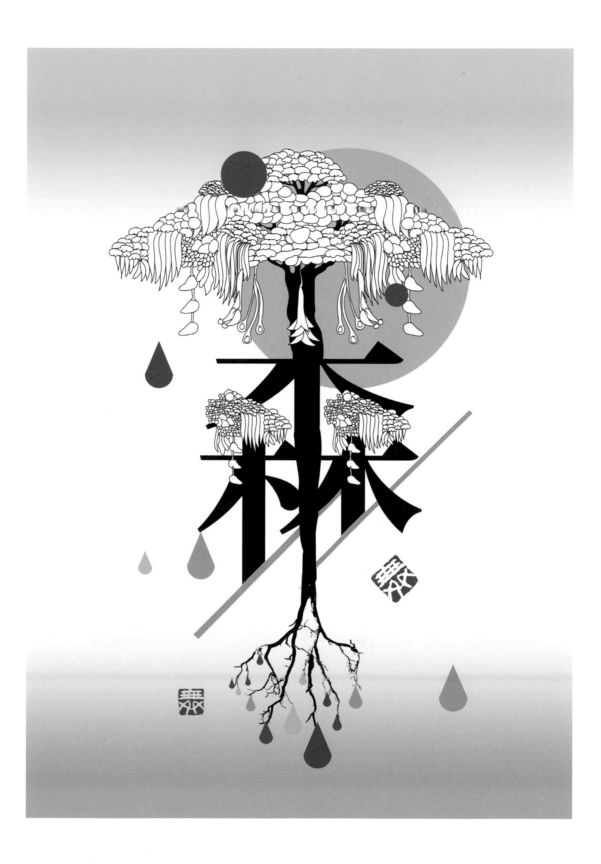

Japan

Designer
Maykol Medina (MaMe Creative Beans)

Inspired by the Chinese characters (木木木 = 森), the designer used trees
as the main graphic element of the design.

Akina Natural Health & Beauty

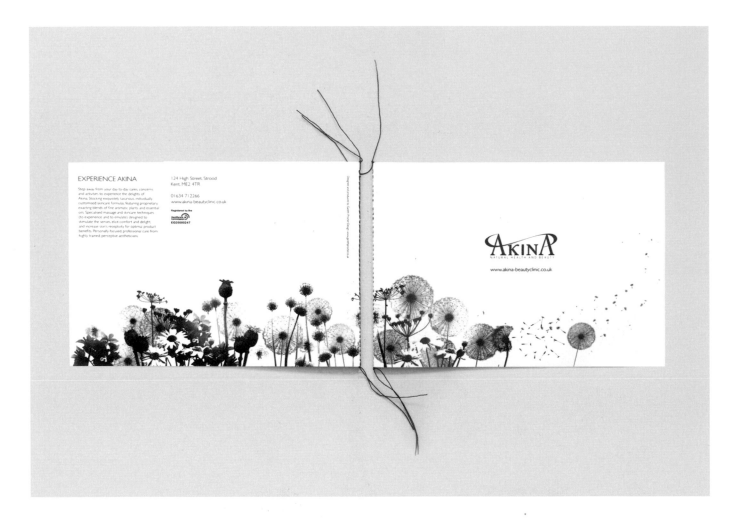

United Kingdom

Design Agency
Gareth Procter Studio

Client
Akina Natural Health & Beauty

Akina is a small independent health and beauty boutique that specializes in products and treatments sourced from natural ingredients. The name is a Japanese word which means "spring flower". With this in mind the designers used nature's ingredients to decorate each element of the brand.

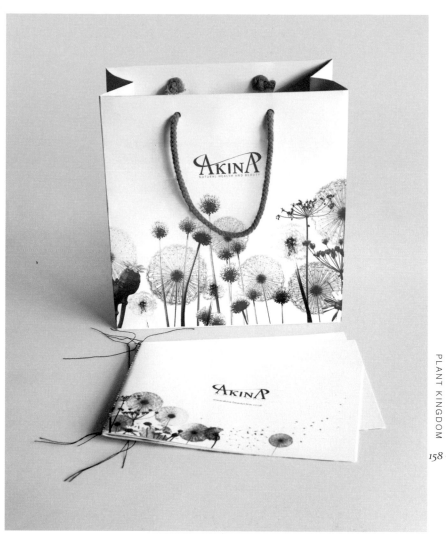

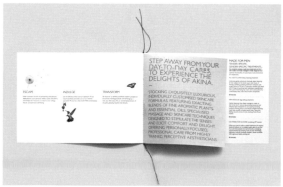

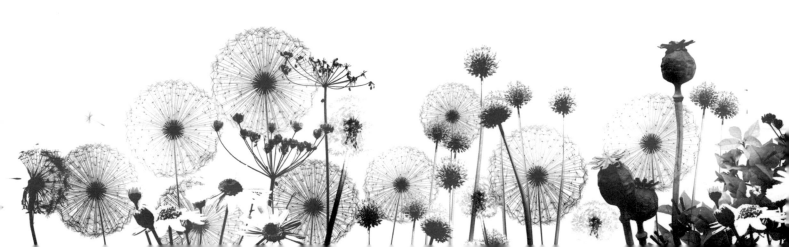

La Marchesa

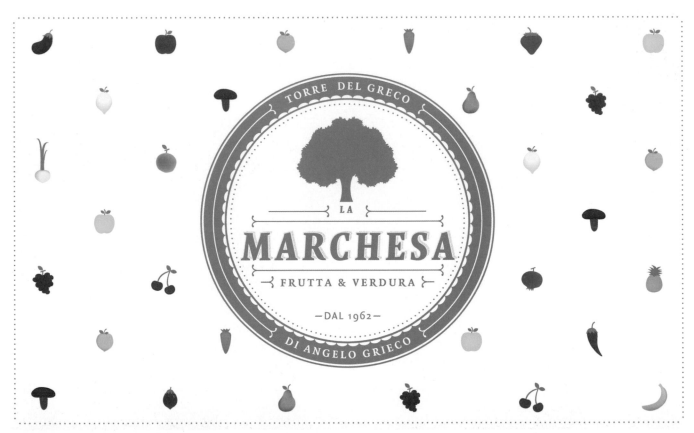

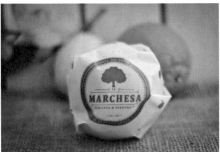

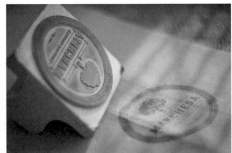

Italy

Designer
Giuseppina Grieco

Client
La Marchesa Fruiter

La Marchesa is a fruit and vegetable shop that's been in operation since 1962. It is located in the quaint, noisy and colorful market district of Torre del Greco, a city which reaches from the sea to Mount Vesuvius. A unique combination of elegance, nature and high-quality fruits is what really represents La Marchesa's values. In order to create an identity that represents this combination, the designer developed a brand that is both elegant and rustic, using a logo which features a strong tree and elegant typography. The brand language is articulated through a fruit-based concept, easily accessible layout architecture and a two-color theme for printed materials.

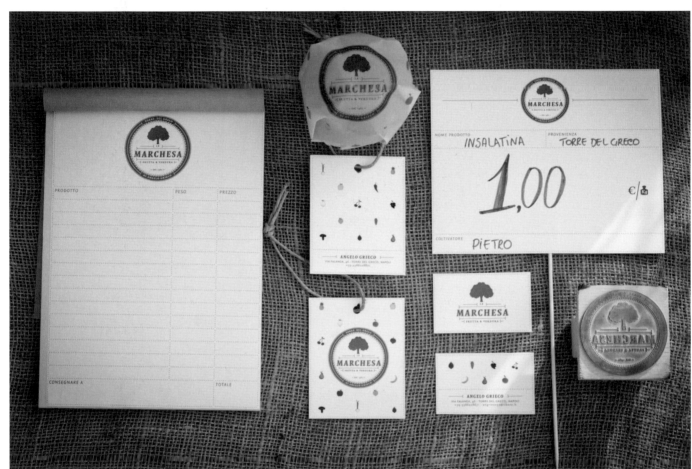

Mind Garden

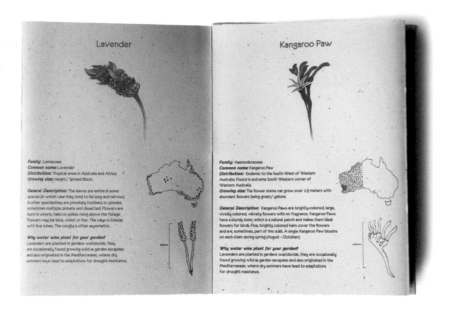

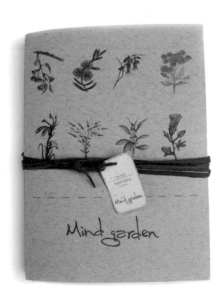

Australia

Designer
Harim Song

Client
Royal Botanic Garden

The design is inspired by the 9 main native water plants in Australia: Eucalyptus caesia, Hakea clavata, native hibiscus, Chrysocephalum apiculatum, kangaroo paw, lavender, common boobialla and Correa glabra. These plants are all indigenous to the drier parts of Australia and have evolved to be able to survive and prosper with very little water and in sometimes extreme conditions. These plants and its flowers are very inspiring and beautiful with brilliant colors and masses of scented blooms.

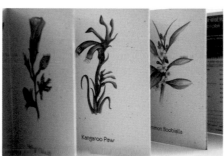
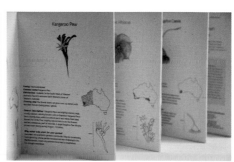

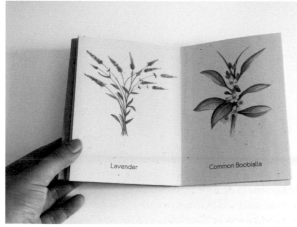
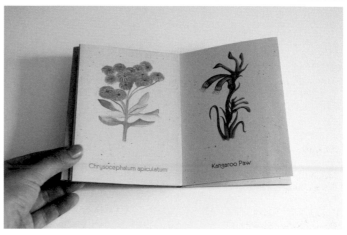

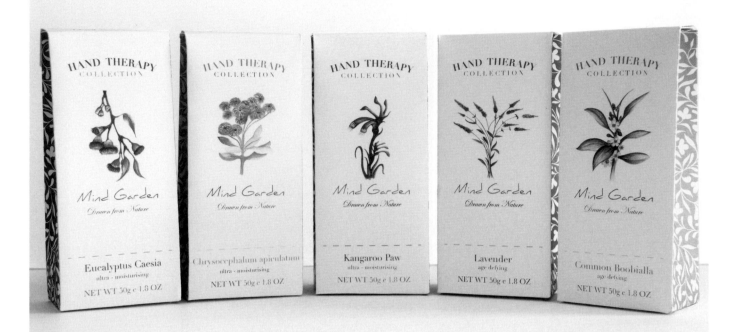

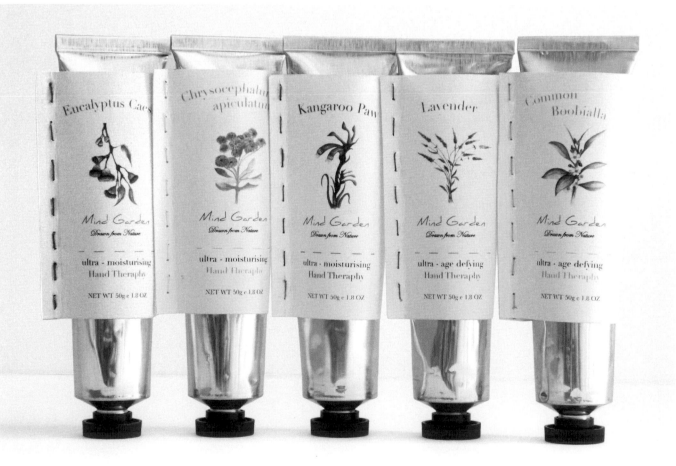

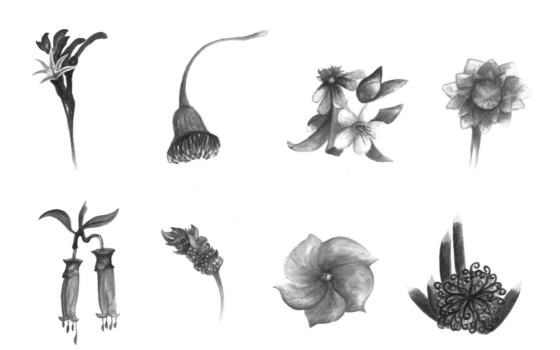

Mind Garden

Parklife

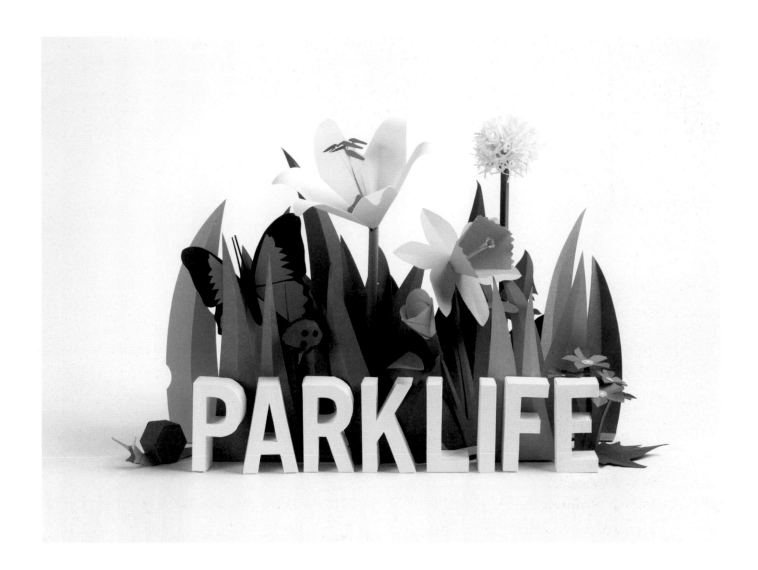

Australia

Design Agency
Omse Studio

Designer
James Kape, Briton Smith

Client
Fuzzy

The brief was to create a brand for a music festival that tours Australia. It needed to reflect the contemporary music at the festival and highlight the beautiful parkland venues. To do this designers commissioned paper engineer Benja Harvey to create a number of miniature park objects, including flowers, leaves, insects etc. These objects were then arranged and photographed as the core visual identity across all print, online, television advertising and event collateral.

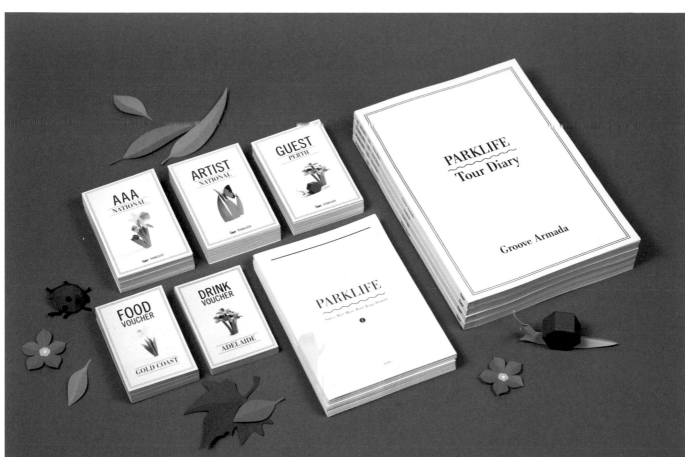

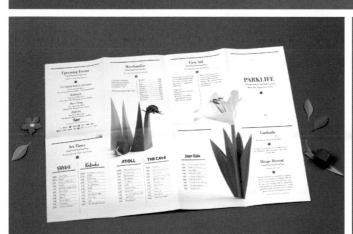

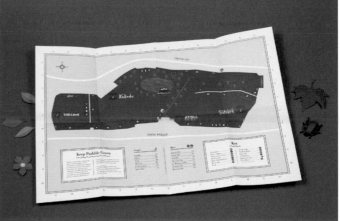

20th Anniversary

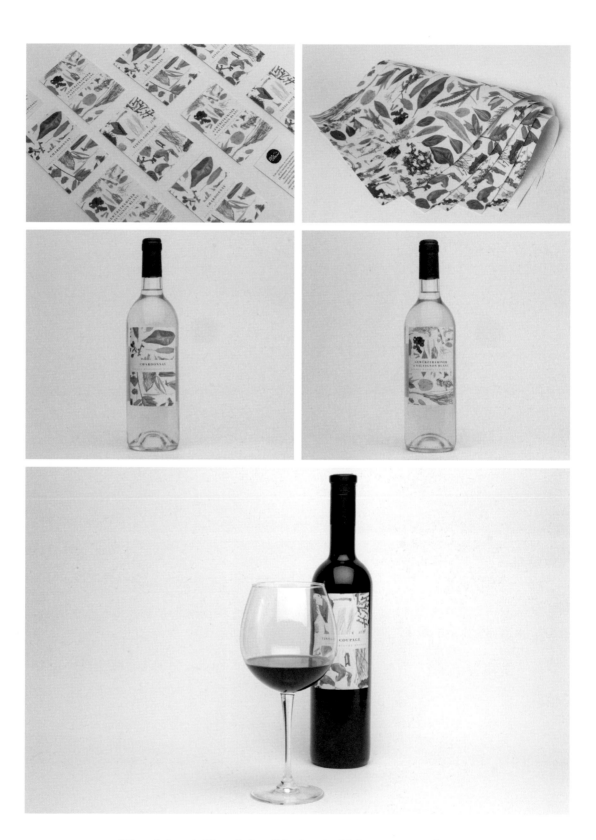

Spain

Design Studio
Less

Designer
Ache Rodríguez

Client
Bodega Rodríguez – Menayo

This project created the redesign of identity, wine labels, wrap paper and posters to commemorate the 20th anniversary of the family wine cellar: Rodríguez-Menayo. The design is made up of local plants, stones and sand around their vineyard from Extremadura in the southwest of Spain, close to Portugal's frontier.

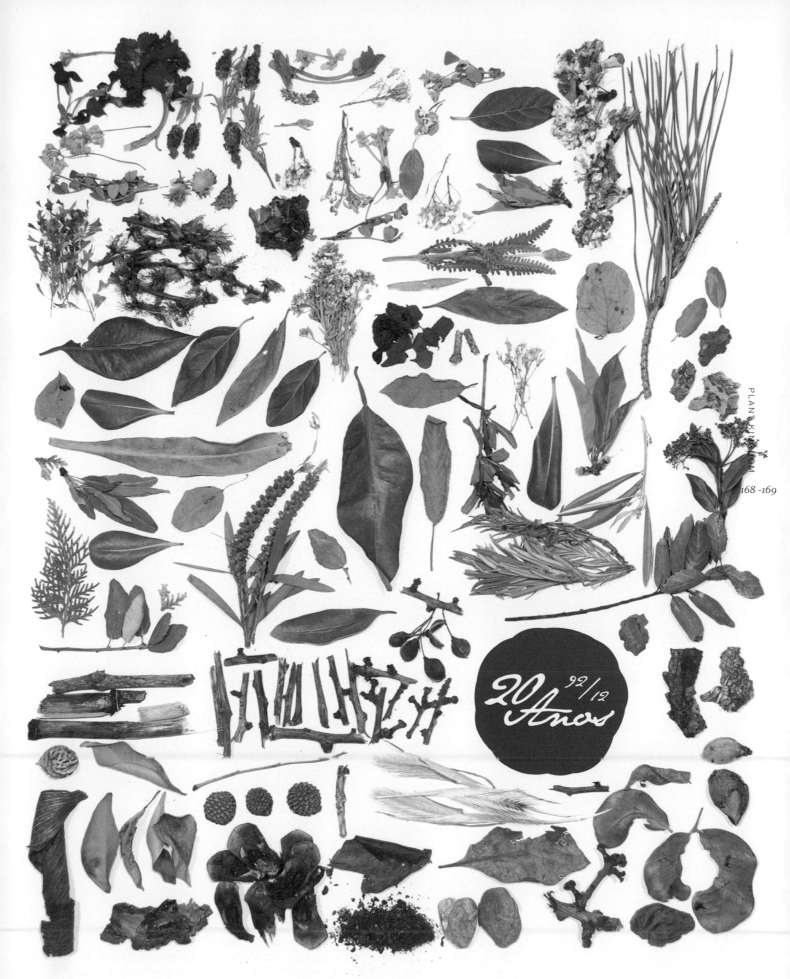

20 Años 92/12

BODEGA · RODRÍGUEZ MENAYO

Botanique

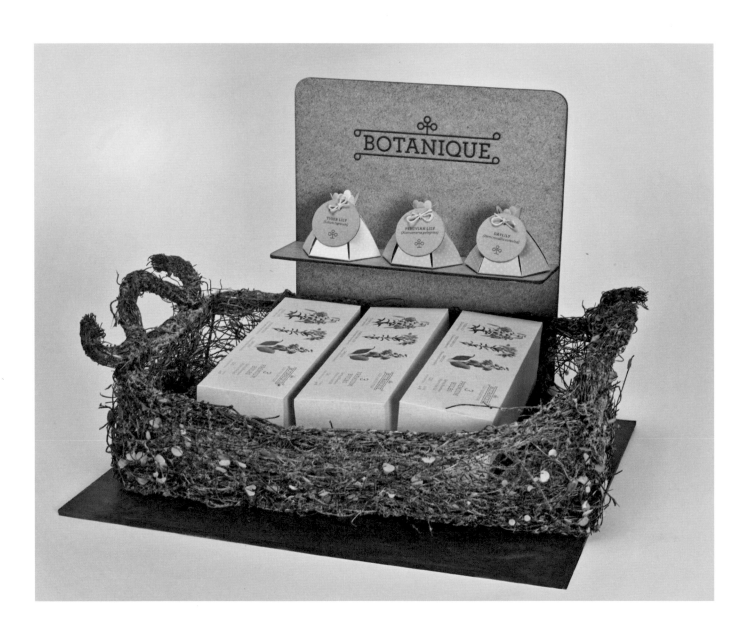

United States

Designer
Lucas Galo

This special anniversary edition packaging contains a collection of lilies with each bulb individually wrapped in a bulb-like box that resembles a blossoming flower when opened.

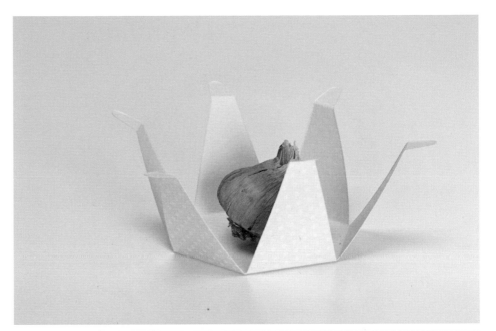

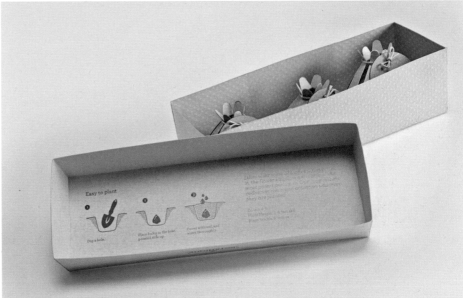

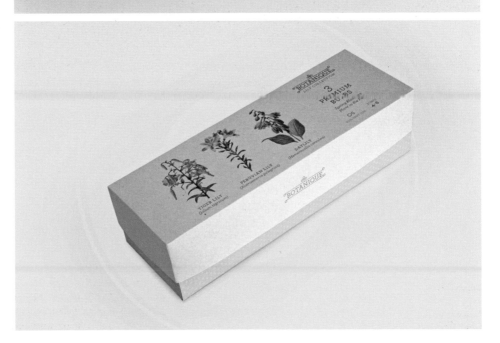

Fresh Label

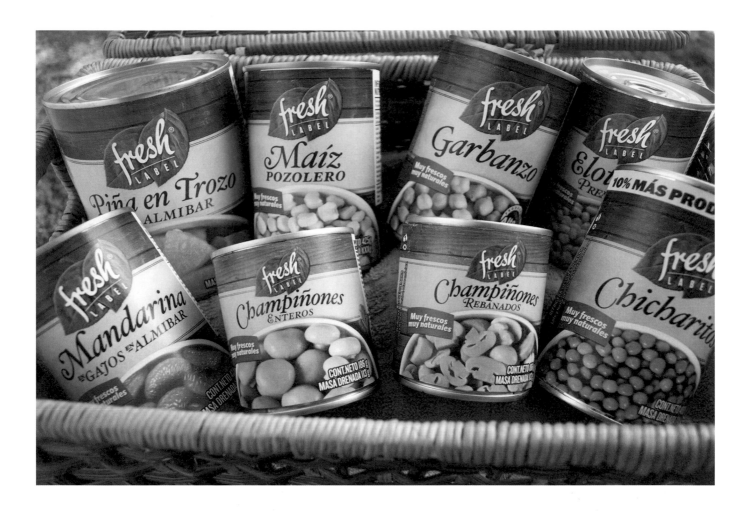

Mexico

Designer
Melanie Barajas

This project illustrates the concept of "Bringing to your table the freshness of fruits and vegetables." The designer used green tones and the combination of wood in contrast with a bowl full of fresh produce. In addition the can has two sides to allow the client to complete the bowl in the store.

Runa

United States

Design Agency
Mucca Design

Creative Director
Matteo Bologna

Designer
**Courtney Heffernan, Andrea Brown,
Erica Heitman-Ford**

Client
Runa

Runa is the first beverage company in North America to sell Guayusa, a tree-leaf that has been brewed for centuries as a source of mental strength and energy.
Mucca Design began by pointing out the strengths that set Runa apart: its organic ingredients, coffee-caliber caffeine level, and smooth taste. They then built a brand that would communicate the product's benefits more effectively. Inspired by its "focused energy", the Mucca team created a visual vocabulary that conveys a sense of energy in a clean, modern, and organic way.

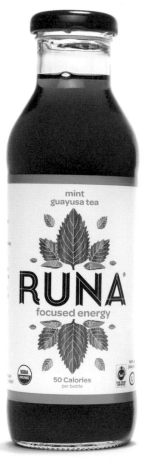
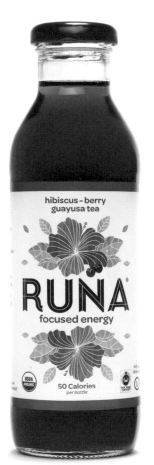
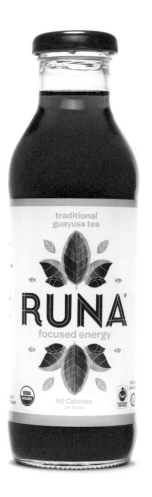
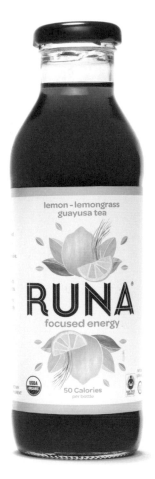

Designer
Danielle Shami

The designer created a new project combining botanical and floral collages.

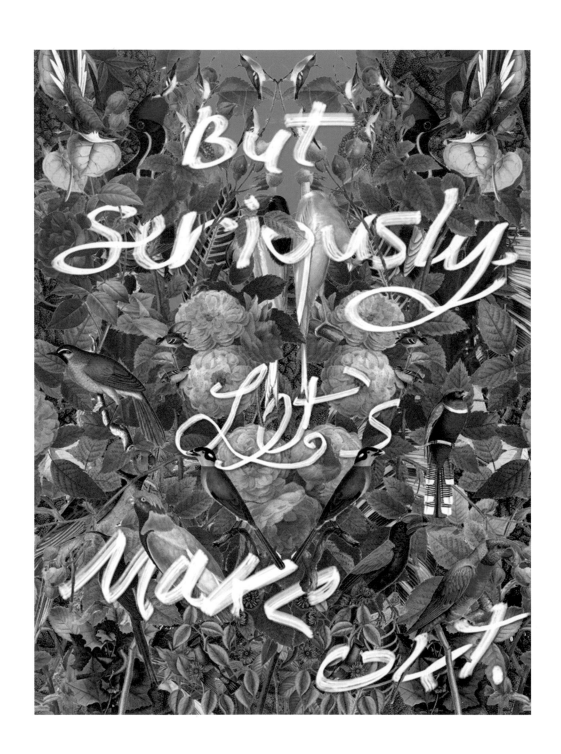

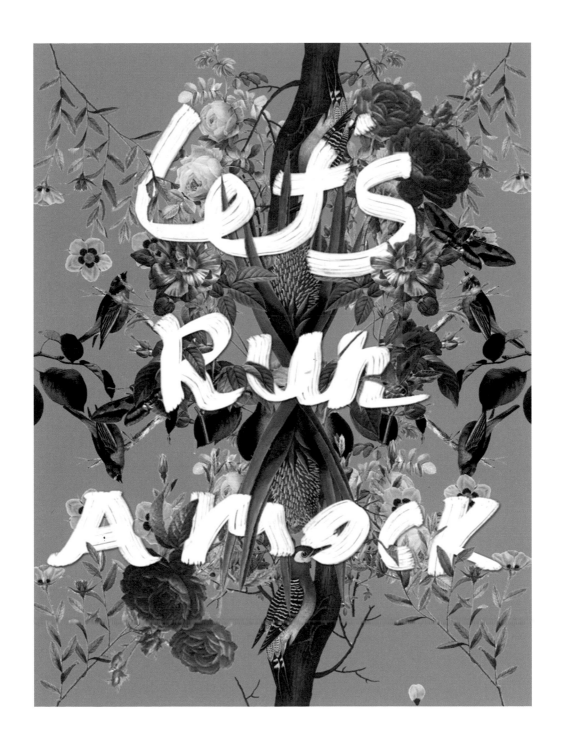

Poetic & Orientalism Design

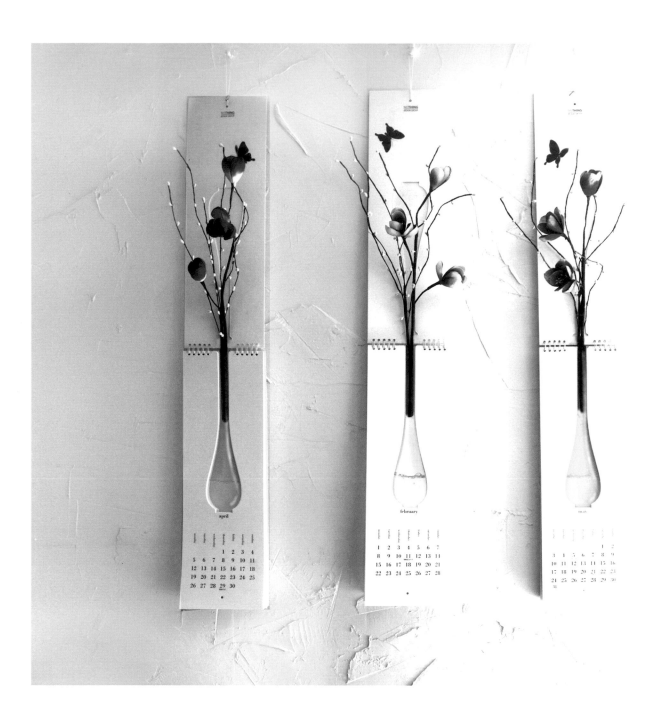

Korea

Design Agency
Nothing Design Group

Designer
Jin-woog Koo

This project is a calendar as well as a vase. Flowers are wonderful indicators of seasons and the designer knows that putting flowers on a calendar can liven up spaces drastically by using organic forms, colors and scent. Each monthly page reveals a die-cut vase in the centre, with a vinyl bag (in vase shape) embedded in the foam base layer. You can put water in it.

Think Global-Eat Local

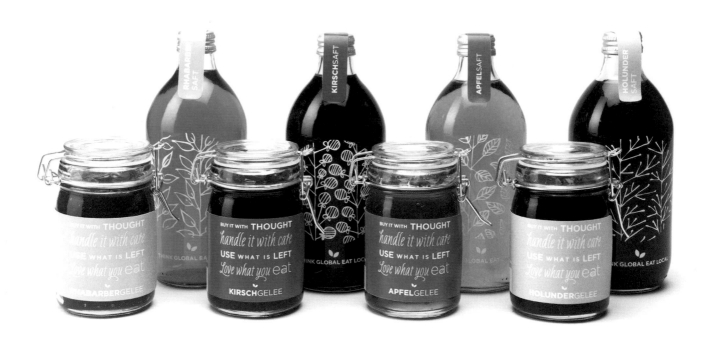

Germany

Designer
Katharina Kobsev

"Think Global-Eat Local" is a collection of food and beverages with the focus on environmental protection. The aim of the bachelor's thesis was to bring awareness to this issue of food culture and sustainability. The preferred purchase of local and seasonal food and beverages as well as proper handling can significantly contribute to the protection of the world's resources. Because sustainability is not just about buying organic or fair trade goods, but about consumer behavior in general.

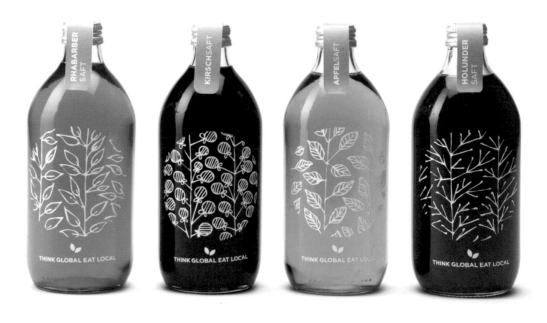

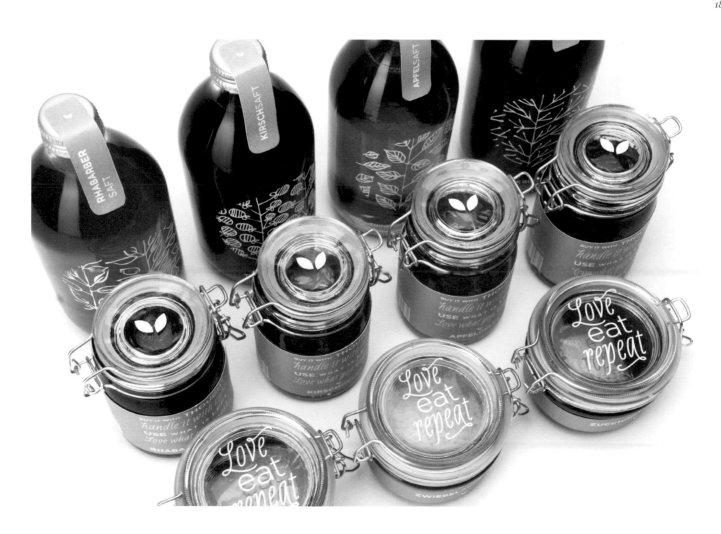

Don Manuel 93

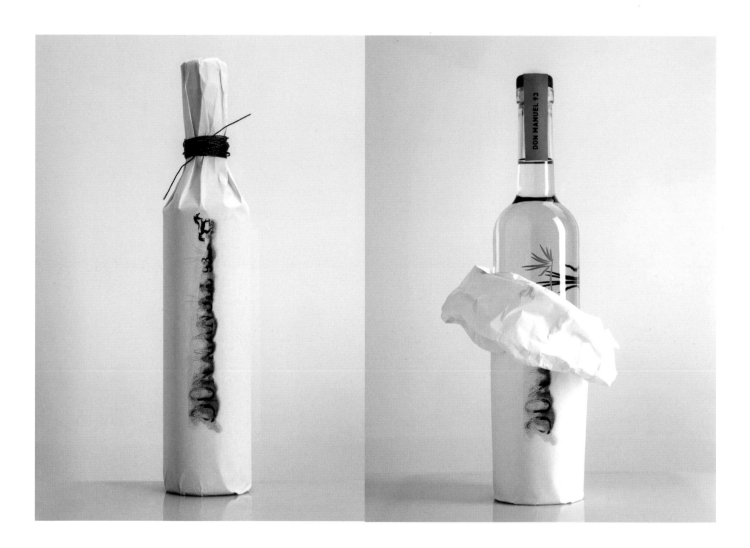

Mexico

Design Agency
Objesion

Designer
Ana Victoria Molina

Client
Don Manuel 93

Don Manuel 93 is the name of this blue, distilled agave (a drink which is similar to tequila) which is cultivated in the Rancho de Don Manuel, located in Taxcala, Mexico. The bottle has an outer wrapper with the image of a horse galloping and featuring the name of the brand behind it. If you remove the paper and place the bottle horizontally up to your eyes you will see a field of agaves. At the other side you can see the name of the brand and the origin of this alcoholic beverage. The images on the bottle are placed over the paper and glass using serigraphy techniques.

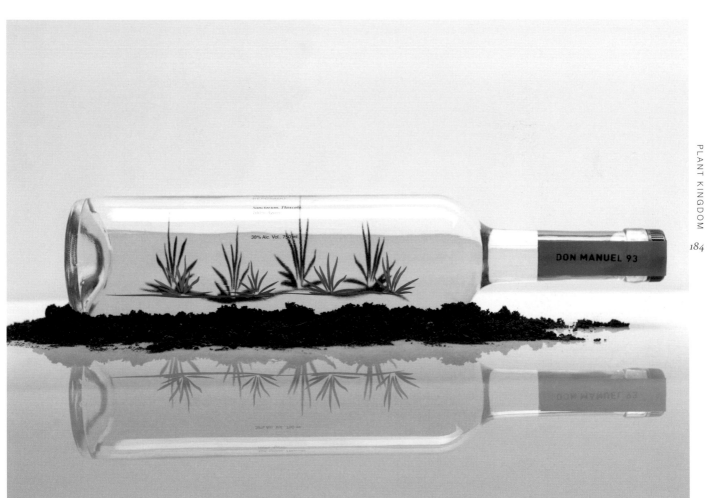

Durscher Syrup Label

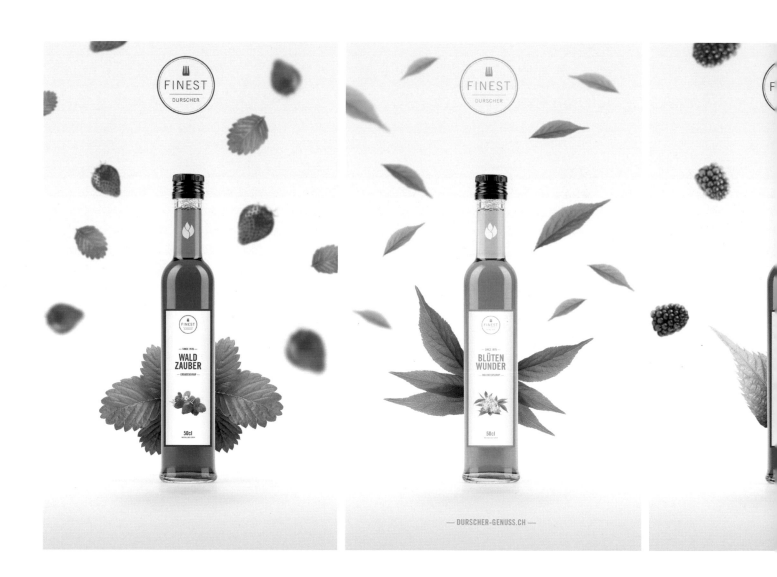

Switzerland

Designer
Simon Spring

Client
Durscher Syrup

The label is designed for Durscher Syrup which is a natural, high-quality syrup that can be used to add a special touch to culinary creations.

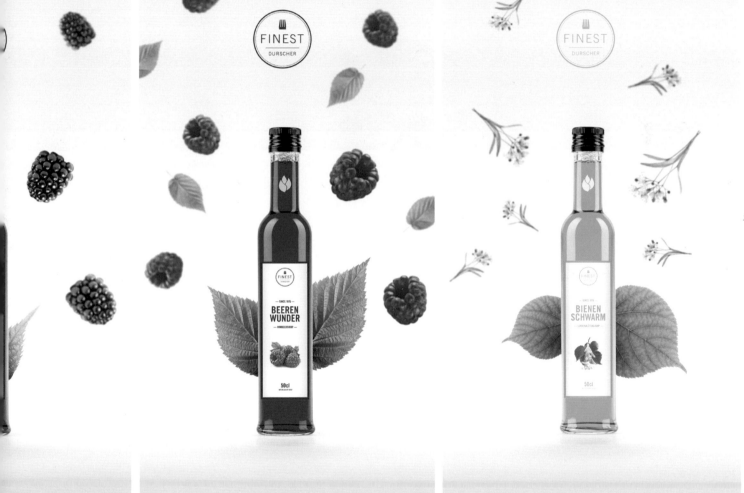

Pretty Petals

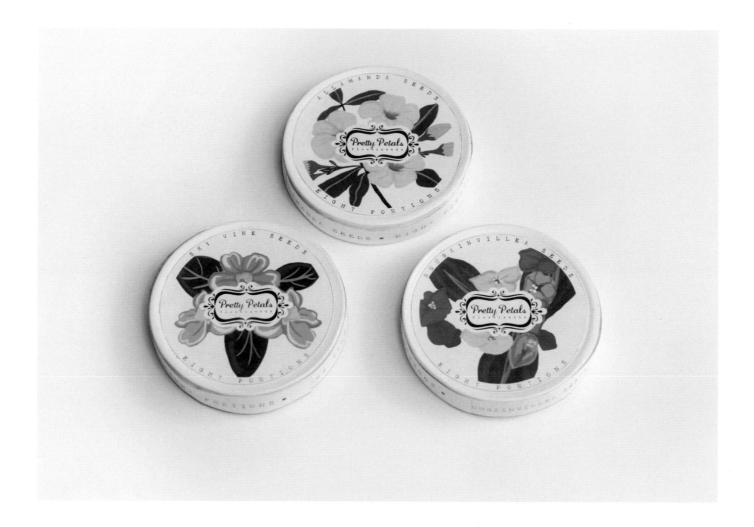

Malaysia

Designer
Ting Sue Lyn

This is a brand that sells all kinds of flower seeds. It is designed in such a way where the seeds are packaged into little triangle sachets with different flowers on them, for convenience and easy accessibility.

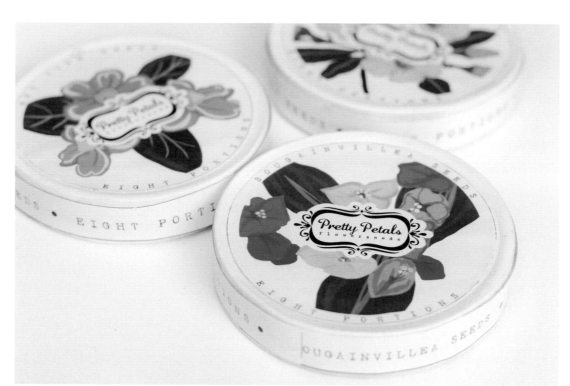

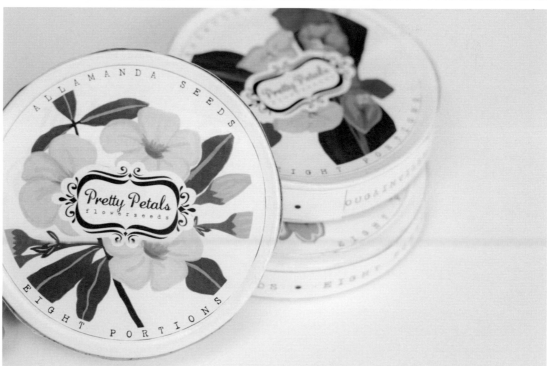

The Garden Lighting Company

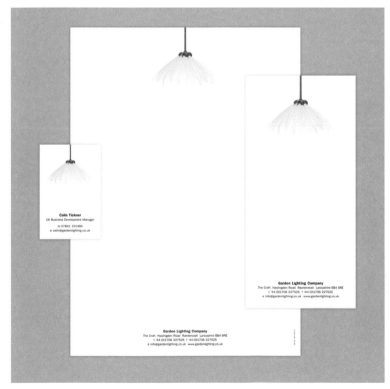

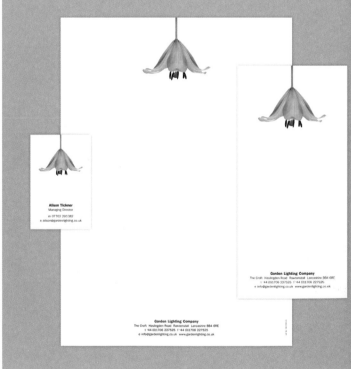

UK

Design Agency
The Chase

Client
The Garden Lighting Company

The Garden Lighting Company designs and installs contemporary lighting solutions that allow people to appreciate and enjoy their gardens in the evenings as much as they do during the day. The logo uses flowers instead of lampshades to link the company inextricably with its core products.

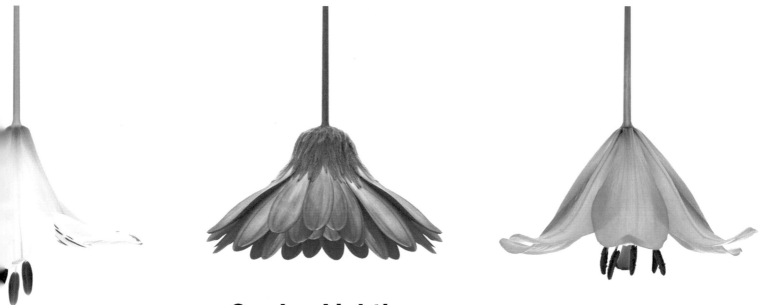

Garden Lighting
Company

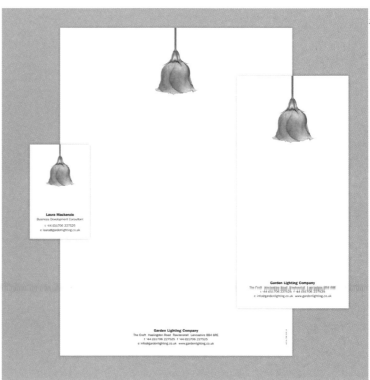

Risya & Nana Wedding Invitation

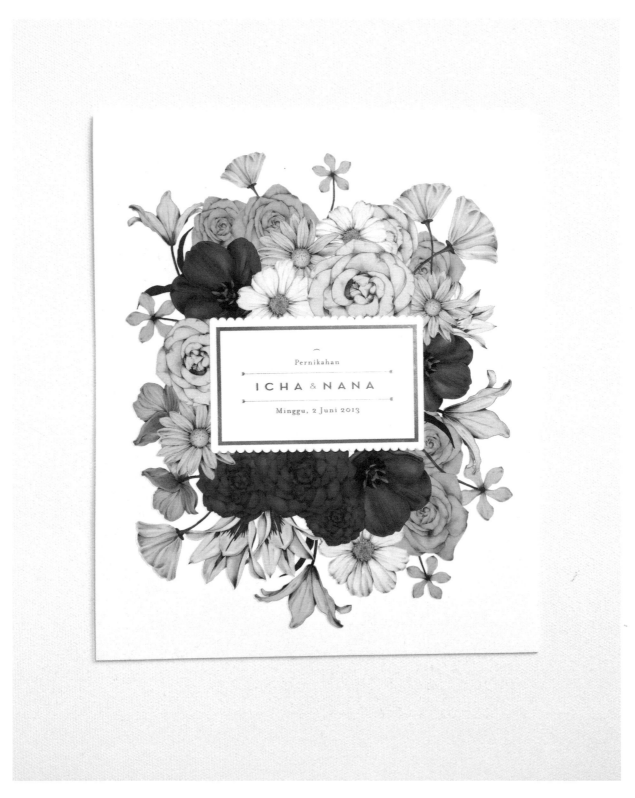

Pernikahan

ICHA & NANA

Minggu, 2 Juni 2013

Indonesia

Designer
Cempaka Surakusumah

Client
Risya & Nana

The designer visualized various flowers for this project because she pictured the feelings of a couple about to get married as something similar to a flower blooming. Giving out this invitation becomes something like handing out a bouquet of flowers to the recipient.

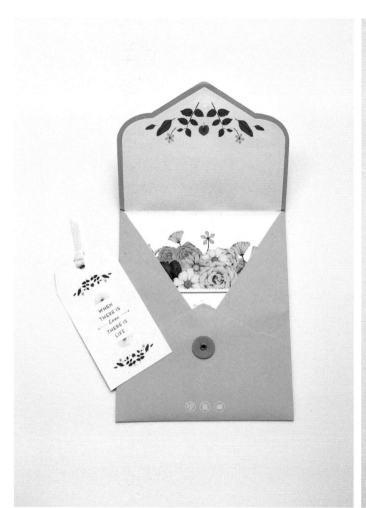

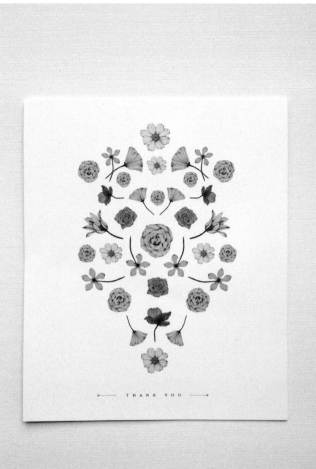

Baker & More

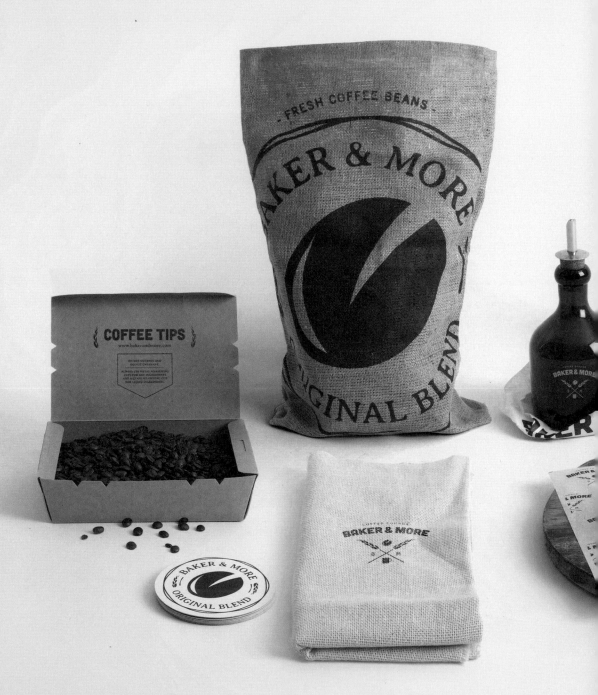

Lebanon

Design Agency
WonderEight

Creative Director
Walid Nasrala, Karim AbouRizk

Art Director
Karim AbouRizk

Client
Baker & More

The main challenge of this project was to make Baker & More stand out in a competitive field of commercial coffee shops and to attract a different, higher class of customer. Designers focused on the materials used (like burlap bags and wooden containers) to help convey the place's genuineness. For the graphic visuals, they focused on the coffee bean and wheat to communicate the ingredients mostly used in the restaurant's menu.

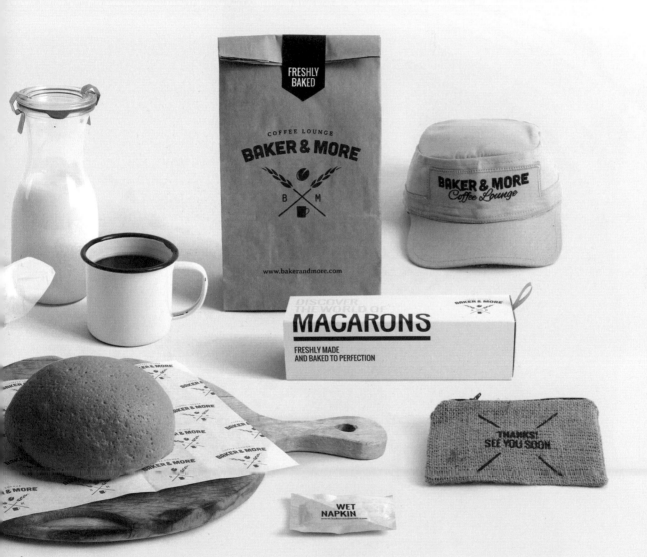

Knuthenlund

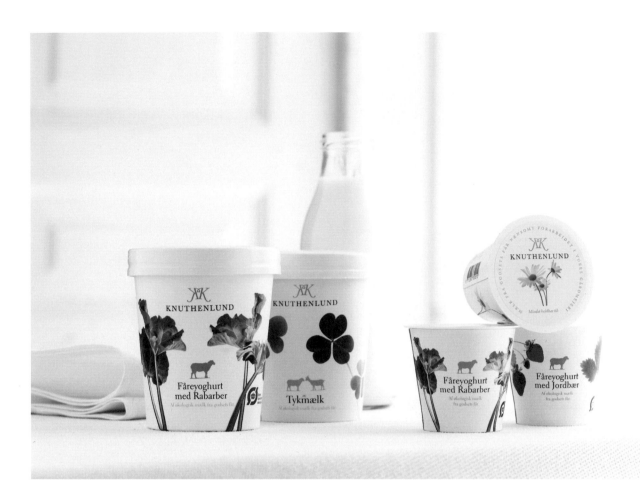

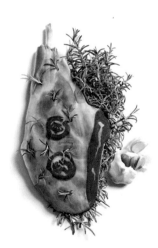

Denmark

Design Agency
Wunsch

Designer
Thomas Kjaer

Client
Knuthenlund

Knuthenlund estate in Lolland is one of the biggest organic farms in Denmark. The estate, which has established its own dairy and cheese production facilities, produces a range of high-quality, dairy products. Every single part of the corporate identity created for Knuthenlund reflects respect for nature, animals and the environment. The extensive use of organic plants, fruits and meat is a tribute to the generosity of nature. At the same time it reminds of a classic, Danish botanical book and dinner set from 19th century.

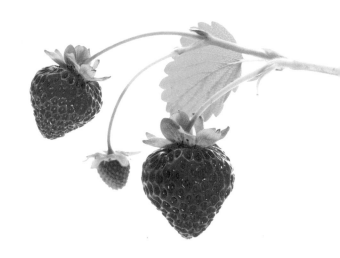

KNUTHENLUND

Liv og glade forårsdage.

KNUTHENLUND

Ekstra glæde op til jul.

KNUTHENLUND

Fra muld til madkunst.

KNUTHENLUND

En sortbroget julenyhed.

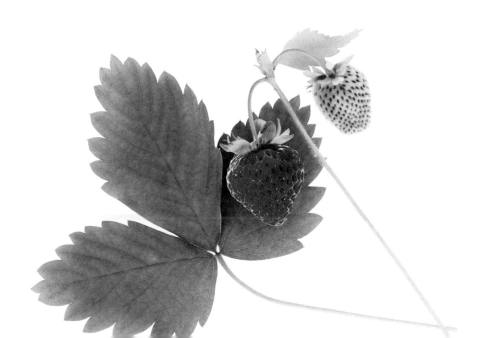

Queen Muar's Money Packet

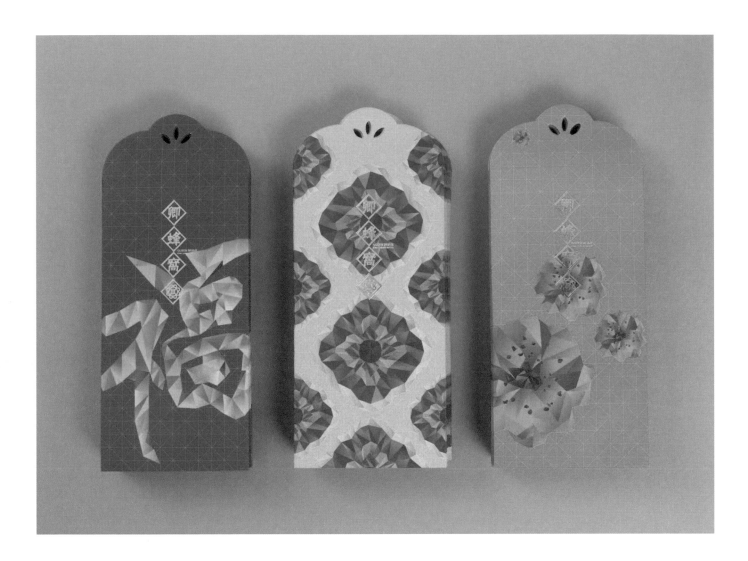

Malaysia

Design Agency
At Home Creative

Creative Director
Raymond Teo

Art Director
Ng Xue Ping

Client
Queen Muar

Queen Muar is a home-based festival cookies bakery in Johor, southern Malaysia. The challenge when fighting for clients for Chinese New Year is to deliver a series of gift-money envelopes that capture their clients' attention, with new style and color combinations that can not easily be found with traditional red envelopes.

Galeria Kaufhof Summer Campaign 2012

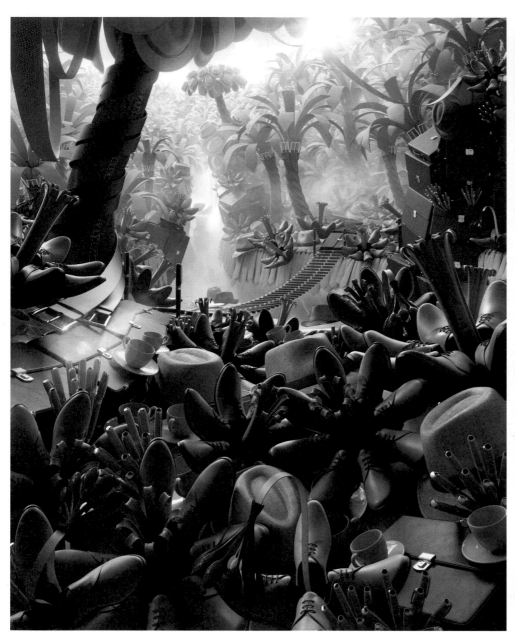

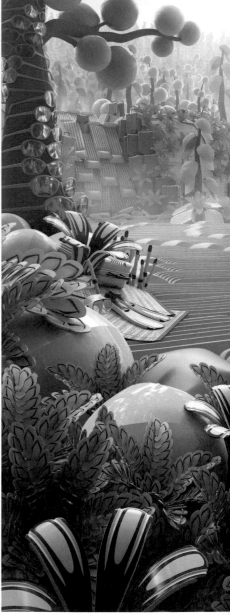

Germany

Design Agency
Viaframe

Client
Galeria Kaufhof

Galeria Kaufhof GmbH is one of the Europe's leading companies in running department stores. The designers created a total of three jungle themes for mannequins and products in the shop windows of all 109 stores across Germany.

The distinctive feature of these pictures, and what makes them so special, is that all the landscapes depicted consist of products that can be bought inside the shops. Even before a test assembling took place and preliminary combinations of products, mannequins and the images were put together, designers could already check the three-dimensional effects using graphics created within the 3D software.

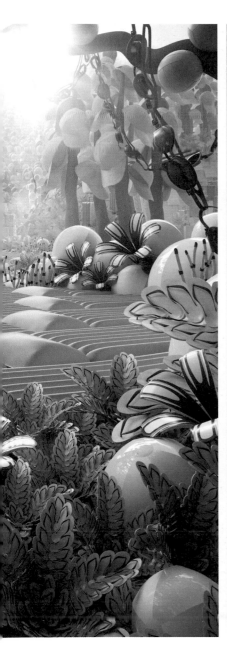
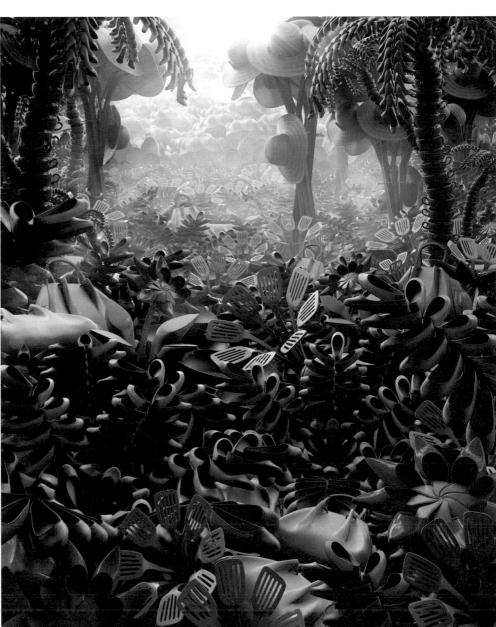

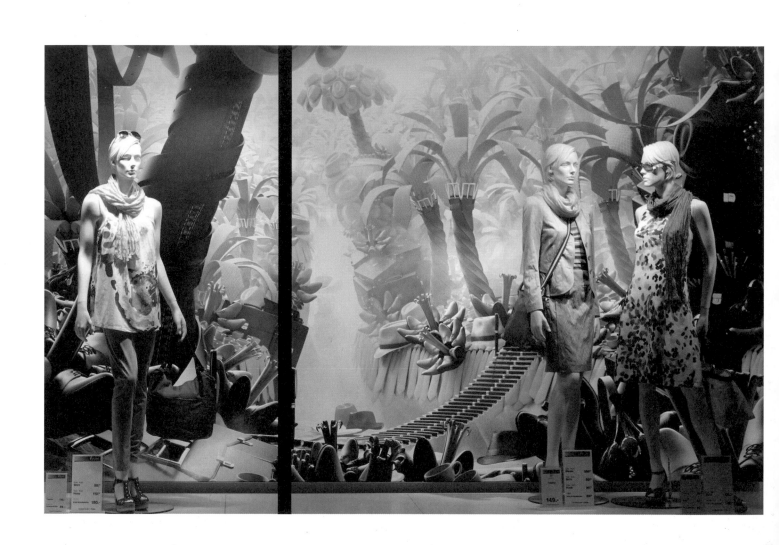

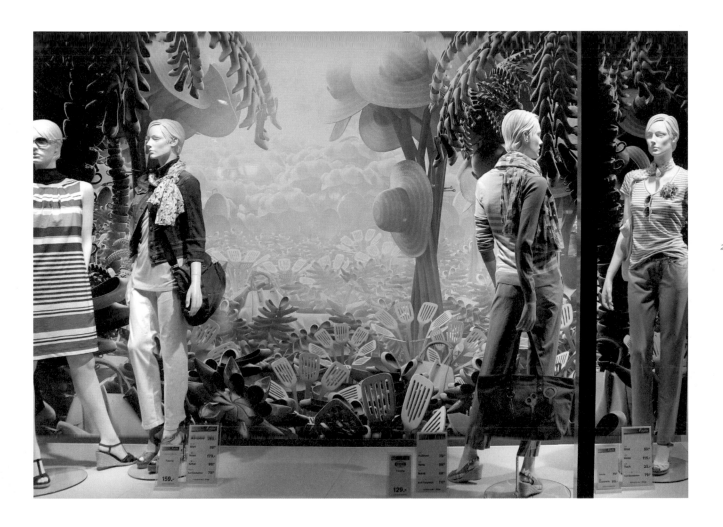

Pure & Authentic

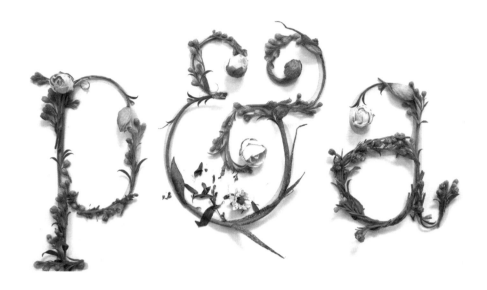

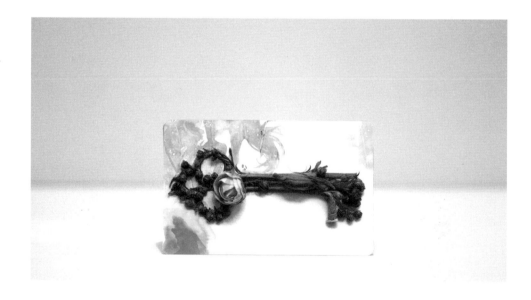

France

Design Agency
ATELIER BIDULE

Client
Pure & Authentic

The key on the card symbolizes the access to the rental place of Pure&Authentic, a bespoke toutist agency. Designers created this unique key with dried flowers and other natural elements to embody the dreamlike destinations recommended by the agency.

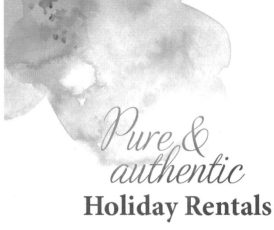

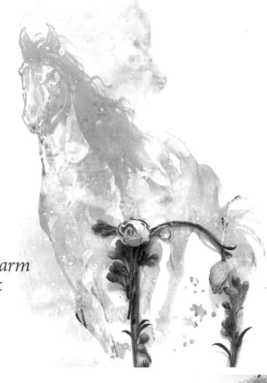

*Pure &
authentic*

Holiday Rentals

Inspiring Retreats, Italian Charm
www.pureandauthentic.co.uk

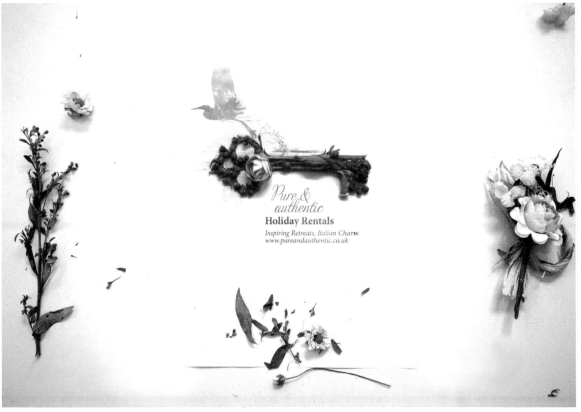

*Pure &
authentic*

Holiday Rentals

Inspiring Retreats, Italian Charm
www.pureandauthentic.co.uk

Anni Hall

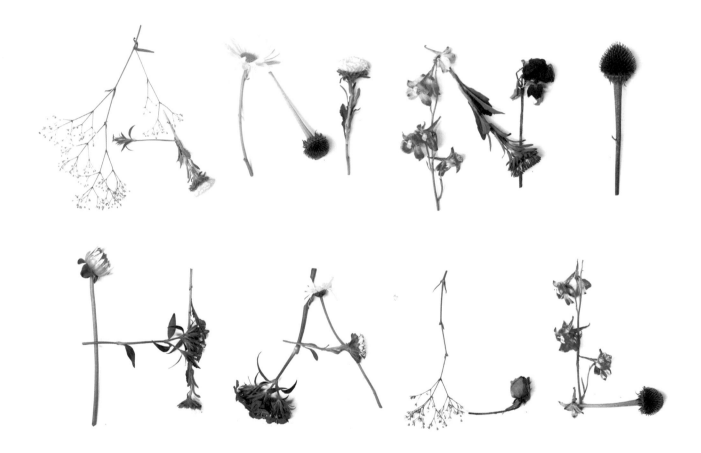

Australia

Designer
Daniel Dittmar

Anni Hall is an Australian writer/editor, now writing on fashion and beauty, film and art. Inspired by the three spots in Sydney that have had a profound impact on her practice (Centennial Park, Gordons Bay, and the Art Gallery of New South Wales), the cropped photography and emotional colours were created to take us to a particular location. Flowers from each place have been incorporated into the branding by adding their fragrance to the printed stationery.

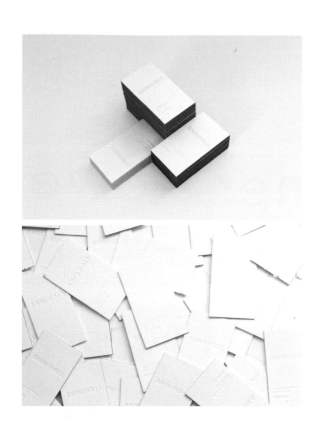

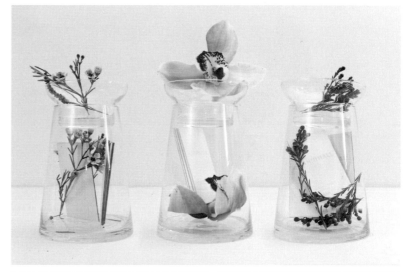

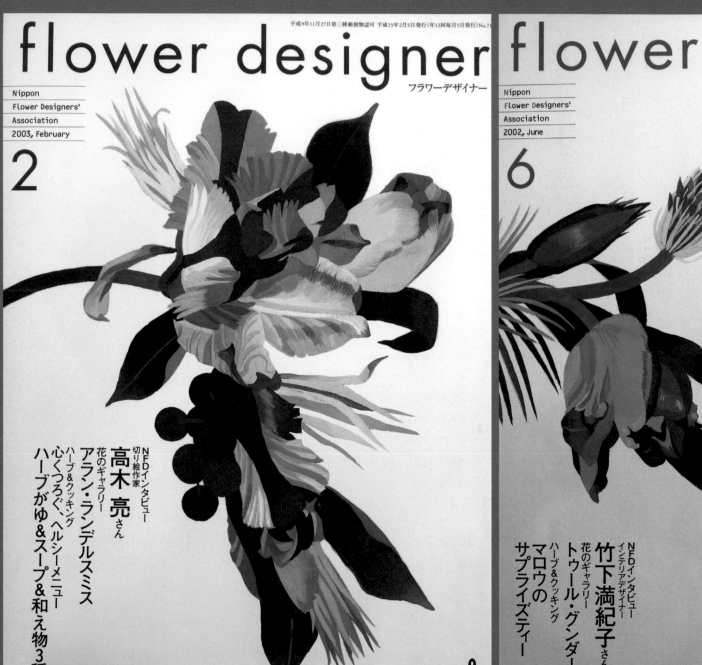

平成9年11月27日第三種郵便物認可 平成15年2月5日発行(年12回毎月5日発行)No.71

flower designer
フラワーデザイナー

Nippon
Flower Designers'
Association
2003, February

2

NFDインタビュー
切り絵作家
高木 亮さん
花のギャラリー
アラン・ランデルスミス
ハーブ&クッキング
心くつろぐ、ヘルシーメニュー
ハーブがゆ&スープ&和え物3種

flower

Nippon
Flower Designers'
Association
2002, June

6

NFDインタビュー
インテリアデザイナー
竹下満紀子さん
花のギャラリー
トゥール・グンダーセン
ハーブ&クッキング
マロウの
サプライズティー

NIPPON
FLOWER DESIGNERS
ASSOCIATION

Japan

Designer
Hiroyuki Izutsu

Client
Nippon Flower Designers' Association

This is a cover image for a member's monthly magazine of Nippon Flower Designers' Association. The designer created the illustration by mixing different flowers as their actual look.

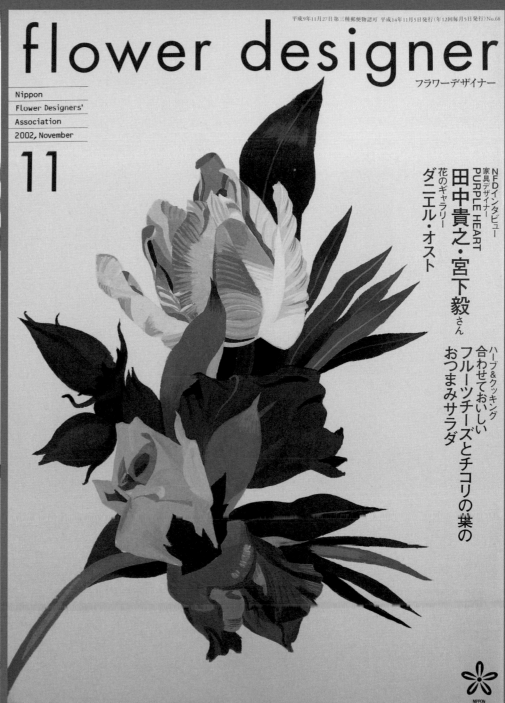

平成9年11月27日第三種郵便物認可 平成14年11月5日発行(年12回毎月5日発行)No.68

flower designer

フラワーデザイナー

Nippon
Flower Designers'
Association
2002, November

11

NFDインタビュー
家具デザイナー
PURPLE HEART
田中貴之・宮下毅さん

花のギャラリー
ダニエル・オスト

ハーブ&クッキング
合わせておいしい
フルーツチーズとチコリの葉の
おつまみサラダ

NIPPON
FLOWER DESIGNERS
ASSOCIATION

平成9年11月27日第三種郵便物認可 平成14年6月5日発行(年12回毎月5日発行)No.63

esigner

フラワーデザイナー

NIPPON
FLOWER DESIGNERS
ASSOCIATION

Sophia Concepto Floral

Mexico

Design Agency
Parallel

Designer
Rubén Alvarez

Client
Sophia Concepto Floral

Sophia Concepto Floral is an elegant flower boutique that combines elegance with concept decoration services. Parallel focused the work on the theme: "classy minimalism as an avant-garde integral service".

Monica

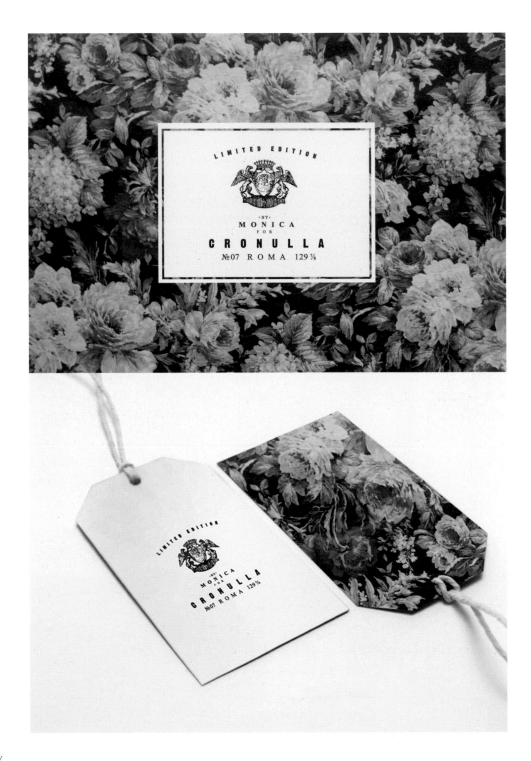

Italy

Design Agency
Ro&Ma

Designer
Roberta Farese

Client
Monica

This project was initiated to create the visual and corporate identity for a new, Italian fashion label called "Monica". The use of the flower illustration reflects the style of the brand.

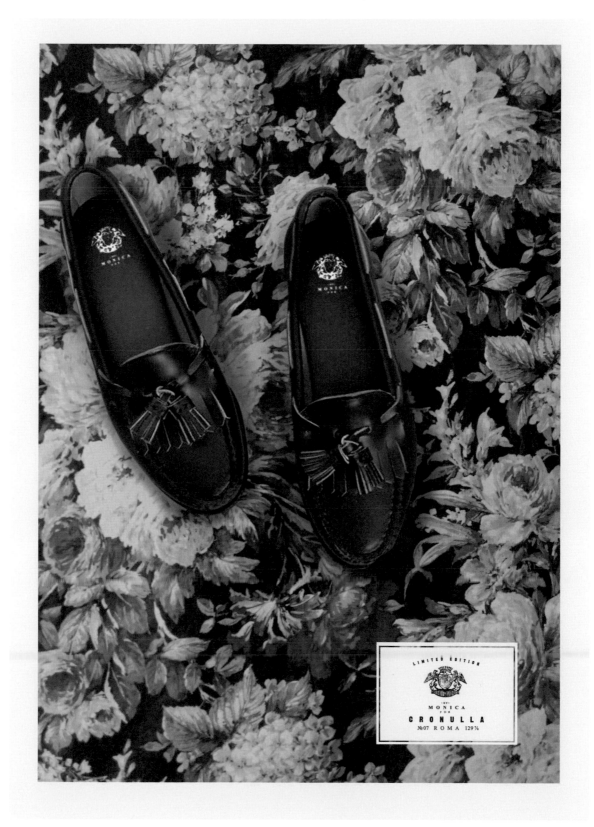

Animalism, Naturalism

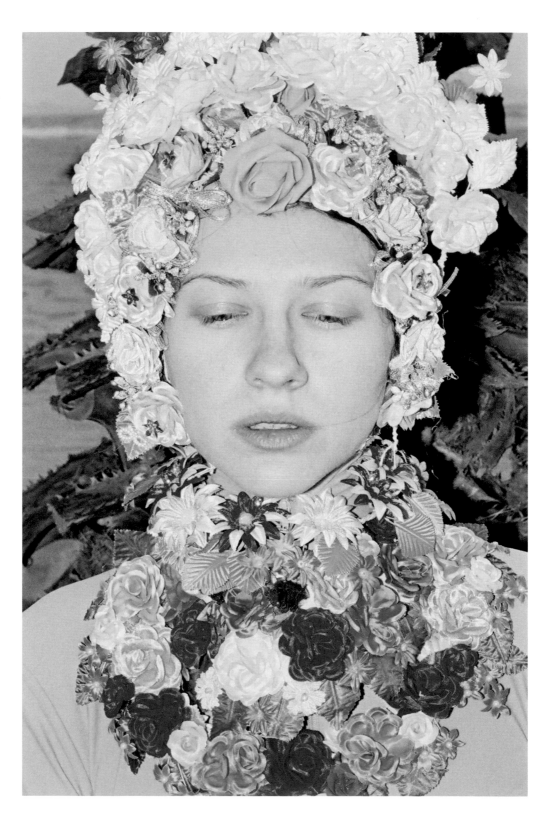

Ukraine

Client
Kenzo, Urban Ourfitters

Photographer
Synchrodogs

This project "Animalism, Naturalism" is an attempt to focus on basic instincts, reaching for the raw sense of self and intimate relation to the surrounding environment and nature.

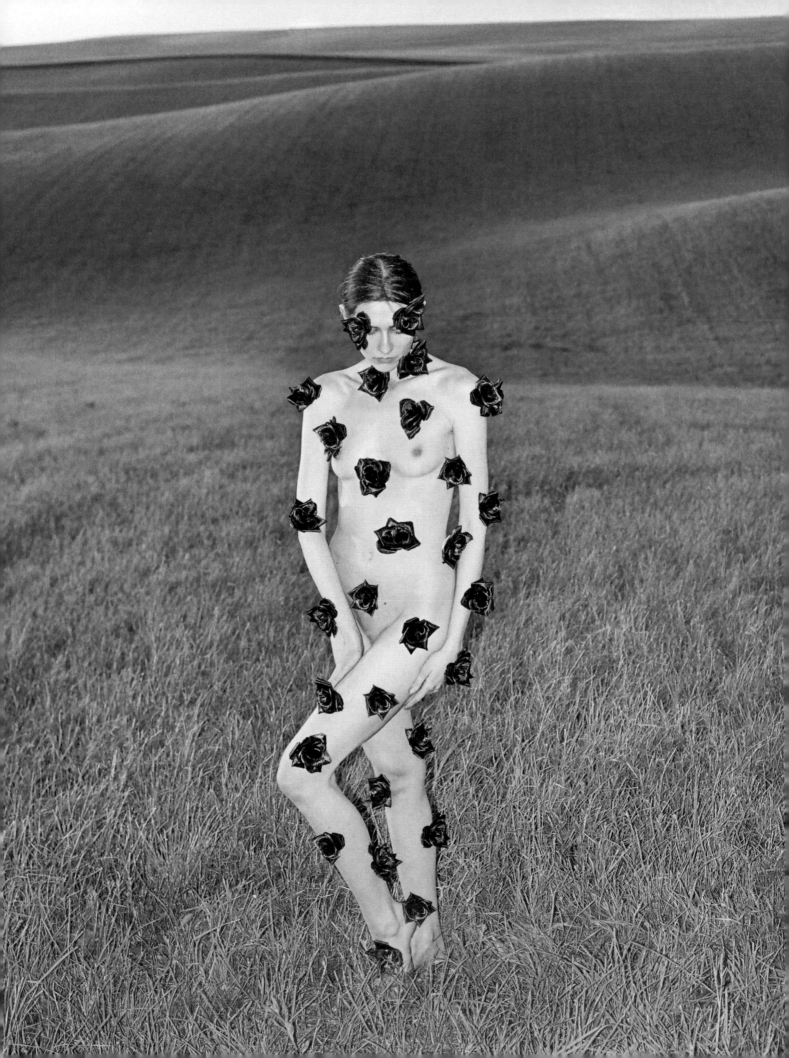

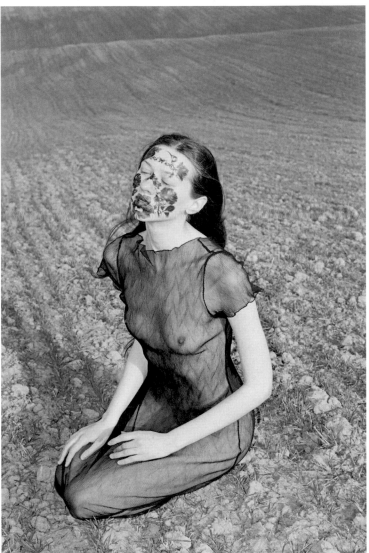

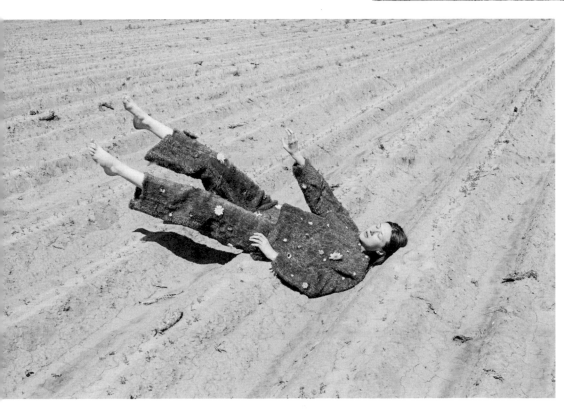

Life is Endless

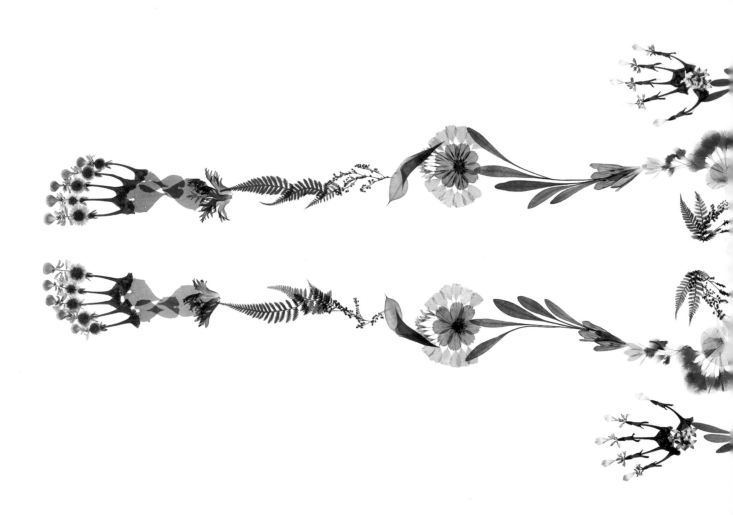

Japan

Design Agency
I&S BBDO

Creative Director
Mari Nishimura

Designer
Naomi Hou

Client
Nishinihon Funeral Service

Death does not only bring sorrow. The designers used plants and flower to present that death which can also bring out the a more positive feeling of watching over the deceased and seeing him off as he departs to take a journey.

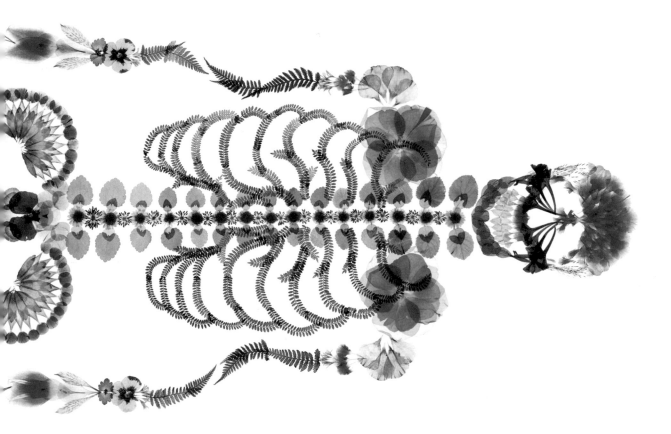

Leaf cutting art

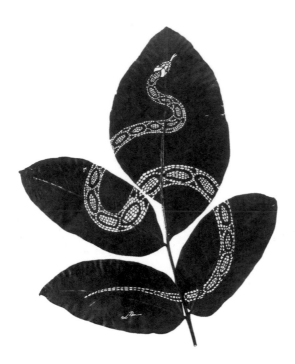

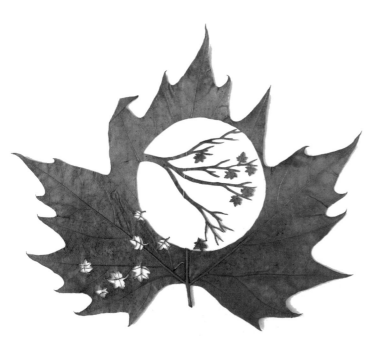

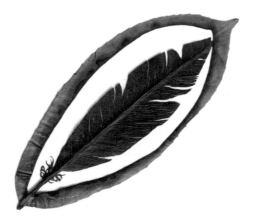

Spain

Designer
Lorenzo M. Durán

Inspired by a caterpillar, Lorenzo decided to cut plant leaves in the same way that other artists do with paper. It looked like a great opportunity to combine two of his true passions: art and nature. Lorenzo has developed his own technique, going through a long trial-and-error process until he found a good way of cutting out his designs without spoiling the leaf. Lorenzo used a surgical scalpel to cut the shape, removing the plant tissue until the image, previously drawn on paper and fixed to the leaf, appears.

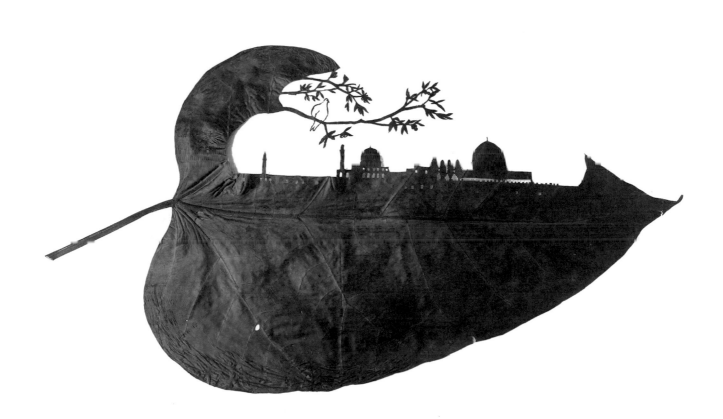

Amazing Space

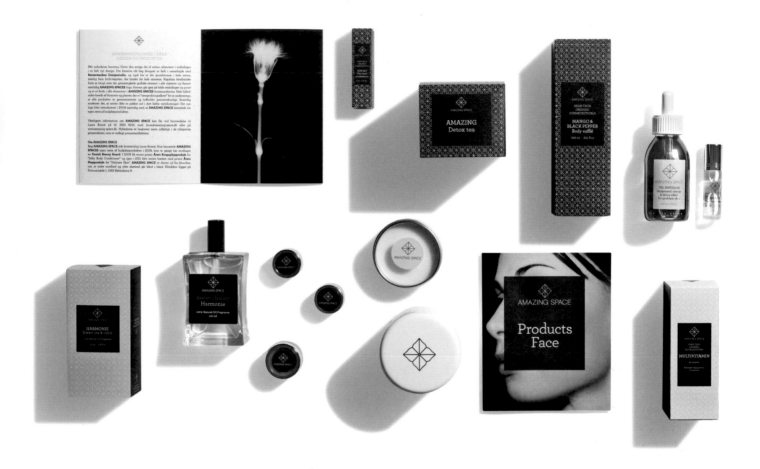

Denmark

Design Agency
Bessermachen Design Studio

Client
Amazing Space

This corporate identity was based on the perennial plant commonly known as lnca lnchi. It is native to the Amazon Rainforest, and its oil is present in all Amazing Space products and treatments. The square shape of the fruit capsule is used as a graphic element throughout the identity. The shape is used in both packaging snd bags. It is utilized on all elements of communication.

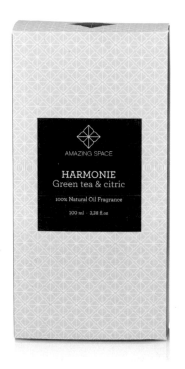

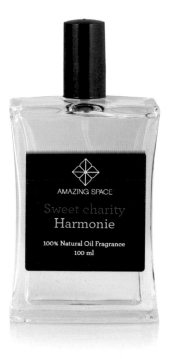

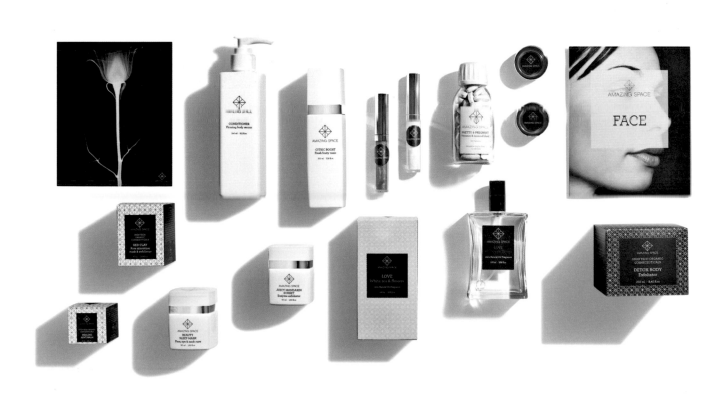

Food Gifting Packaging

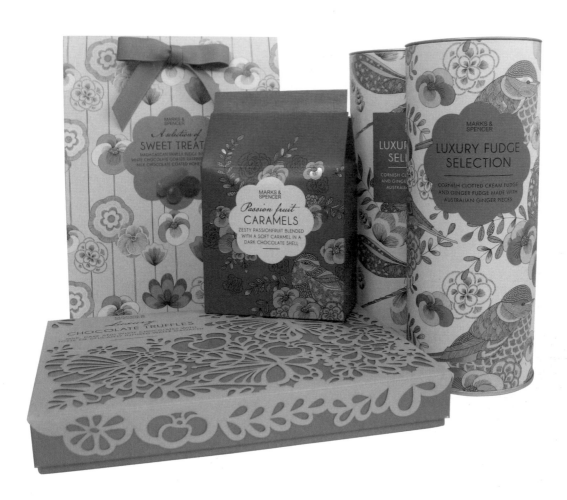

United Kingdom

Creative Director
Dianne Macnab

Art Director
Katy Relf

Designer
Millie Marotta

Client
Marks & Spencer

Since the collection was to be launched in the spring time the designer wanted to illustrate something that suggested this time of year. Therefore she decided to explore various plants within the artwork including, flowers, buds, leaves, new shoots, grasses and ferns.

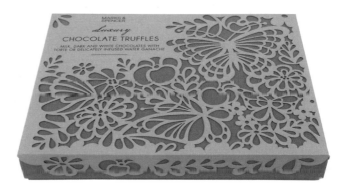

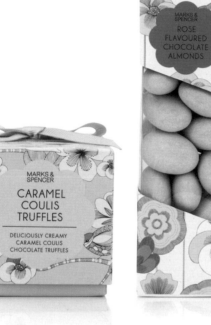

MARKS &
SPENCER

CARAMEL
COULIS
TRUFFLES

DELICIOUSLY CREAMY
CARAMEL COULIS
CHOCOLATE TRUFFLES

MARKS &
SPENCER

ROSE
FLAVOURED
CHOCOLATE
ALMONDS

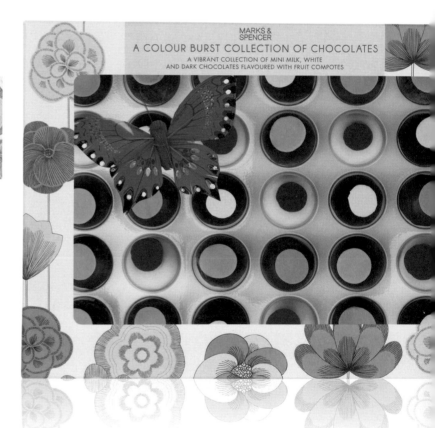

MARKS &
SPENCER

A COLOUR BURST COLLECTION OF CHOCOLATES

A VIBRANT COLLECTION OF MINI MILK, WHITE
AND DARK CHOCOLATES FLAVOURED WITH FRUIT COMPOTES

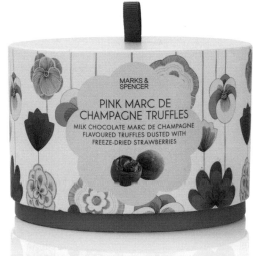

**MARKS &
SPENCER**

PINK MARC DE
CHAMPAGNE TRUFFLES

MILK CHOCOLATE MARC DE CHAMPAGNE
FLAVOURED TRUFFLES DUSTED WITH
FREEZE-DRIED STRAWBERRIES

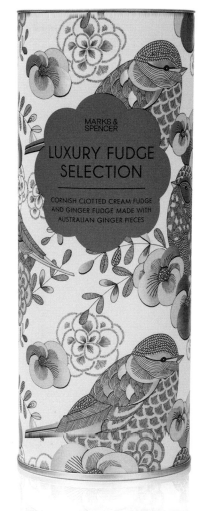

**MARKS &
SPENCER**

LUXURY FUDGE
SELECTION

CORNISH CLOTTED CREAM FUDGE
AND GINGER FUDGE MADE WITH
AUSTRALIAN GINGER PIECES

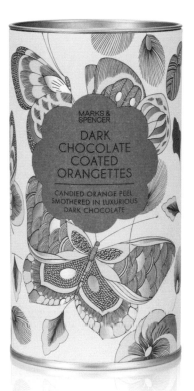

**MARKS &
SPENCER**

DARK
CHOCOLATE
COATED
ORANGETTES

CANDIED ORANGE PEEL
SMOTHERED IN LUXURIOUS
DARK CHOCOLATE

Taylor Black

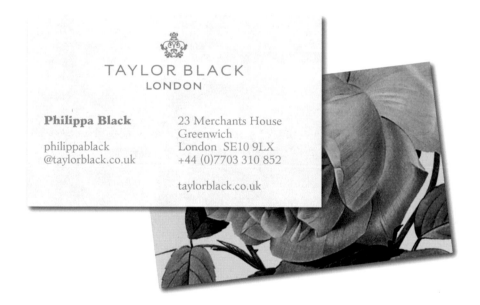

United Kingdom

Design Agency
Interabang

Designer
Adam Giles, Ian Mclean

Client
Taylor Black

Taylor Black is a handmade jewelry brand in London. The signature rose became the key to the identity, reflected in the crown emblem and imagery. The vintage feel was highlighted through the use of original Victorian botanical illustrations, which were intensely cropped to give them visual tension.

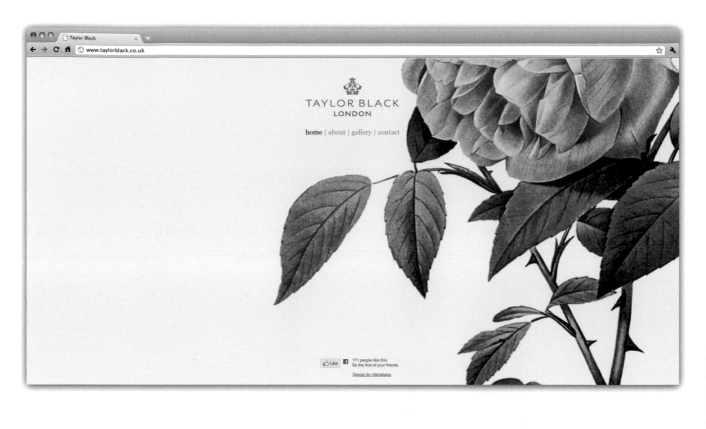

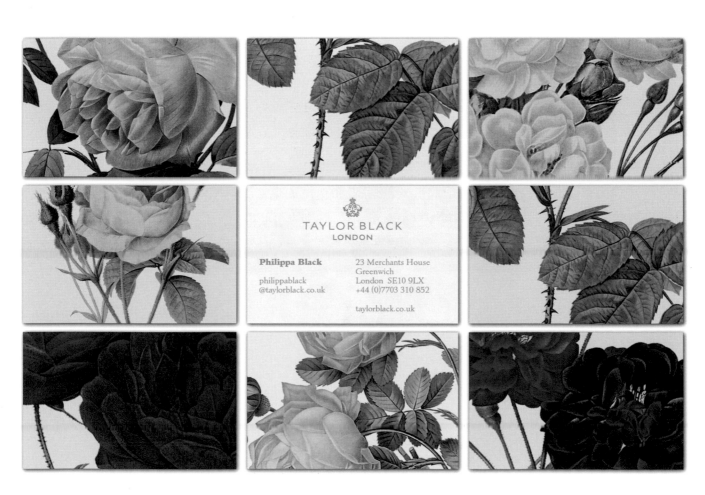

Qian Hu Fish Farm

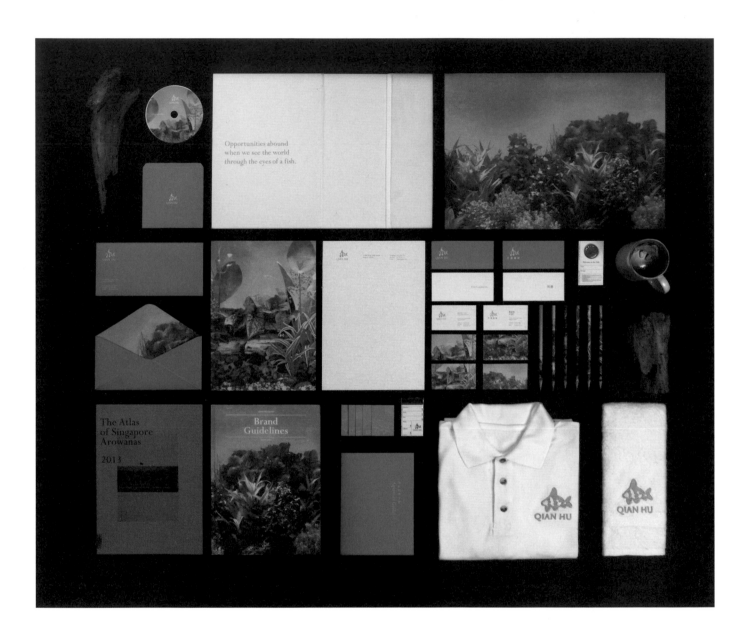

Singapore

Designer
Darius Ou

This project's direction uses 1980s Singaporean nostalgic aquarium imagery and vibe to explore on Qian Hu's rich history. The retro style reflects on the old-world pastime of fishkeeping, but has been given a modern reinterpretation. Common aquatic plants were used for the imagery.

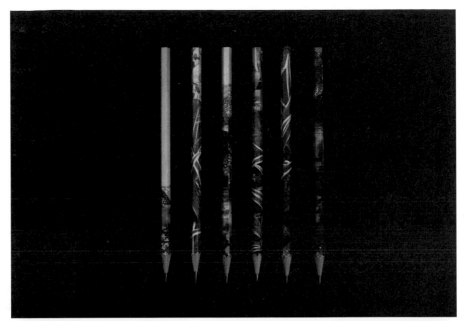

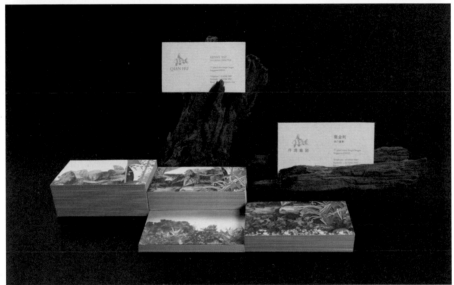

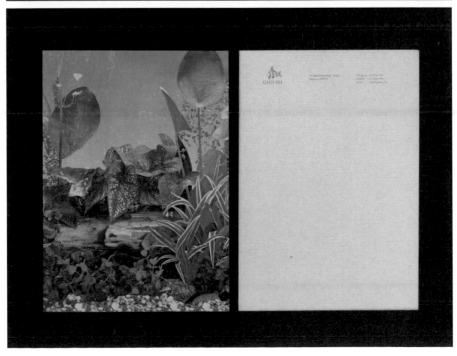

The Girly Veggiefruit Alphabet

Portugal

Designer
Aitch

The Girly Veggiefruit Alphabet is a personal project of the artist. The designer enjoyed every step of the process, from searching for various fruits and veggies for the alphabet to thinking of how to portray them as cute ladies and attributing them each a personality.

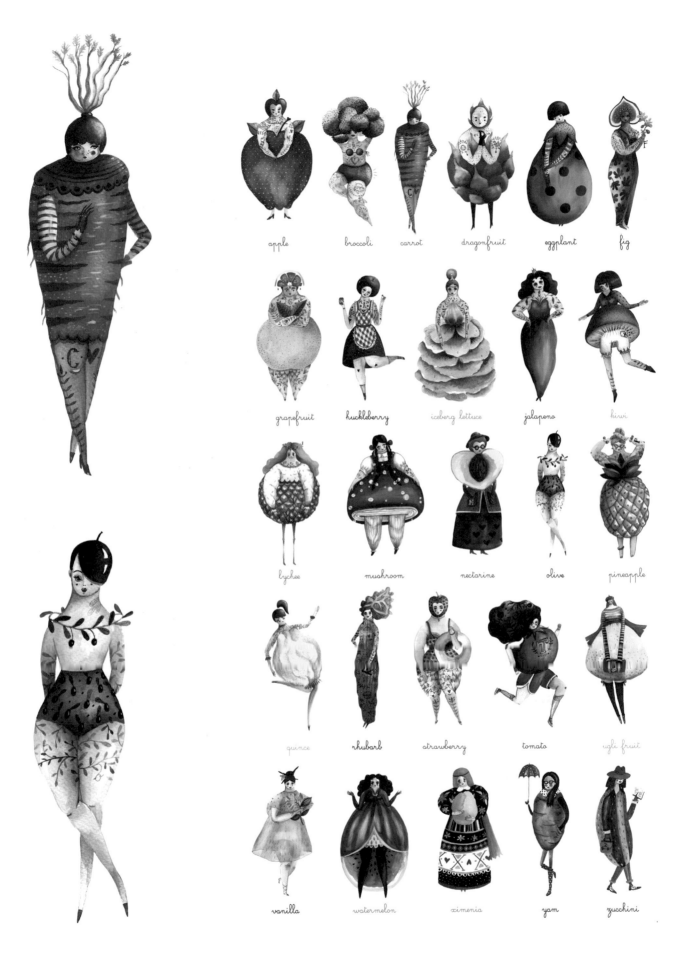

apple broccoli carrot dragonfruit eggplant fig

grapefruit huckleberry iceberg lettuce jalapeno kiwi

lychee mushroom nectarine olive pineapple

quince rhubarb strawberry tomato ugli fruit

vanilla watermelon ximenia yam zucchini

Hermès Métamorphose

Canada

Design studio
Vallée Duhamel Inc.

This is a video created for the luxury parisian brand Hermès and subtly featuring some of their key products. Everything transforms into something new, leading the viewer through a ludic story of surprising scenes.

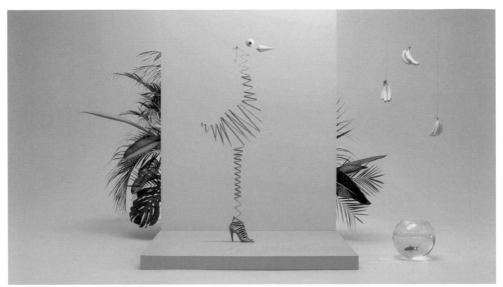

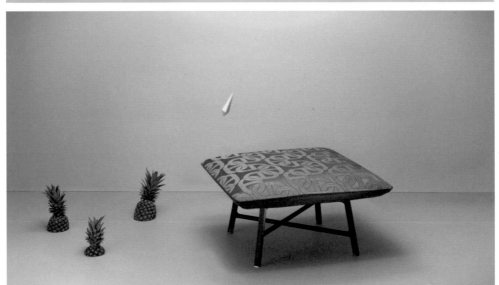

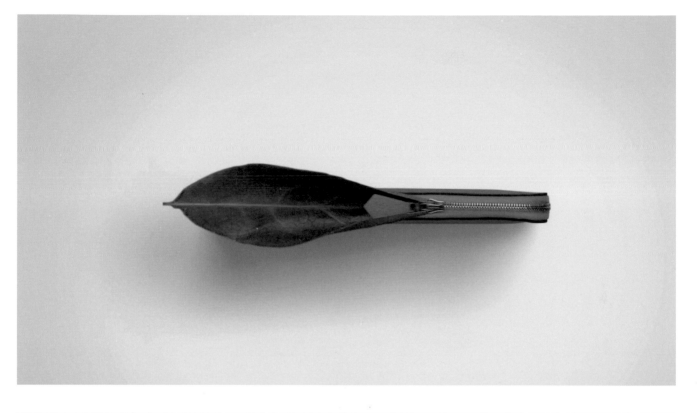

Odd Pears Campaign

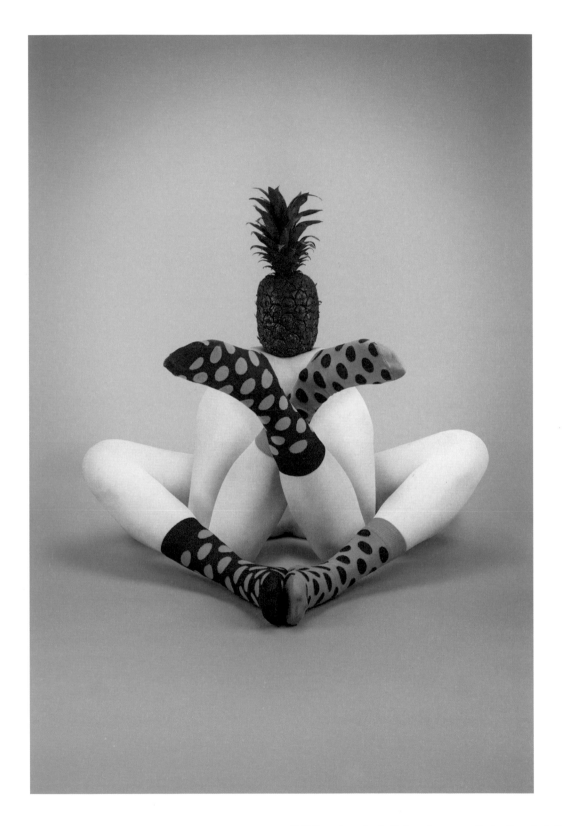

USA

Designer
Leta Sobierajski

Odd Pears is an Australia-based company that sells socks in Pears, not
pairs. A Pear is three individual socks: two matching, one odd.
The designer was asked to create a series of images for posters and
postcards to promote the polka-dotted collection. The result is a surreal,
fantastically colored group of face-less figures sporting the Odd Pears in
clashing colors and curious compositions.

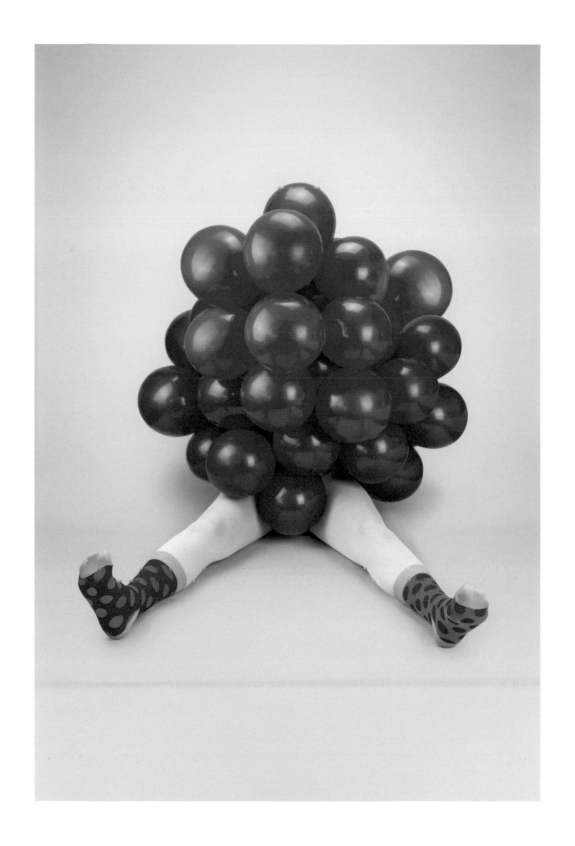

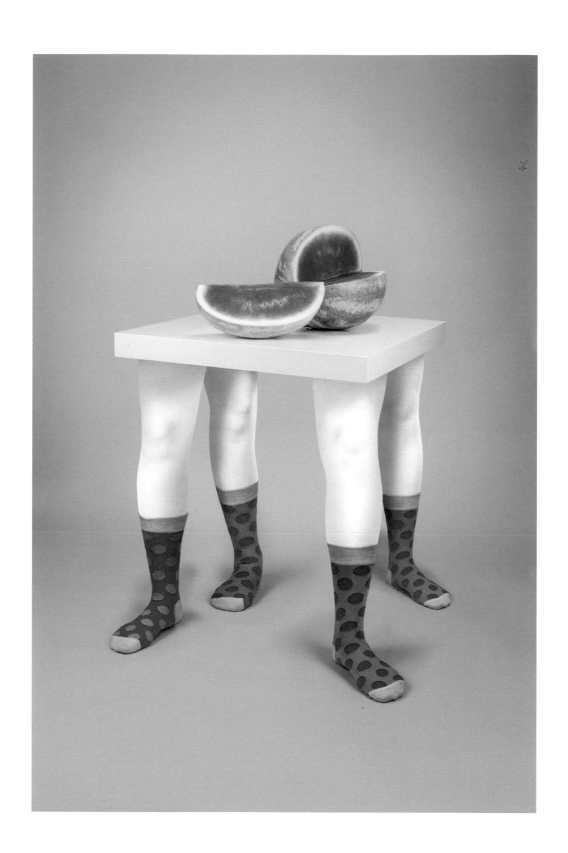

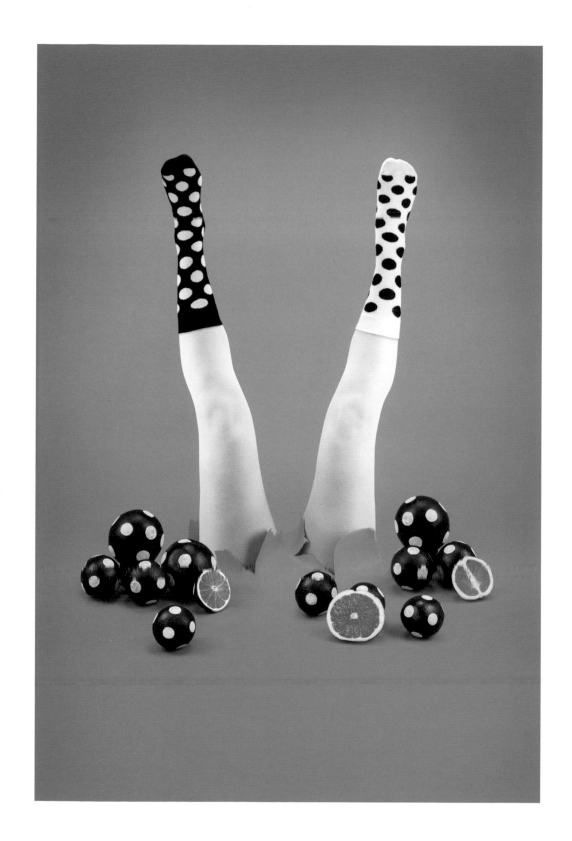

VW Beetle by Vrbanus

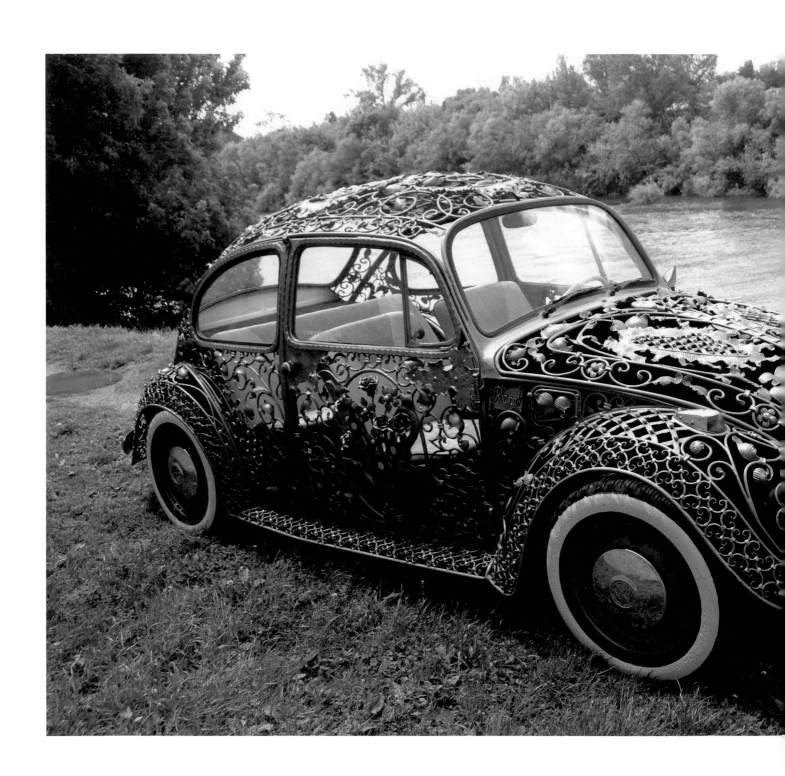

Croatia

Design studio
MG Vrbanus

Designer
Željko Vrbanus

"MG Vrbanus" is well-known in Croatia for its hand-made products in hammered metal. In this project the designer had decided to do something special to show the company's expertise. They came with the idea of turning an old Volkswagen Beetle into an iconic car. The details of the car are painted by hand and gold-plated with 24 kt gold. Later for an exhibition the designer had installed over 5000 Swarovski crystals on the metal joints and other parts, in order to give the car a more sparkling look.

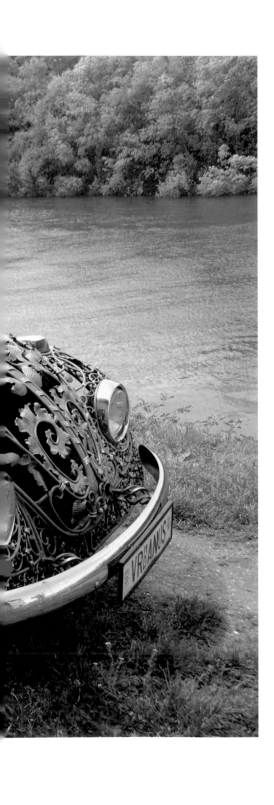

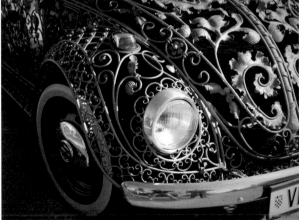

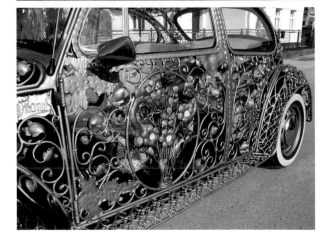

Botanical Garden

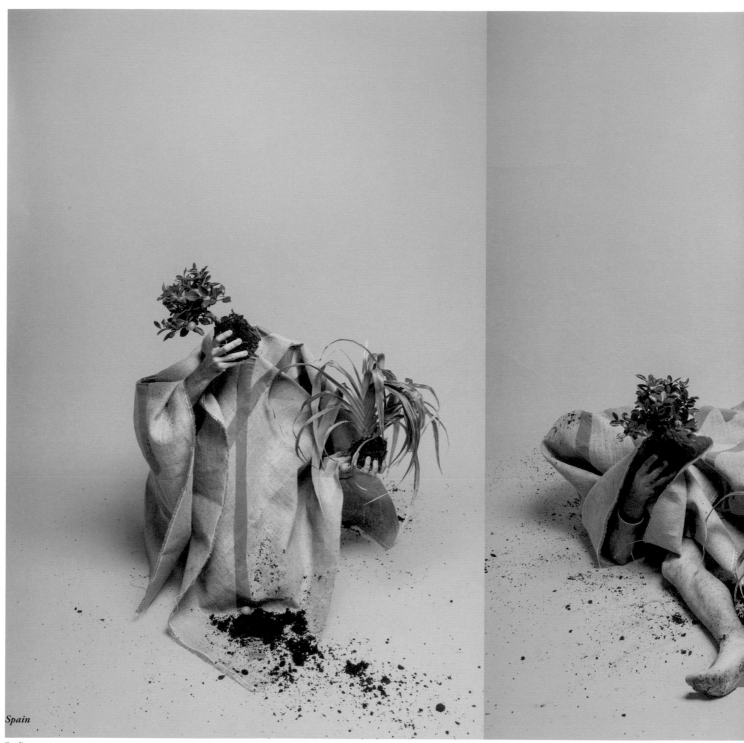

Spain

Studio
cocolia

Art Director
Pink Morro

Designer
Pink Morro

Photography
Marc Bordons

The designer Pink Morro aimed to explore the link between human figure and surrealism through eccentric visuals. The muted colors of fabric and tape have enhanced the color of the plants in the images.

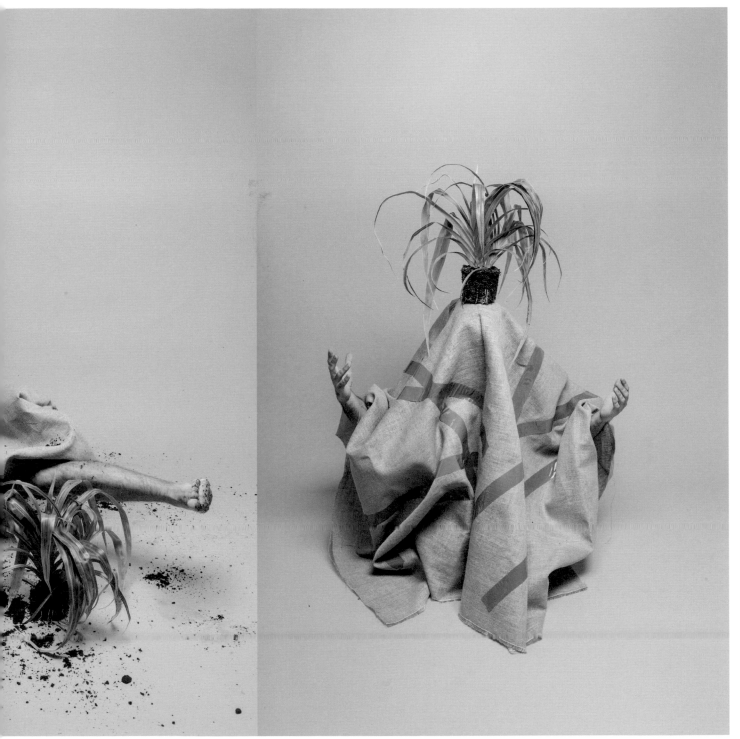

8: a Container Gardening Kit

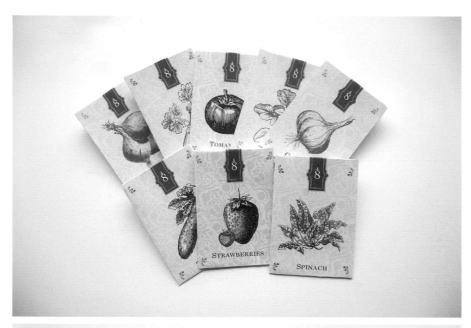

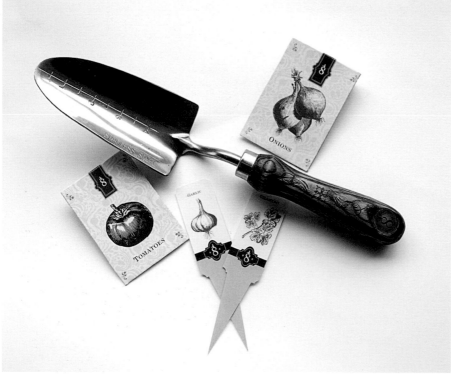

Canada

Design Agency
August Studio

Designer
Joel Derksen

8 is a container gardening kit that unites the social elements of food, ethical and moral issues about food production, and contemporary technology together. The design focuses on the autumnal, cozy, and nostalgic feelings we get when we reflect upon food, combined with a contemporary sensibility.

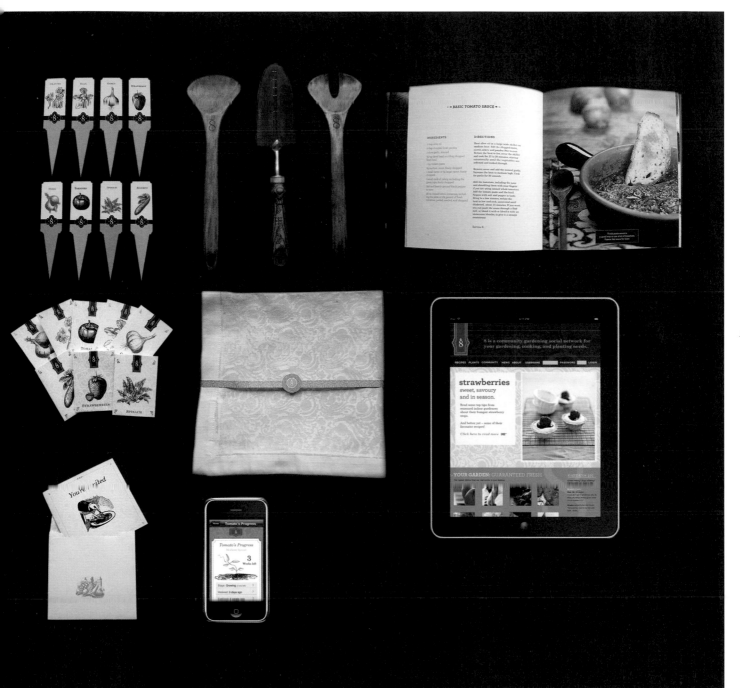

Oxygen in the Park

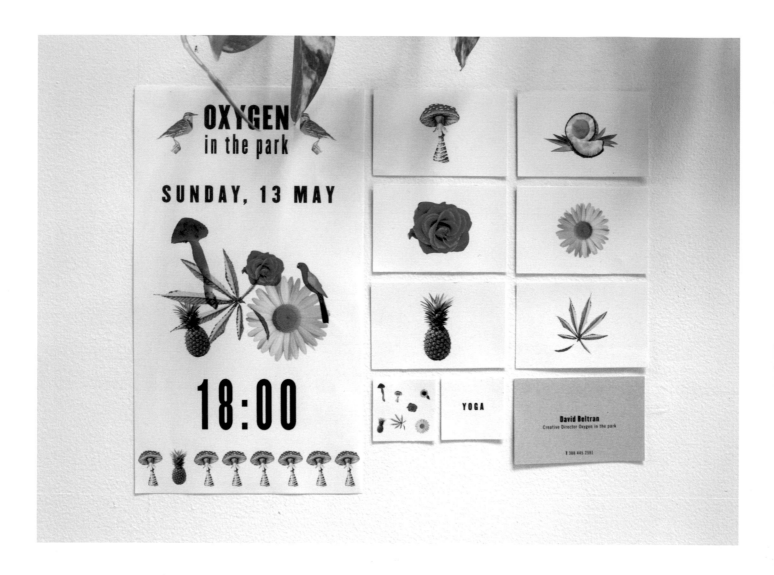

Italy

Design studio
Federica Marziale Studio

Creative Director
Federica Marziale, David Beltran

Designer
Federica Marziale

Client
Oxygen

The project's primary aim is "back to the nature". Oxygen in the park wants to bring people to the park every Sunday, and to invite them to live in contact with nature by healthy activities: yoga, music, food, picnic and sport. There is a hippy idea behind this concept: freedom in respect of nature.

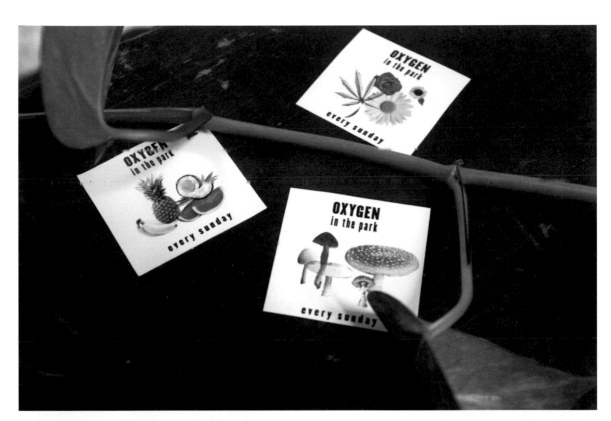

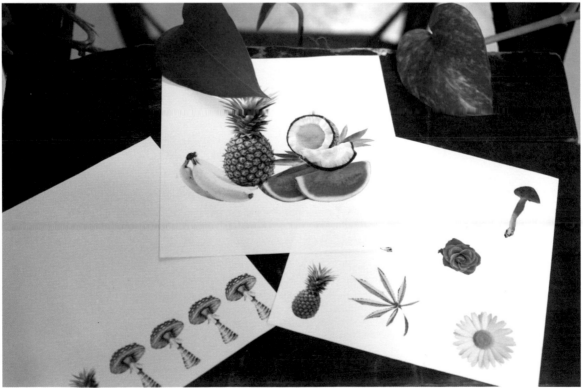

INDEX

ACKNOWLEDGEMENTS

We would like to thank all the designers and contributers who have been involved in the production of this book. Their contribution is indispensable in the compilation of this book. We would also like to express our gratitude to all the producers for their invaluable opinions and assistance throughout this project. And to the many others whose names are not credited but have aided in the production of this book, we thank you for your continuous support.

FUTURE COOPERATIONS: If you wish to participate in SendPoints' future projects and publications, please send your website or portfolio to editor01@sendpoints.cn